ISRAEL

50 YEARS

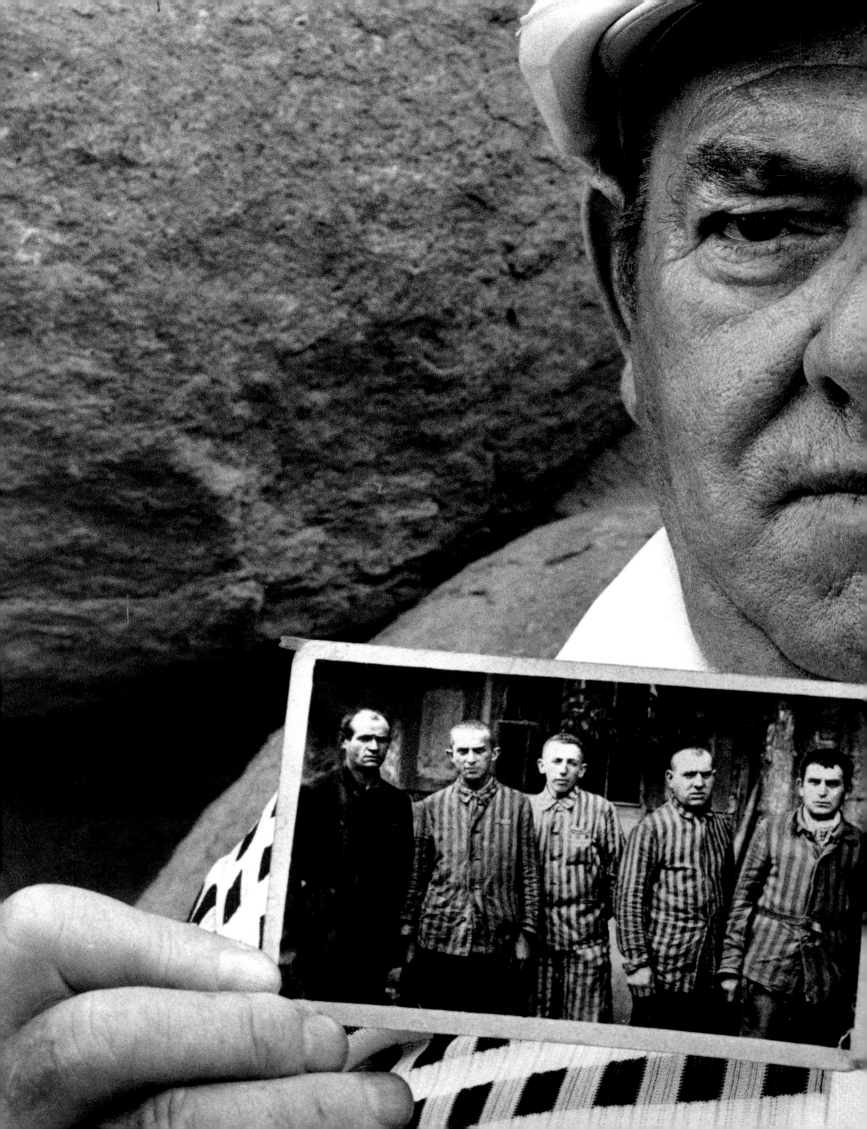

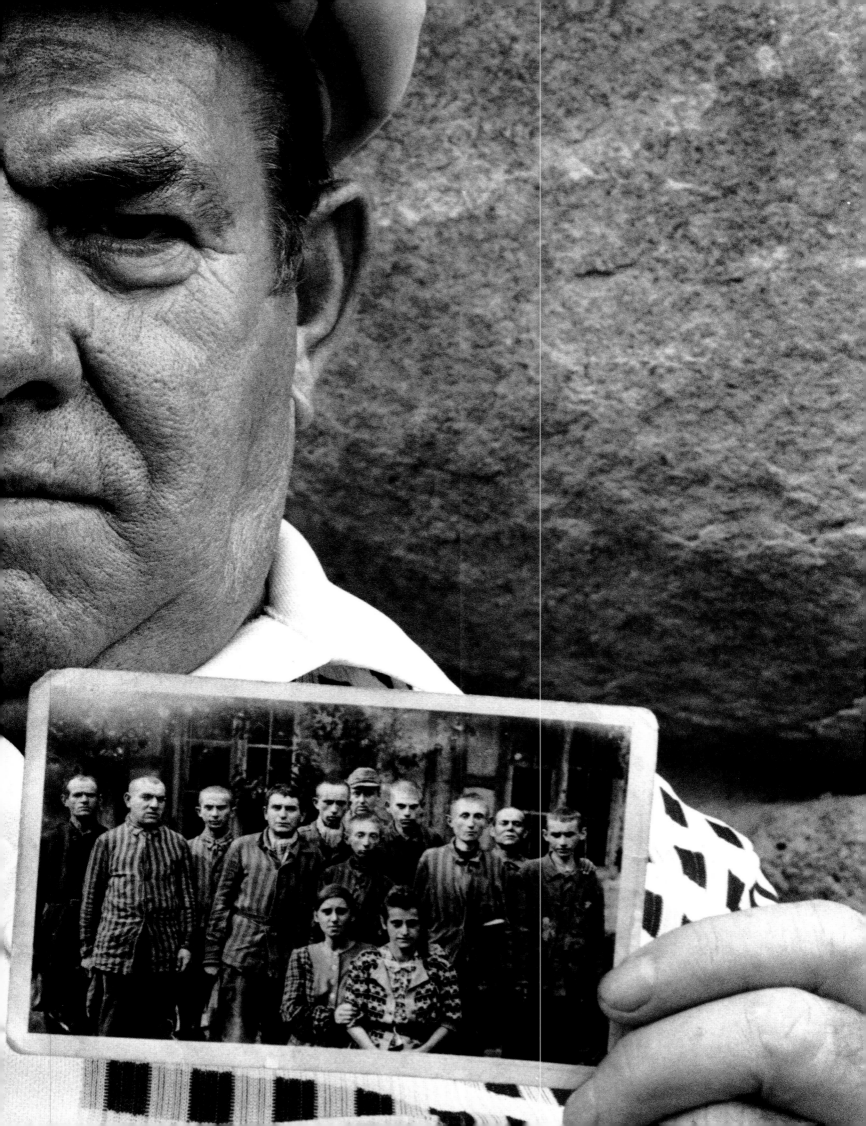

THE PHOTOGRAPHERS

ABBAS
MICHA BAR-AM
BRUNO BARBEY
IAN BERRY
RENE BURRI
CORNELL CAPA
ROBERT CAPA
RAYMOND DEPARDON
NIKOS ECONOMOPOULOS
ELLIOTT ERWITT
LEONARD FREED
PAUL FUSCO
JEAN GAUMY
BURT GLINN
HARRY GRUYAERT
ERICH HARTMANN
THOMAS HOEPKER
CARL DE KEYZER
HIROJI KUBOTA
ERICH LESSING
DON MCCULLIN
PETER MARLOW
SUSAN MEISELAS
INGE MORATH
JAMES NACHTWEY
MARTIN PARR
MARC RIBOUD
GEORGE RODGER
DAVID SEYMOUR
DENNIS STOCK
CHRIS STEELE-PERKINS
LARRY TOWELL
PATRICK ZACHMANN

**THE PUBLISHER WISHES TO THANK THE FOLLOWING
WHOSE SUPPORT MADE THIS PUBLICATION POSSIBLE:**

**ANNETTE AND JACK FRIEDLAND
LYNNE AND HAROLD HONICKMAN
CONSTANCE AND JOSEPH SMUKLER
MARTHA AND ED SNIDER**

◄

1 Holocaust survivor
during a reunion
staged in Jerusalem
Patrick Zachmann 1981

ISRAEL

50 YEARS

AS SEEN BY MAGNUM
PHOTOGRAPHERS

APERTURE

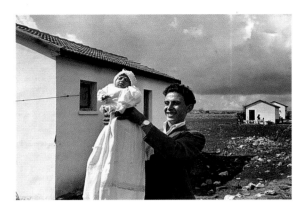

1948-1957

PLATES 2-44
Robert Capa David Seymour
Burt Glinn
Inge Morath
George Rodger

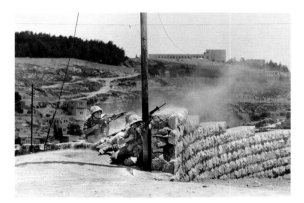

1958-1967

PLATES 45-89
Micha Bar-Am Elliott Erwitt Don McCullin
Ian Berry Leonard Freed Inge Morath
René Burri Burt Glinn
Cornell Capa Erich Hartmann

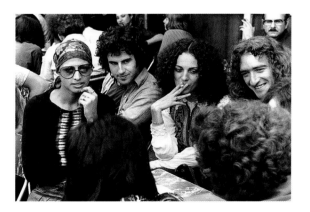

1968-1977

PLATES 90-127
Abbas Raymond Depardon Hiroji Kubota
Micha Bar-Am Leonard Freed Erich Lessing
Bruno Barbey Jean Gaumy Marc Riboud
Ian Berry Thomas Hoepker

CONTENTS

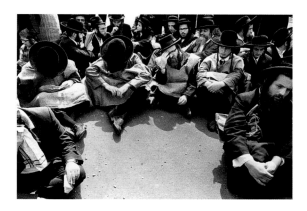

1978-1987

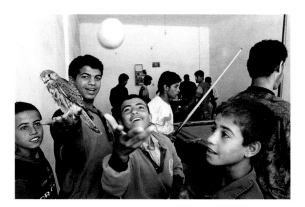

1988-1997

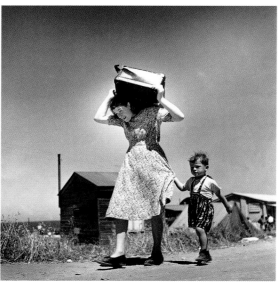
Immigrants in a transit camp - Robert Capa 1948

ISRAEL, the only state born at the end of the half century in which many of the states disappeared, is the crudest and hardest place one can live today. It is also a place where one hears the young sing at night, and even the old ones talk about the future.

The ships carrying the immigrants are newly bought boats, in reality broken-down steamers with a long history of running the British blockade, or small schooners bringing in Jews from the ghettos of surrounding Moslem countries. The immigrants on these boats are the motley remains of a people who two thousand years ago left these shores to scatter to the far corners of the earth and are now coming back, most of them to live and some of them to die in the Holy Land.

When I aired my doubts about Israel's immigration policy to one of the high government officials, he told me: 'By any logic, the creation of the state of Israel was not possible. It was born through a will stronger than reason, and grew through suffering greater than human beings are expected to support. We began on the bare hillsides under the hostile eyes of armed Arabs. Now we have the land and we have the arms. The new immigrants will suffer somewhat, but the new state needs them – and they need Israel!'

Curiously, the present state owes its existence just as much to Hitler and Bevin as to its own accomplishments. Without Nazism it could never have gotten mass immigration and without Bevin to encourage the Arabs to fight and flee, it would never have gotten its present territory. But the new country, born out of victorious battle, is granted no peace.

But the faith and future of all of these conflicting people and ideals rest on the shoulders of a score of early immigrants from western Russia who head the first government of Israel. The problems they face now are graver than a year ago when five Arab armies were converging upon the little country. They must settle the hundreds of thousands of new immigrants, and to do this must create new industries and increase exports.

Not far from the Weizmann Institute lives an old man, sitting on the dirt floor of a little abandoned Arab dwelling. He is an old rabbi from the Yemen, a small Arab state on the Red Sea where Jews lived for two thousand years but have not been chased away. He also spends his afternoon in deep meditation and scarcely lifted his eyes from his dog-eared Talmud as I photographed him. But when I left, saying goodbye with the traditional 'Shalom,' the old Rabbi looked up and murmured, 'Shalom, shalom – ve eyn Shalom!' ('Peace, peace, but there is no peace!').
Robert Capa 1948

OUT OF the 900,000 Palestinian Arabs who fled Israel three years ago, 500,000 came to Jordan and were given citizenship and civil rights by King Abdullah Ibn Al Hussain. Proportionately, that would be the same as allowing two million people to descend on the USA overnight. The percentage equivalent would be the same, but the thought is perhaps too overwhelming for comprehension.

…The dream of return to their homeland is almost gone and, with its fading, has come the search for some alternative - something that might at least give them a hope of bettering themselves. UNRWA so far is only

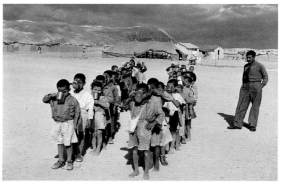
School in Jordanian refugee camp - George Rodger 1952

an opiate, and the rumours of schemes that will give them work are long in materialising. There is no help coming from other Arab countries. From past experience, they discount suggested aid from Britain. America is silent. But one small voice can be heard. It is the voice of Russia.
George Rodger 1952

ISRAELI Jerusalem is not a beautiful city; it has almost no visual charm or grace. It has been built for the most part and built the way the Israelis seem to build everything: rugged, blocky and serviceable. There is none of the beauty or picturesque quality of the Old City here, but there is a quality of grim purposefulness about the people. They don't seem too concerned about living in a divided city; they just expand westwards instead of concentrically as in most cities. On the other hand, they seem to be very aware of inhabiting the capital city of a nation still at war with all its neighbors, though they are certainly not living in fear of the potential enemy within talking distance.

Most of the Israelis in Jerusalem seem unconcerned about their inability to get into the colorful Old City, although the ultra religious yearn for access to the Wailing Wall. Unless you are taken as a tourist and shown the borders, and the proximity of the Jordanian positions, you are hardly aware that this is a split city: the Israelis are far too busy with other things. They are functioning

1948-1957

in a very complex and many layered city. West Jerusalem is a university town, it is a government town, it is a medical centre, it is the beginnings of an industrial town, it is an immigrant center and it is a religious center.
Burt Glinn 1957

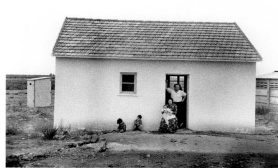
New settlers - Burt Glinn 1957

THE NEWEST, and perhaps one of the strangest sagas in the age-long history of Israeli immigration is the story of a group of 80 Italian peasants from southern Italy who, after an extraordinary conversion to the Jewish faith, made their way to the northern hills of Galilee. It is an amazing epic of spiritual belief and hardship and struggle, growing out of the specific conditions of life in southern Italy.

San Nicandro Garganico, the home town of Donato Manduzio, the founder, prophet, and leader of the group of new Jews, is a small, hot, dirty village where peasants till the fields and vineyards with ancient tools, where life goes on just as it did centuries ago. In this region of small, clannish groups and religious sects, Manduzio (called Levy), a half-paralysed victim of the First World War, of humble origin, confined to bed, plunged himself into the study of religious problems and began discussing all kinds of religious literature with friends who visited him. In the early Thirties, reading the Old Testament, he slowly gathered about him a group of followers to whom he preached beliefs based on the Old Testament.

Manduzio's influence had spread, and his teachings were being accepted by growing numbers of individuals, when a travelling salesman, delayed in San Nicandro by an automobile accident, spent the night in Manduzio's home. From him, Manduzio learnt that there are Jews in the world – people who consider the Old Testament as the basis of their religion. The intensity of his new found faith increased.

In the mid Thirties, as leader of the group, Manduzio made an application to the Chief Rabbi of Rome, asking for official acceptance into the Jewish community. At first his letters were seen in Rome as a practical joke, but the persistence of the group from San Nicandro eventually aroused the interest of the Chief Rabbi, who initially tried to dissuade the group from joining the ranks of the persecuted Italian Jews.

For many years, the status of the little community remained that of 'semi-Jews'. Italian authorities attacked them for propagandising a religion, and they were fined for conducting a place of worship without proper authorisation. They were hidden by the entire village to escape the German anti-Semitic laws. Only after the Second World War were they accepted as the Jewish community of San Nicandro.

The liberation of 1943 opened a new period for the Jews of San Nicandro. The Israeli brigade of the British 8th Army paraded through the town and for the first time Manduzio was to meet fellow Jews, and from that time on the community voiced the desire to journey to Israel, the land of their 'fathers'. Sadly, Manduzio never lived to see this hope materialise. He died in 1948, but two years later his dream was fulfilled when the entire community emigrated to Israel.

Eventually, the group decided to settle on a site in Galilee, lacking both water and trees, in the midst of abandoned farmland that had remained untilled for centuries. It is in this new village named Alma that the converted Jews of San Nicandro are now living, along with Jewish settlers from Tripoli. In its dry valley, surrounded by hills, life in Alma is

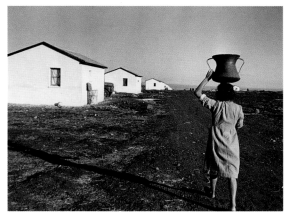
Alma village, Galilee - David Seymour 1951

strenuous. Water will only be available in a few months, when the new pipeline operates. The infertile, stony ground requires hard labor to clear and prepare it for cultivation. Slowly, roads are being built and improved.

In spite of the hardships, a great, almost mystical feeling of satisfaction prevails among the 80 simple Italian settlers. They have been accustomed to hardship all their lives. There they sincerely feel that they have reached the Holy Land, where their problems will be solved. They have confidence in the future; they are sure that they can make the desert bloom.

Like many new immigrants in Israel, they still speak their native language; only the children manage to learn Hebrew. For religious services, they read the Old Testament, chapter by chapter, in Italian, and sing the religious hymn written by Manduzio, which, with their own musical accompaniment, is strangely reminiscent of Italian church singing. It is an amazing sight to watch members of this community – the Italian faces among the Arab-like Tripolitanians – building a new home together. It is another fascinating chapter in the great modern migrations to Israel; it may be the most curious and unusual of them all.
David Seymour 1951

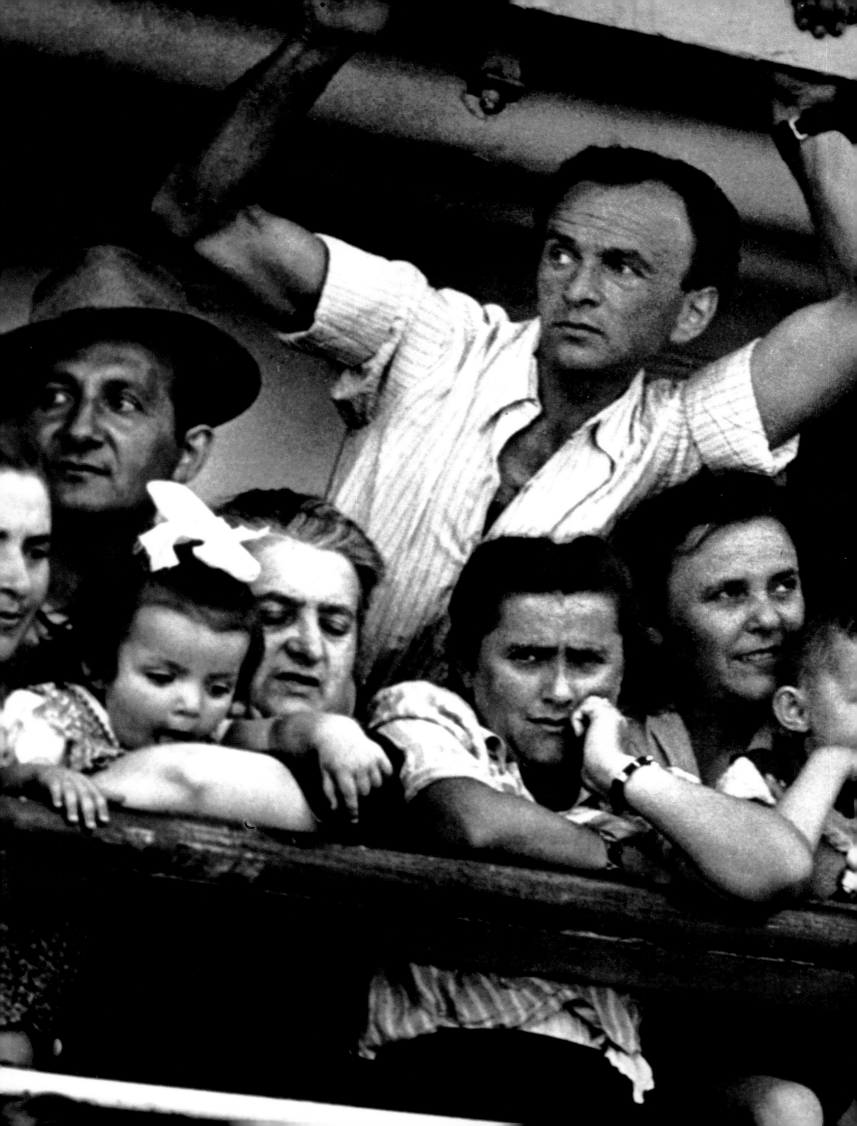

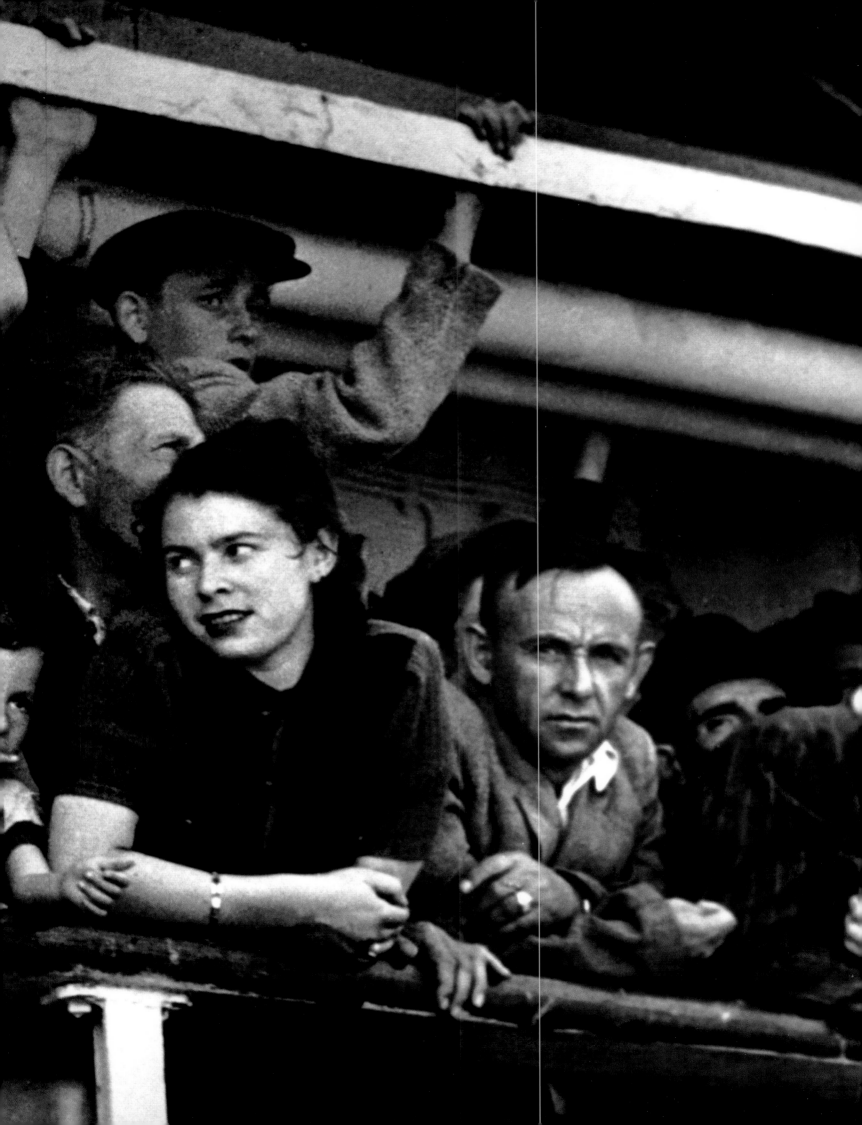

3 David Ben-Gurion
 reads the
 proclamation of
 the State of Israel
 Robert Capa 1948

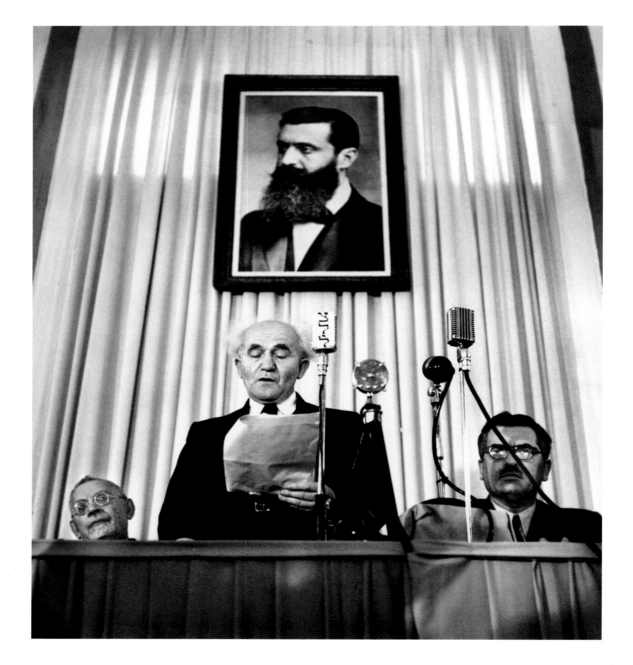

◄
2 The arrival of
 refugees by boat
 in Haifa
 Robert Capa 1948

►
4 Menachem Begin
 at a political rally
 Robert Capa 1948

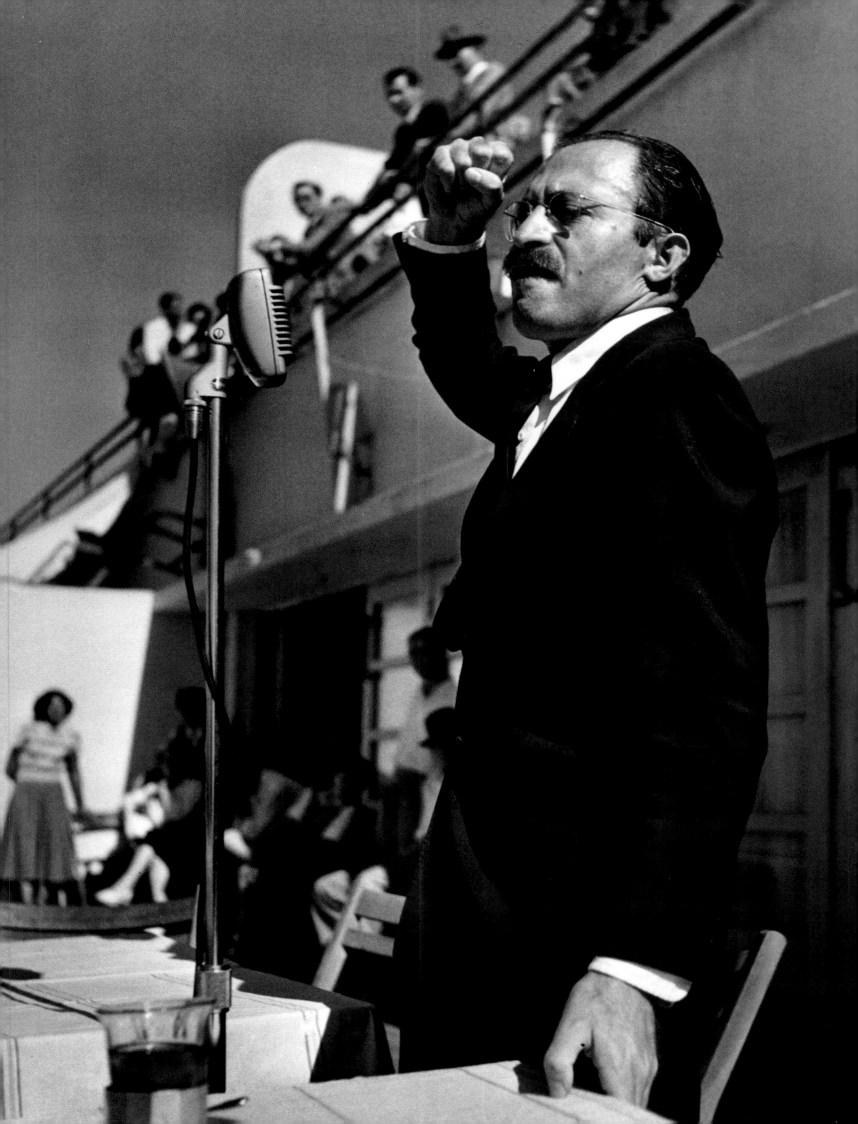

5 Sir Alan
 Cunningham,
 the British High
 Commissioner for
 Palestine, leaving
 from Haifa
 Robert Capa 1948

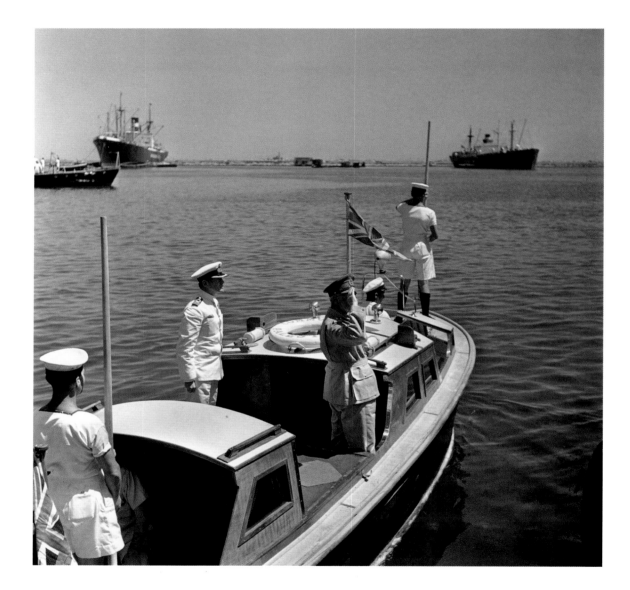

6 Chaim Weizmann,
first President
of Israel, is led
in to vote in
the municipal
elections
Robert Capa 1950

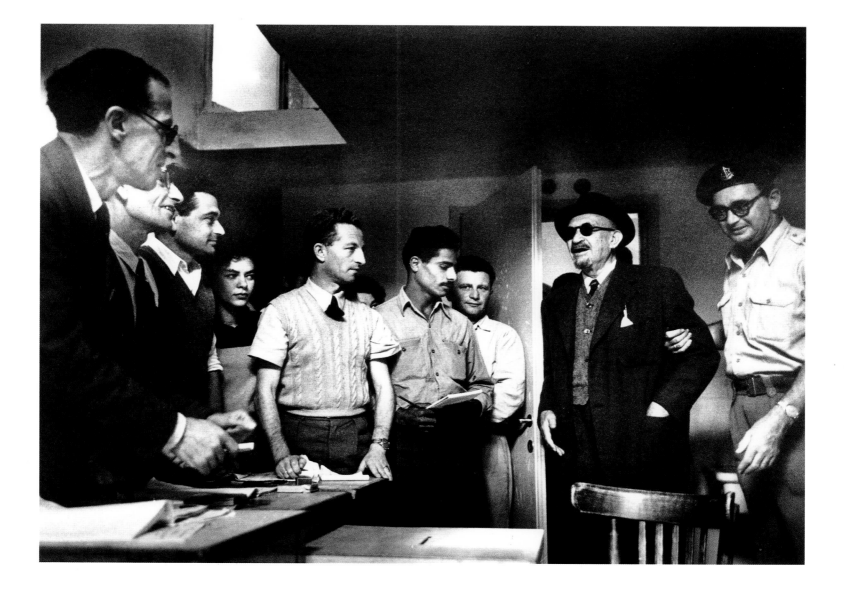

▶
7 Fighting for territory
in Jerusalem on the
night before the
cease fire, an Israeli
machine gunner
keeps guard over
a newly occupied
building
Robert Capa 1948

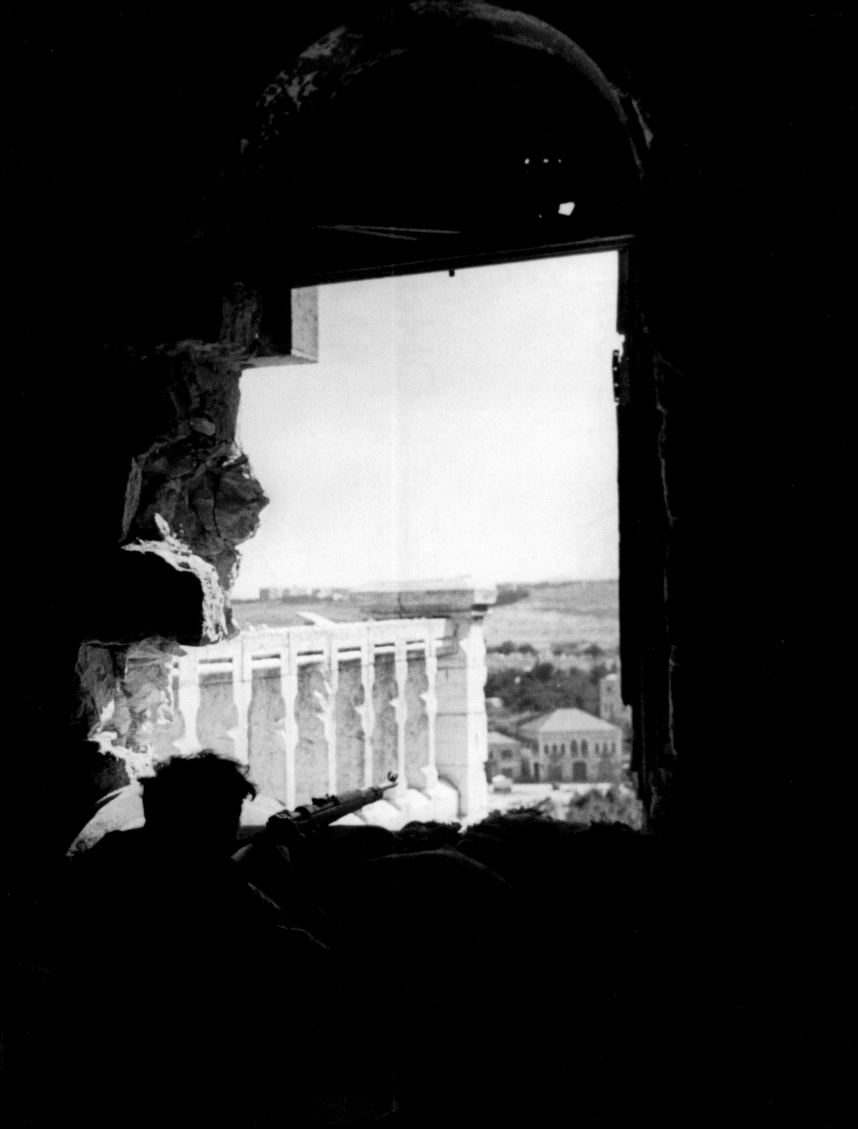

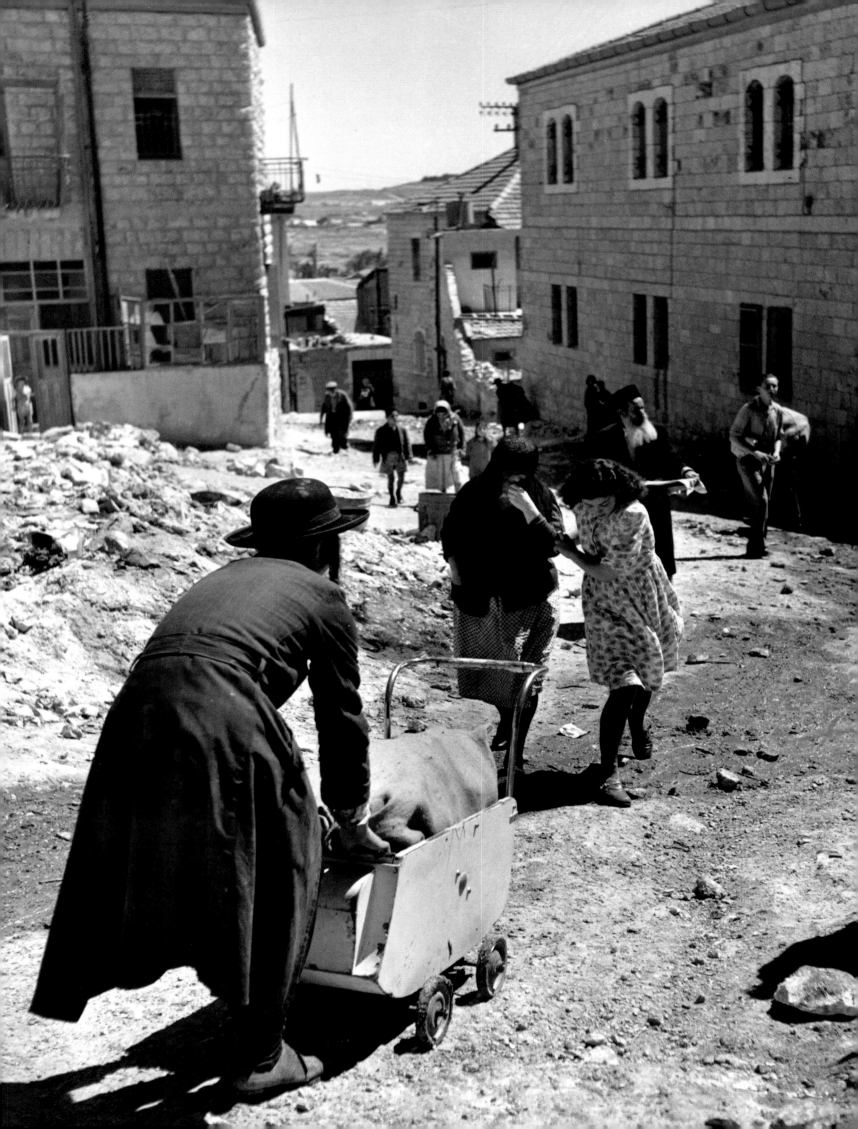

9 A sign just outside
 the walls of the
 Old City watched
 over by Jordanian
 police, showing
 the road to the left
 blocked as it enters
 Israeli territory in
 West Jerusalem
 George Rodger 1952

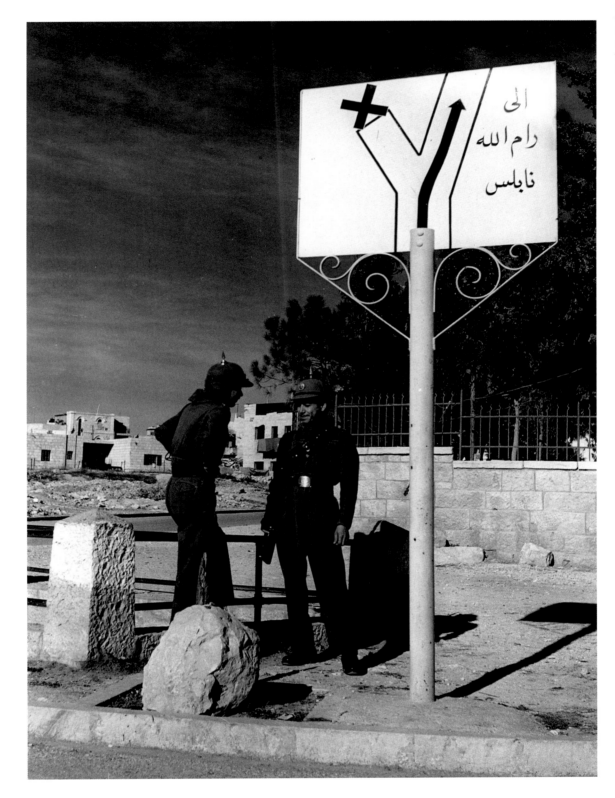

◄
8 The first morning
 of the cease fire,
 the people of the
 Mea Sharim quarter
 of Jerusalem emerge
 to collect rations
 ready for the Sabbath
 Robert Capa 1948

►
10 Tank traps on the
 Damascus road
 as it runs past the
 walls of the Old
 City in Jerusalem
 George Rodger 1952

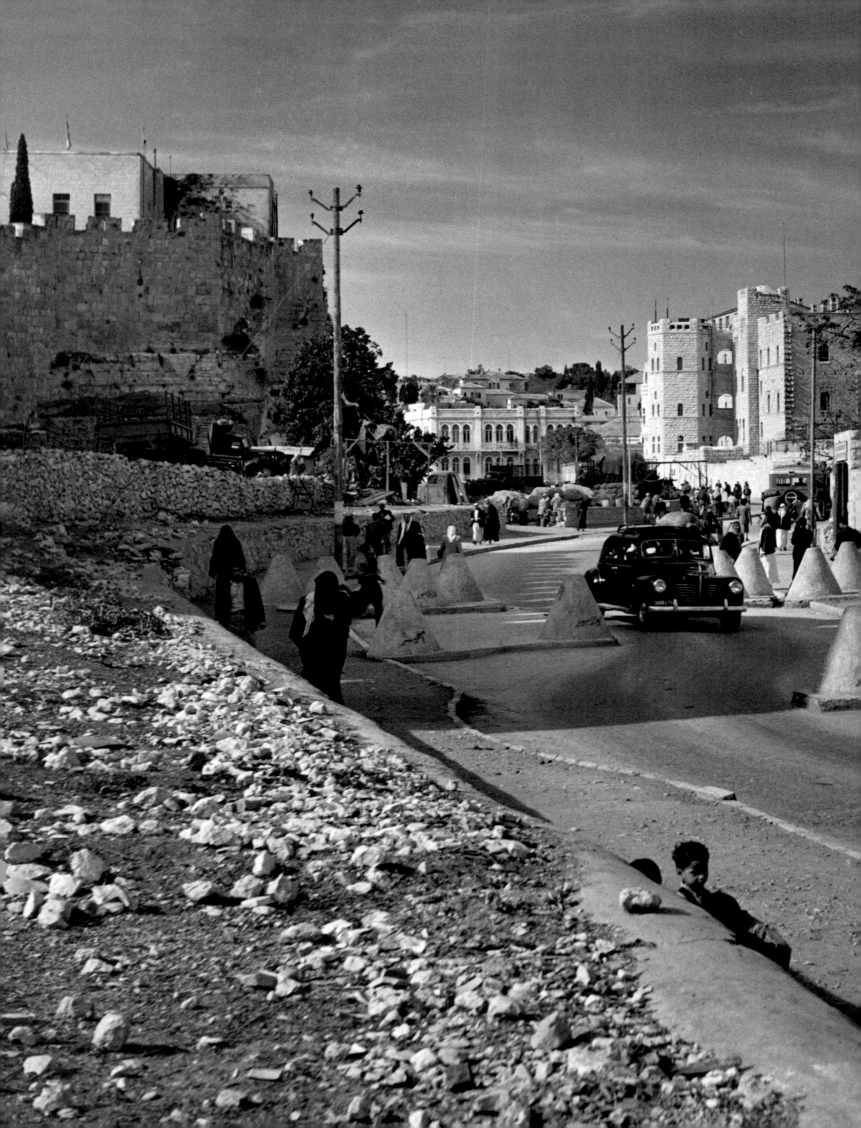

11 Absorption camp
in Haifa, where
immigrants had
to stay until
housing could be
found for them
Robert Capa 1950

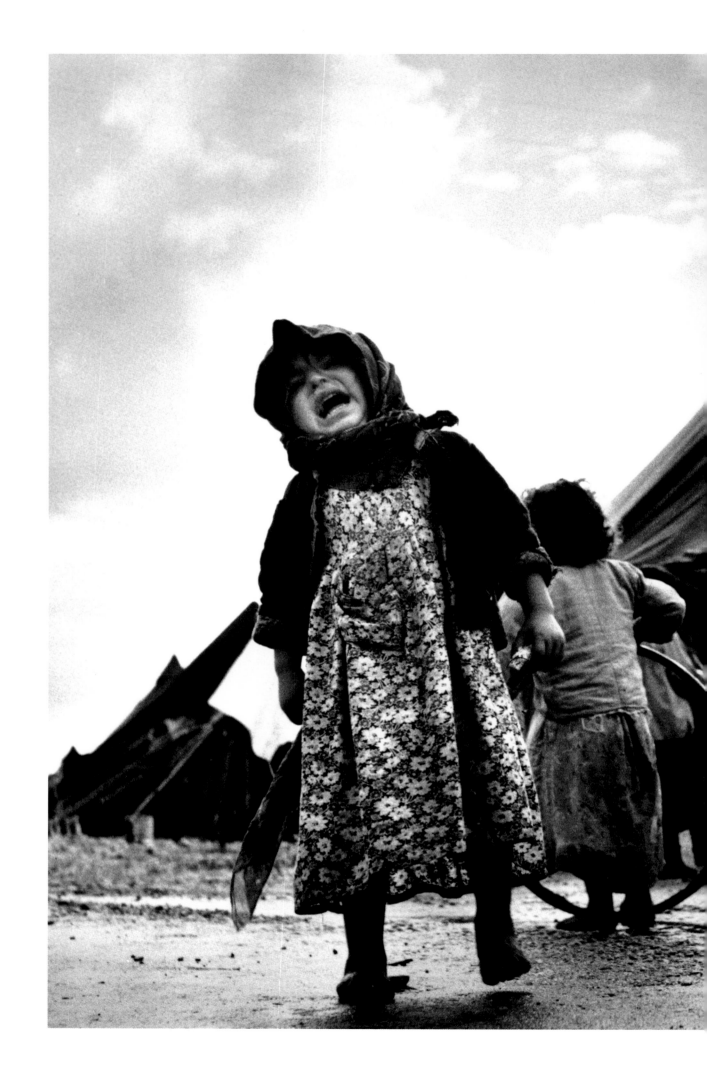

12 **New arrivals in Haifa
disembark from the
*Theodor Herzl***
Robert Capa 1948

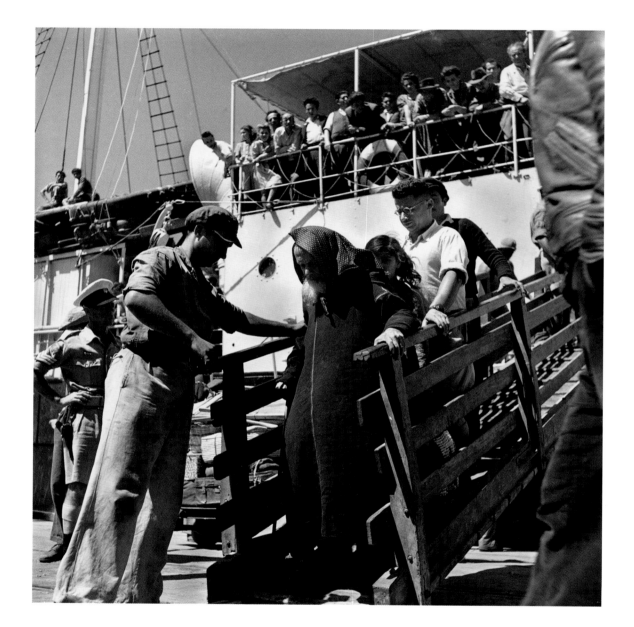

▸
13 **A reception center
for new immigrants
in Haifa**
Robert Capa 1948

14 **Catholic nuns pray
 on the Via Dolorosa,
 Jerusalem**
 George Rodger 1952

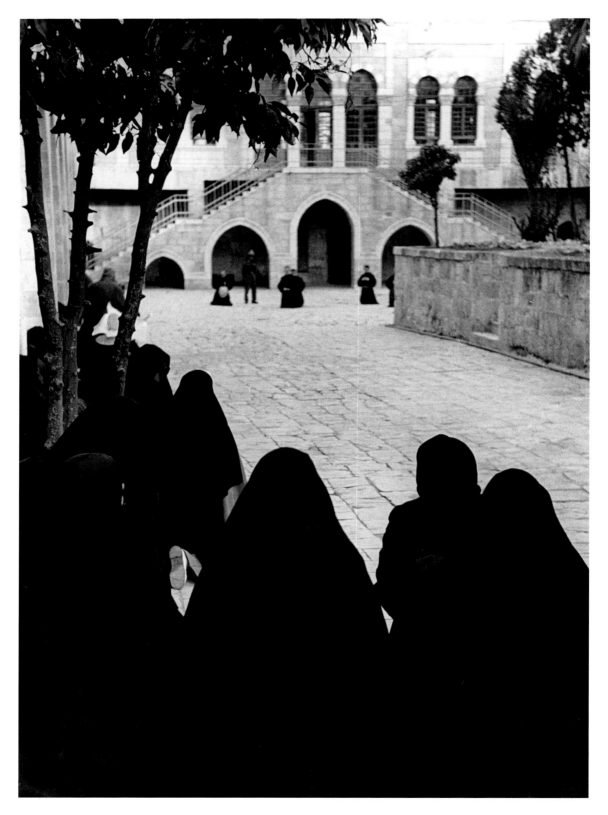

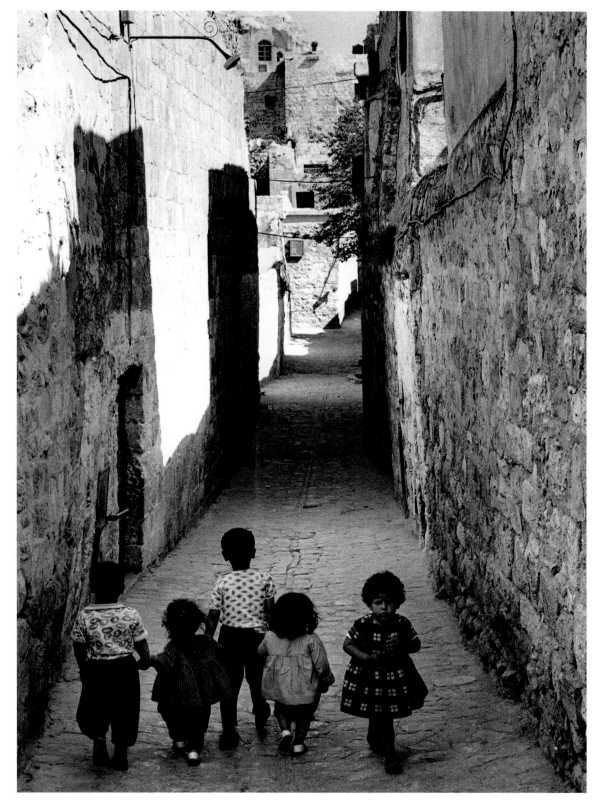

16 Miriam is the first
child born to Eliezer
Trito, a member of
the extraordinary
Italian Jewish
community described
by David Seymour
in the opening
of this chapter.
She is dressed in
a traditional Italian
baptismal robe
David Seymour 1951

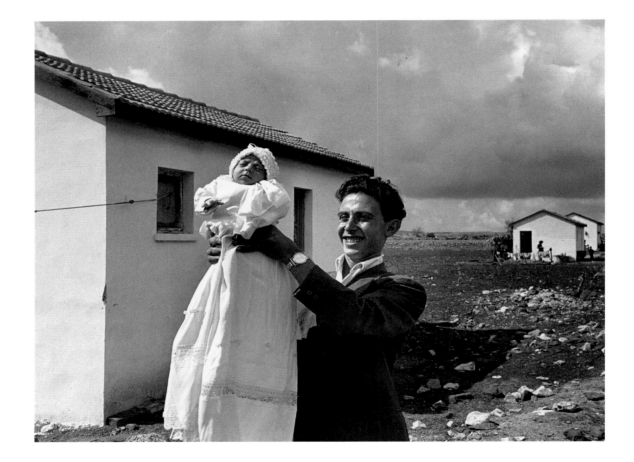

▶

17 **Immigrant transit
camp in Haifa**
Robert Capa 1949

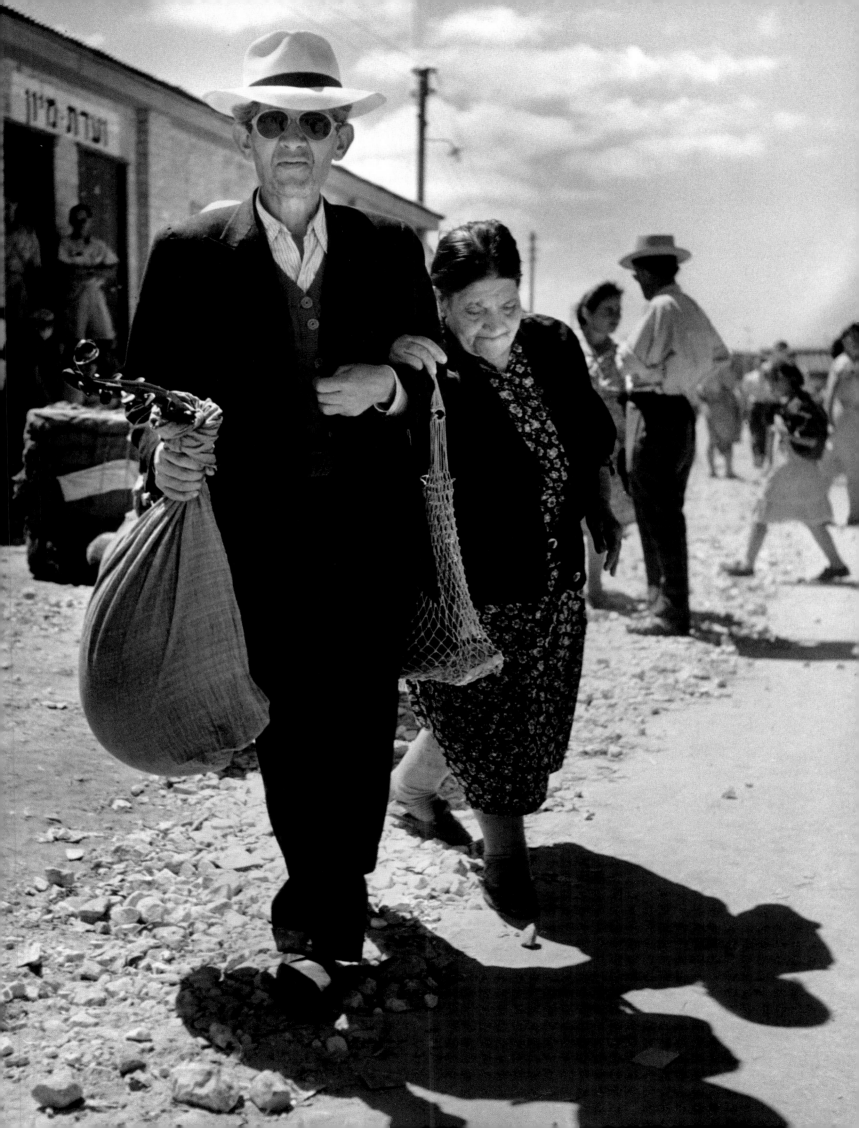

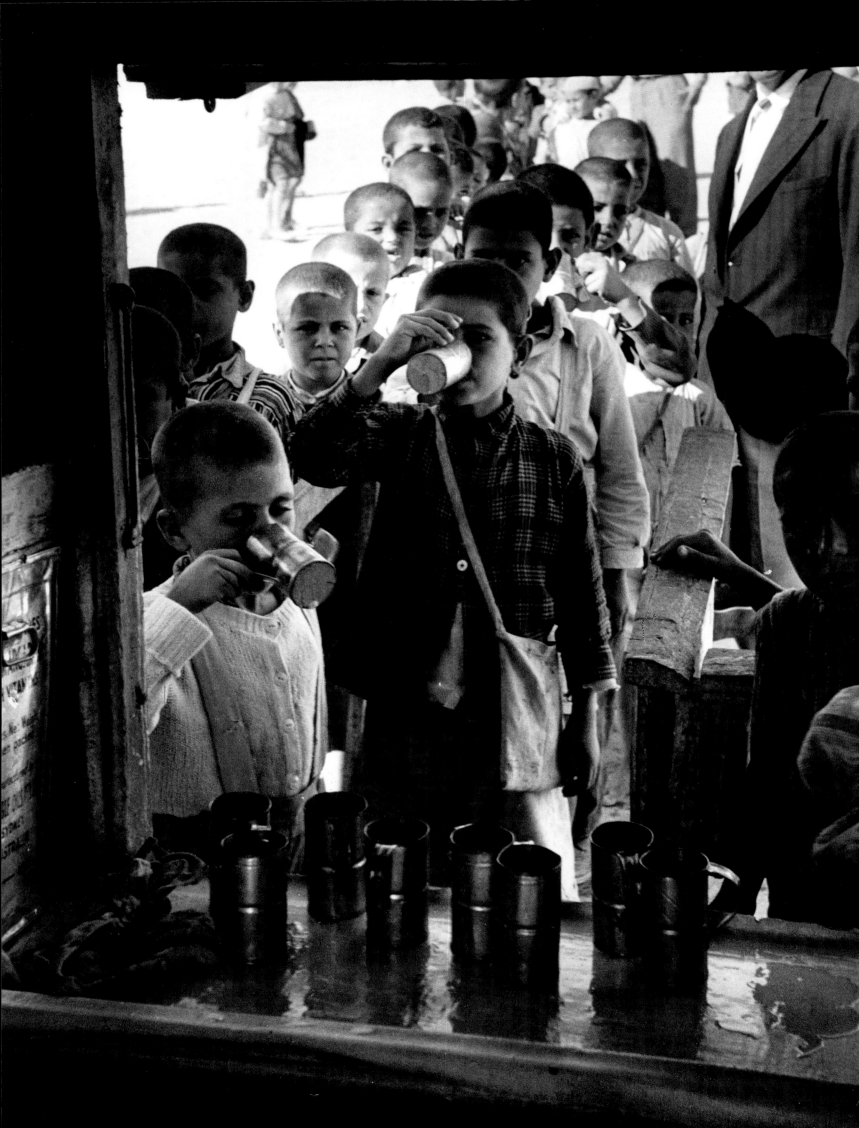

19 **A torn tent serves
 as a classroom in
 the same YMCA
 school**
 George Rodger 1952

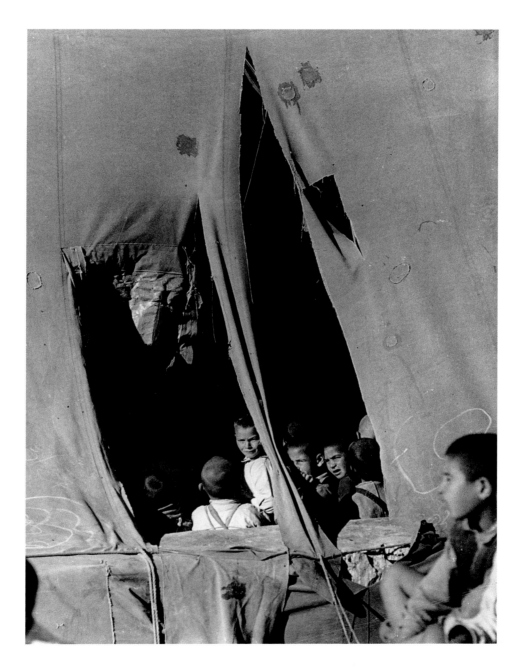

◄
18 **Children line up
 for the milk rations
 supplied by UNICEF
 at a YMCA school
 in the Jordan Valley**
 George Rodger 1952

20 **Building a
permanent road
at a work camp
in Faradia**
Robert Capa 1950

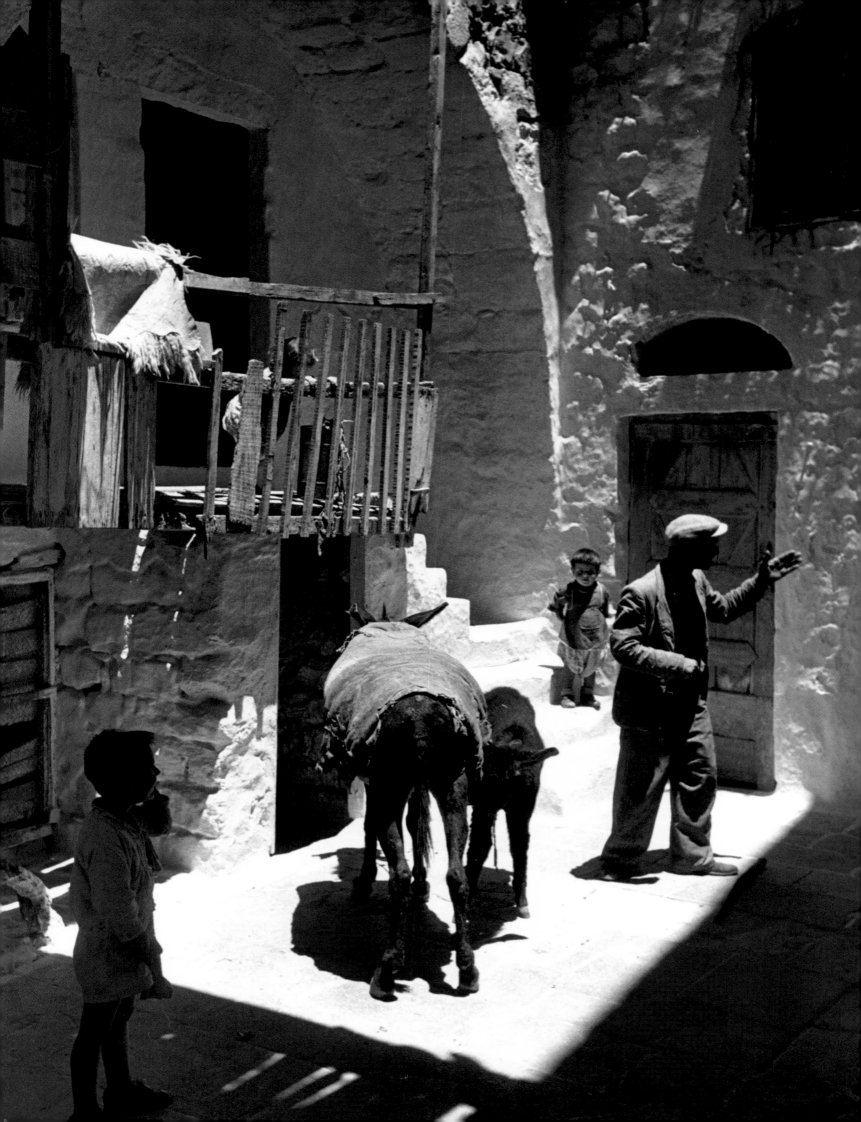

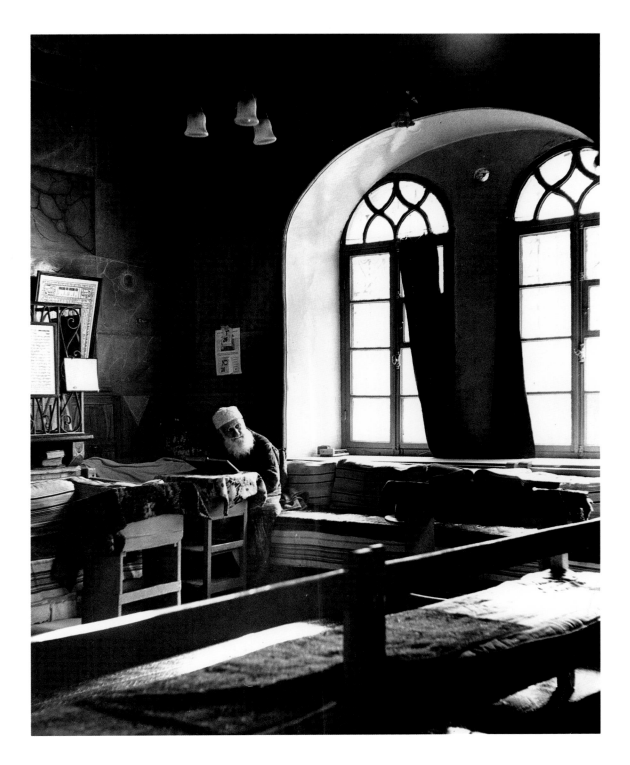

◄
22 **Safed, a center of
Cabalistic studies
for centuries.
Within many of its
fourteenth century
houses are
courtyards where
animals are kept**
Robert Capa 1948

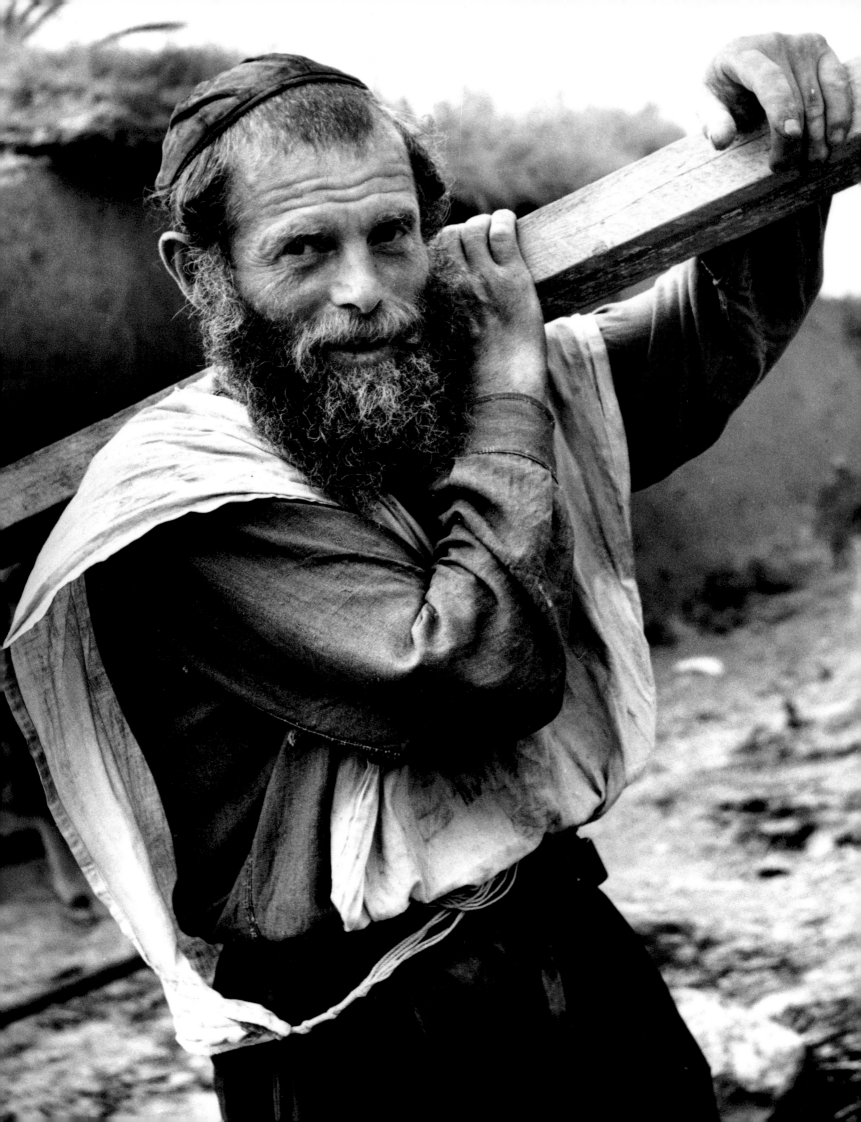

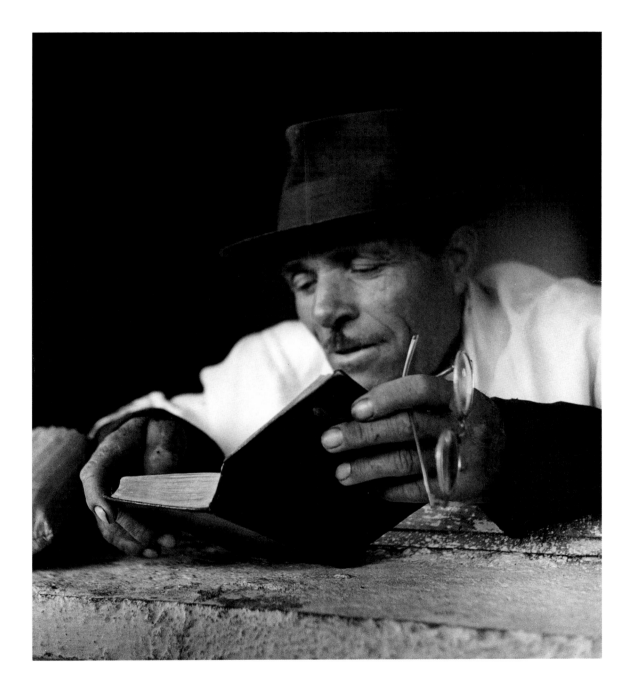

◄

24 Joshua Friedman
was in Auschwitz
from 1941, where
his wife and five
children were killed.
He now lives in a
religious settlement
in the Negev
Robert Capa 1948

▶

26 A welder at work
at a factory near
Ashkelon
constructing
pipelines for the
Israeli irrigation
scheme
David Seymour 1954

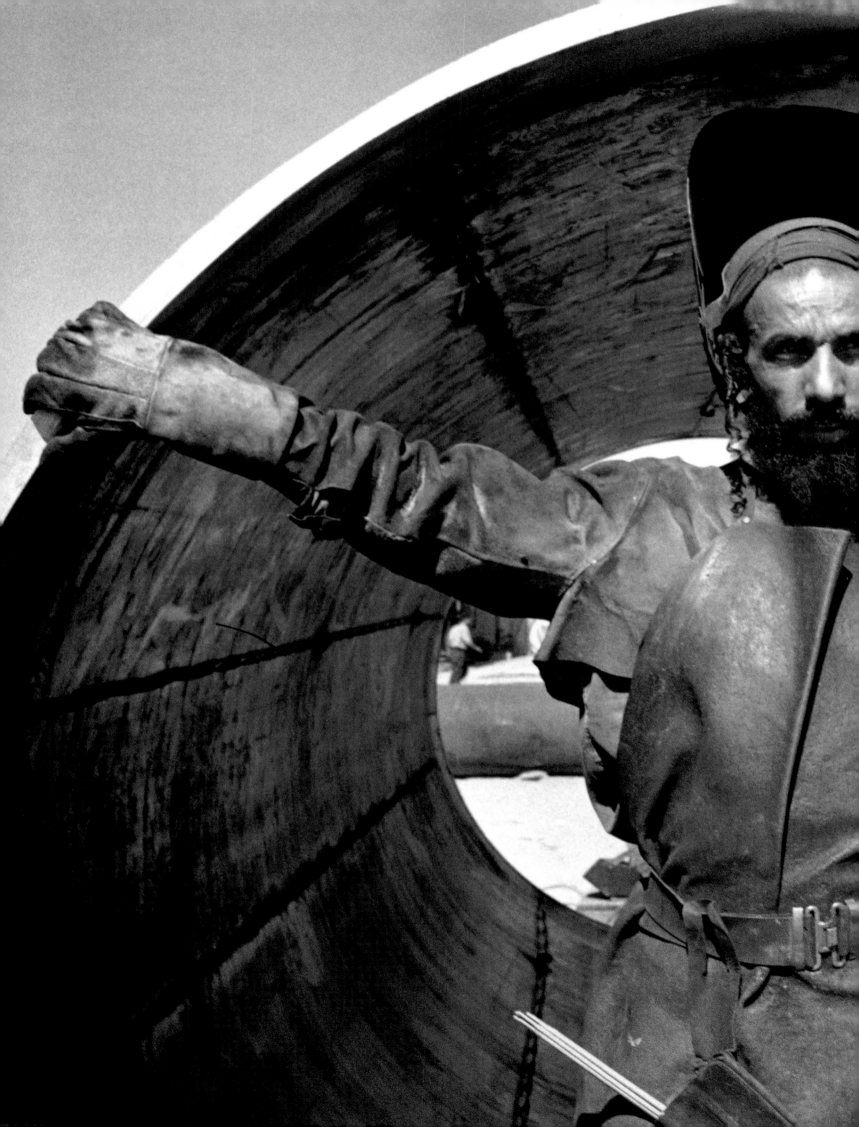

27 **A young fisherman,
a member of
Rakkath, a fishing
cooperative in
Galilee**
David Seymour 1954

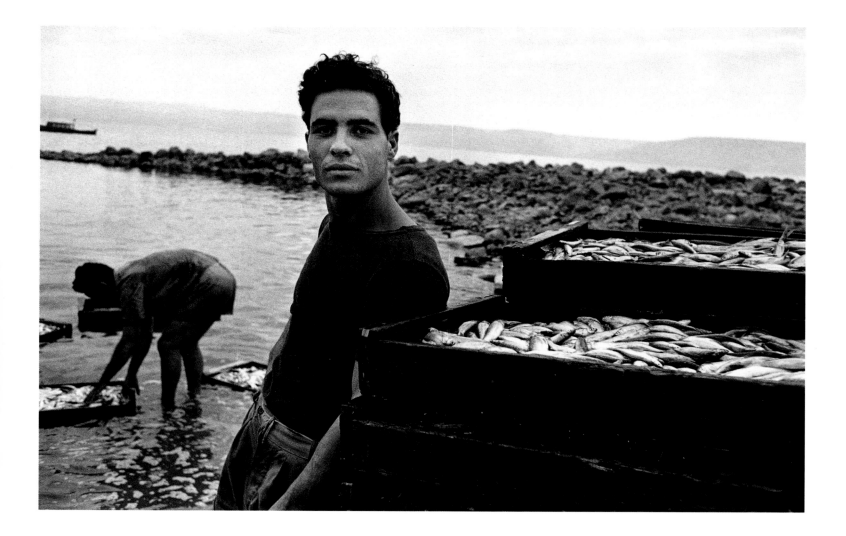

28 **A young Israeli
preparing for
sentry duty**
David Seymour 1951

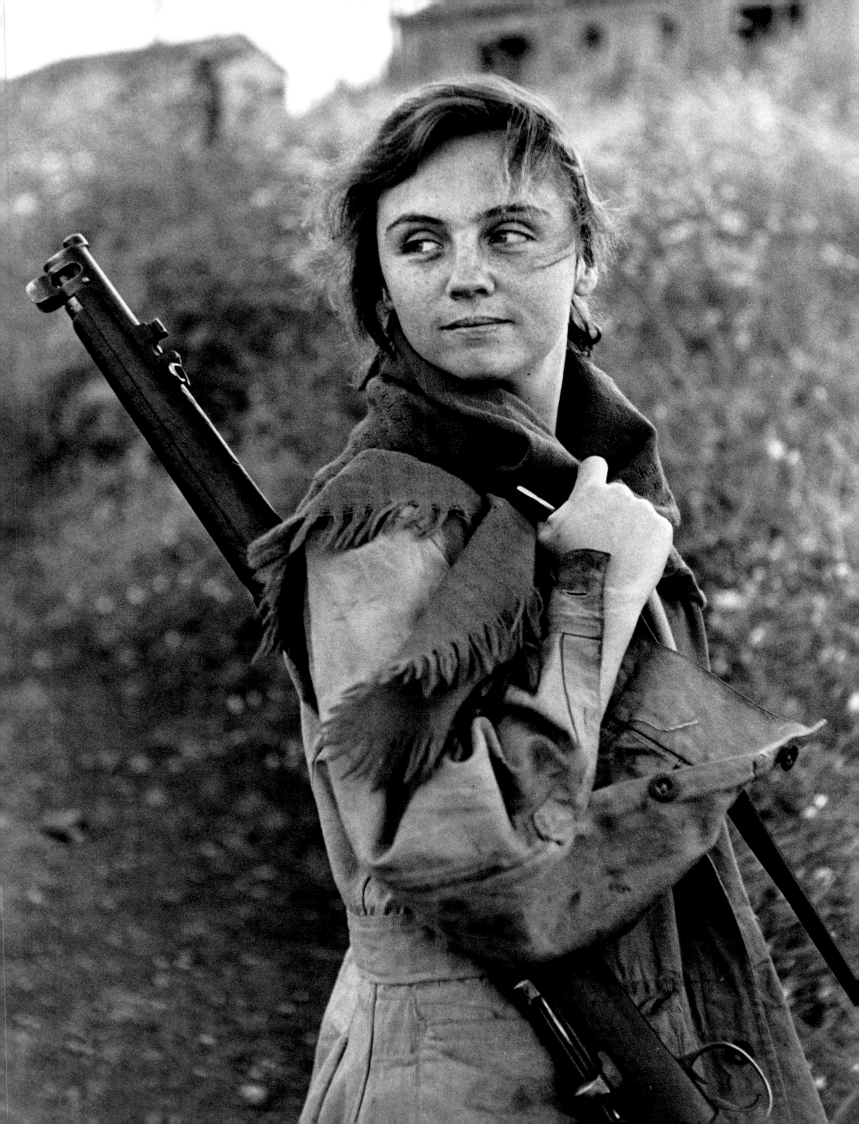

29 **A kibbutz border
 defense center in
 northern Galilee**
 David Seymour 1952

▶
30 **The funeral of an
 Israeli watchman,
 killed during a
 border incident,
 Jerusalem**
 David Seymour 1953

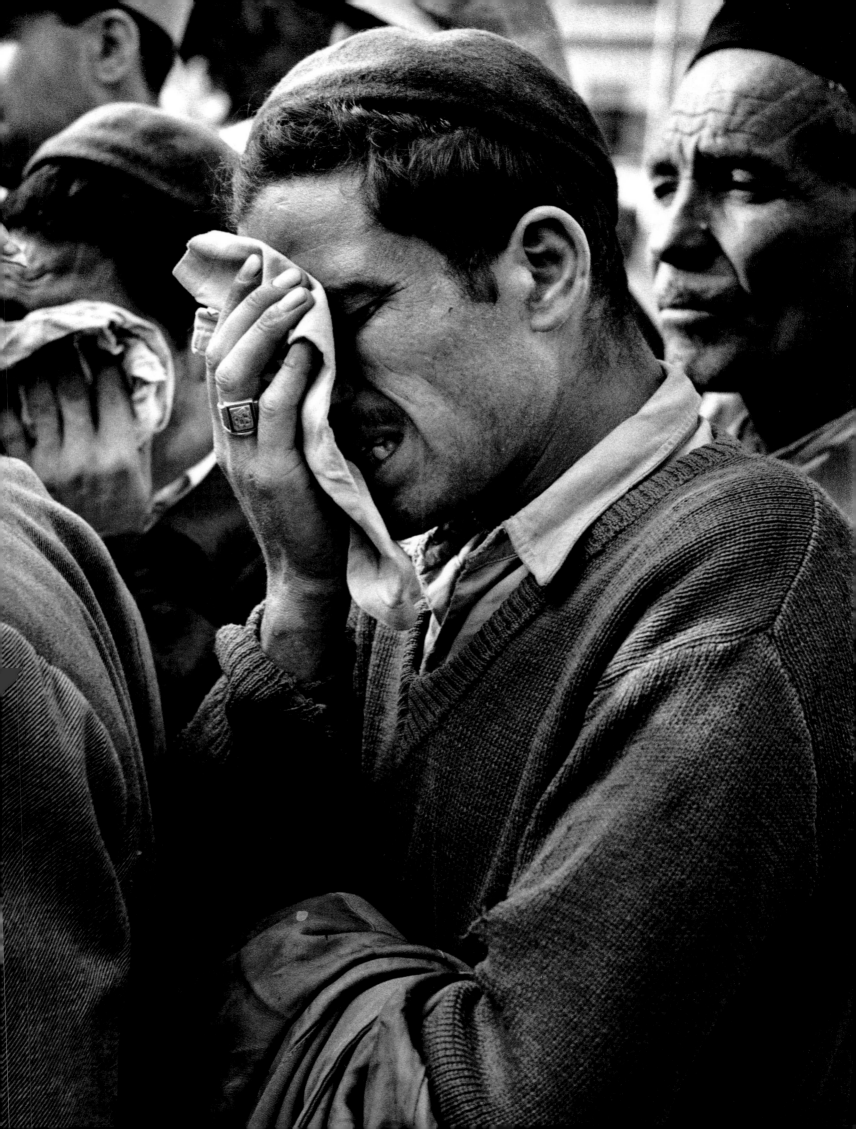

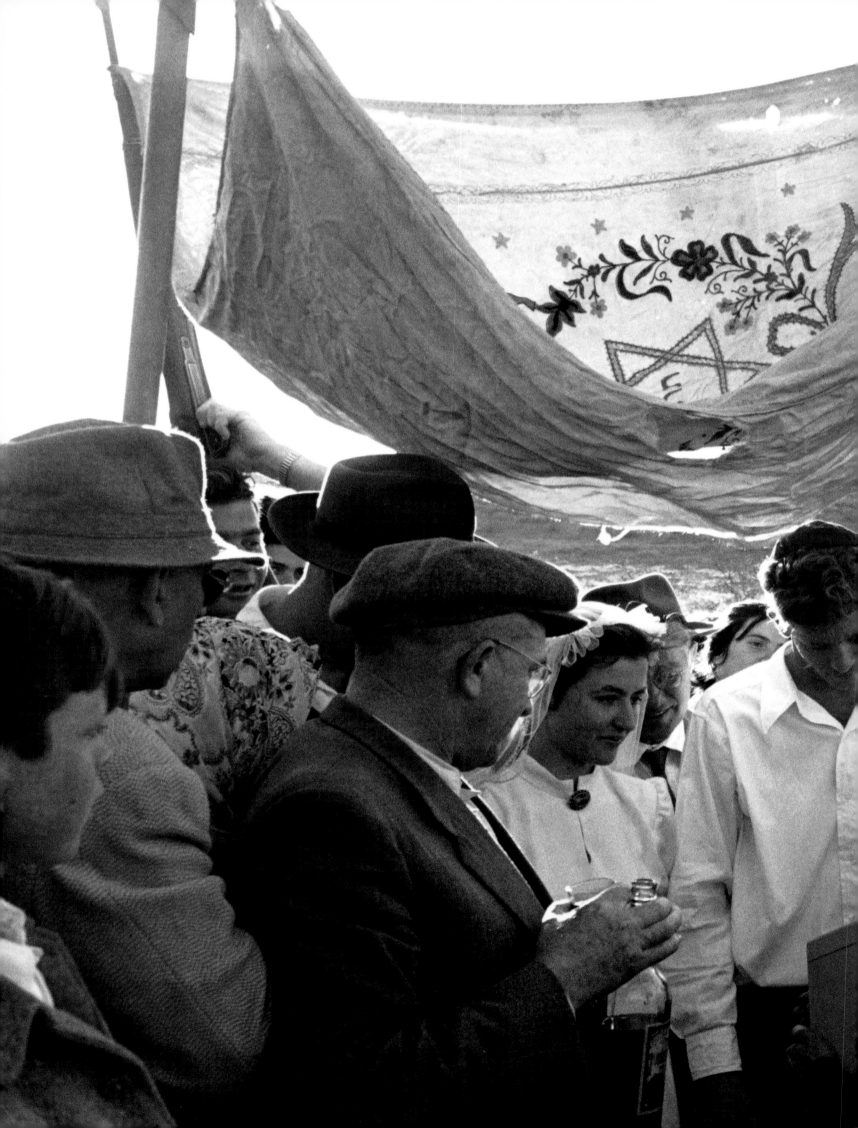

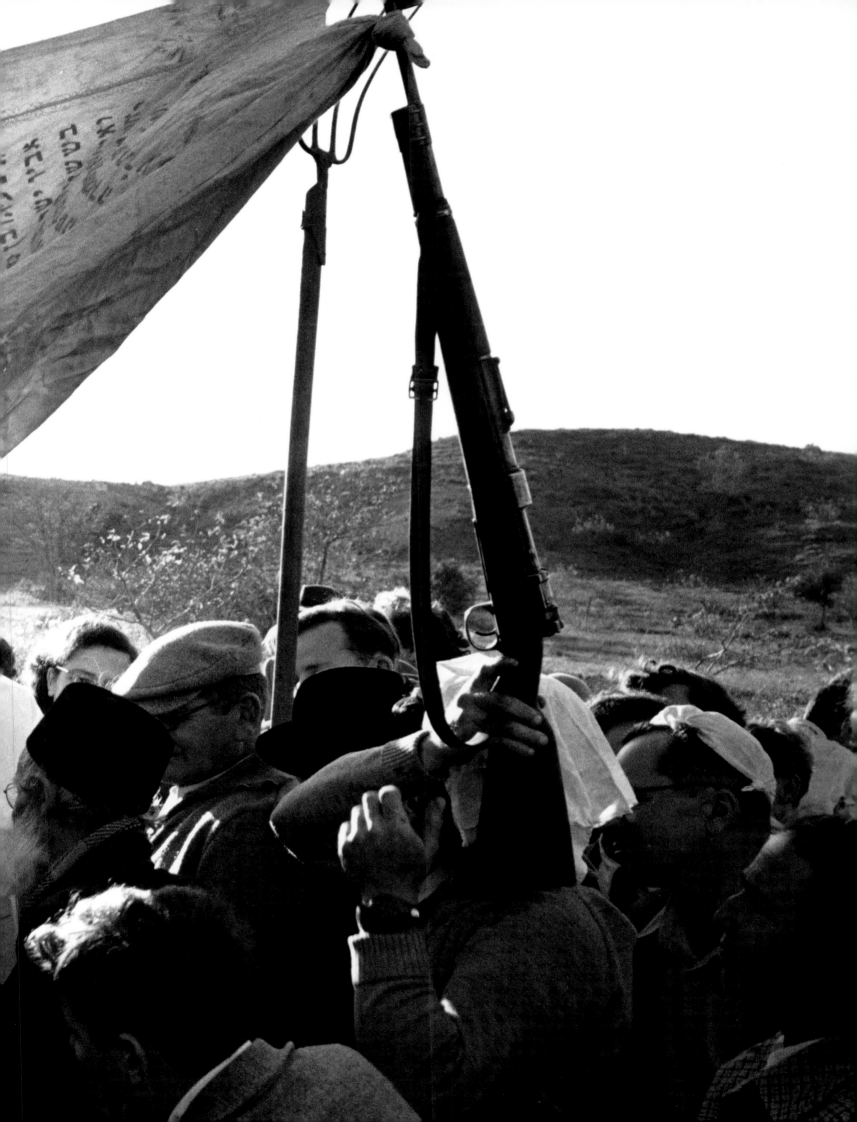

32 **An Israeli officer
 interrogates
 a prisoner from
 a Palestinian
 settlement in the
 Gaza Strip at the
 onset of the Sinai
 campaign**
 Burt Glinn 1956

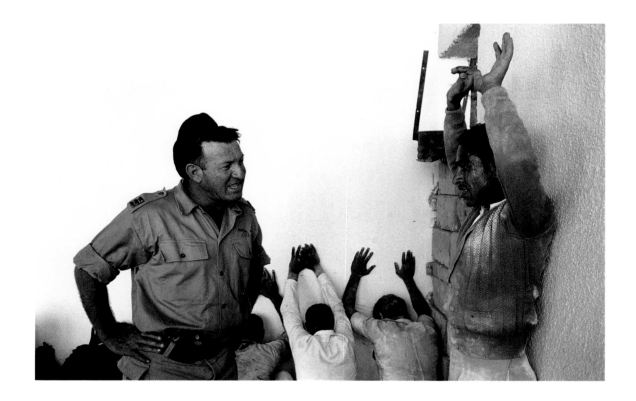

31 **A wedding under
 a makeshift canopy
 or Huppah supported
 on farm implements
 and guns**
 David Seymour 1952

33 **Palestinian prisoners
 held under guard
 in Gaza**
 Burt Glinn 1956

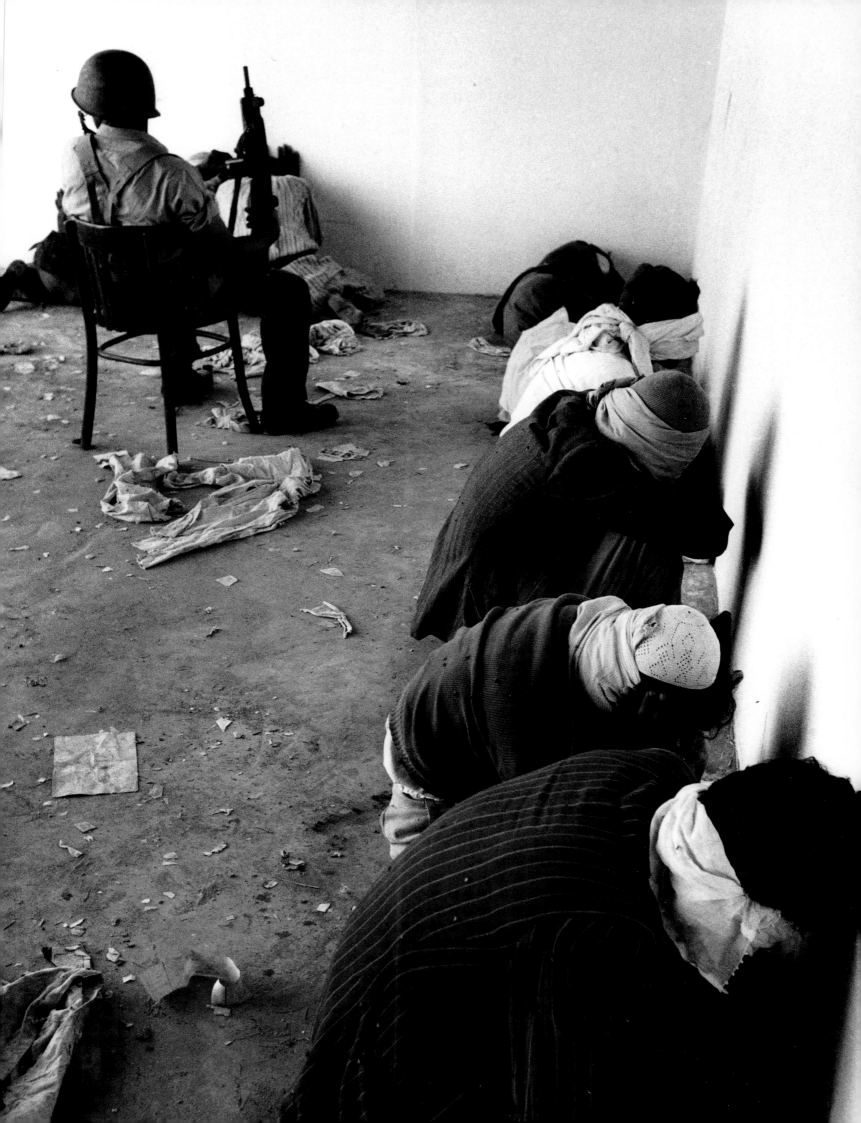

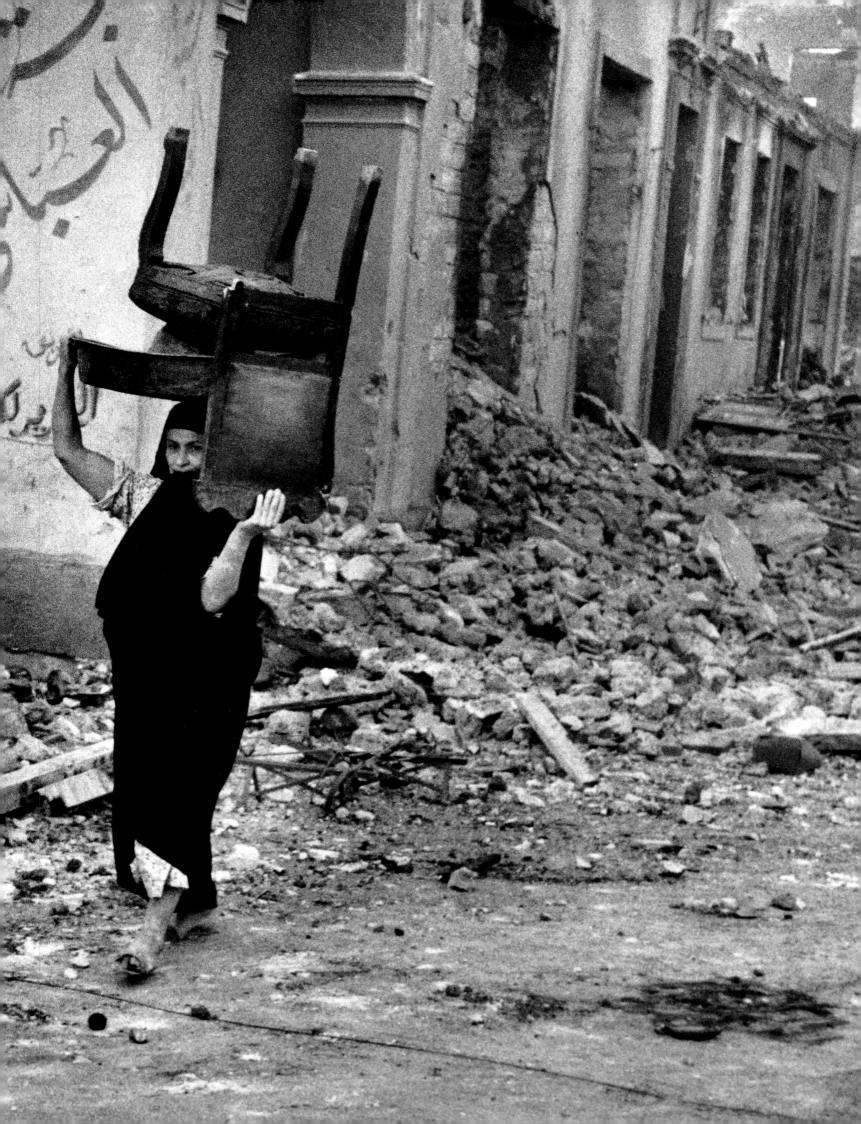

35 **Pools of blood in a Yeshiva schoolroom in which four students and their teacher were killed during a Palestinian raid**
Burt Glinn 1956

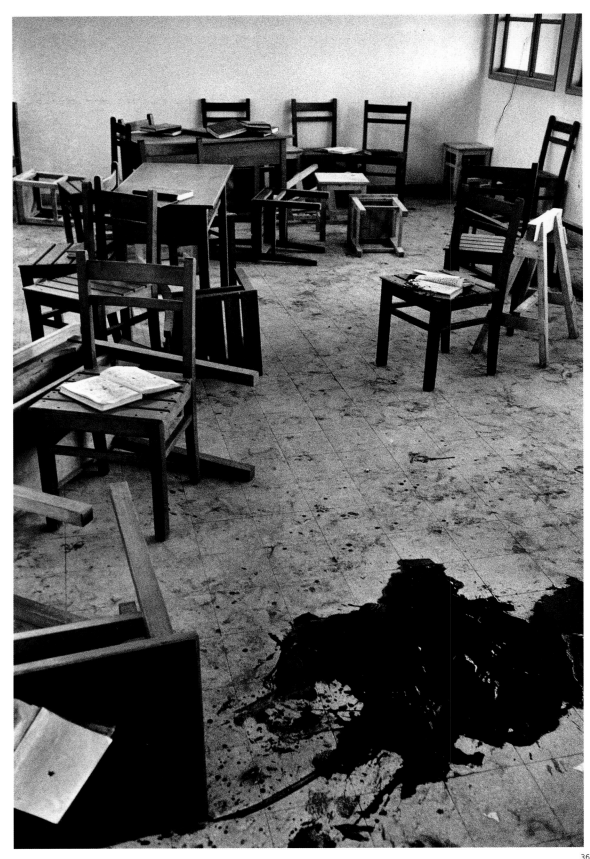

34 **An Arab woman saves what she can in the devastation of Port Said, during the Anglo-French invasion that coincided with the Israeli campaign**
David Seymour 1956

36 **Frightened Arab children watch the approach of Israeli troops, El Arish, Sinai**
Burt Glinn 1956

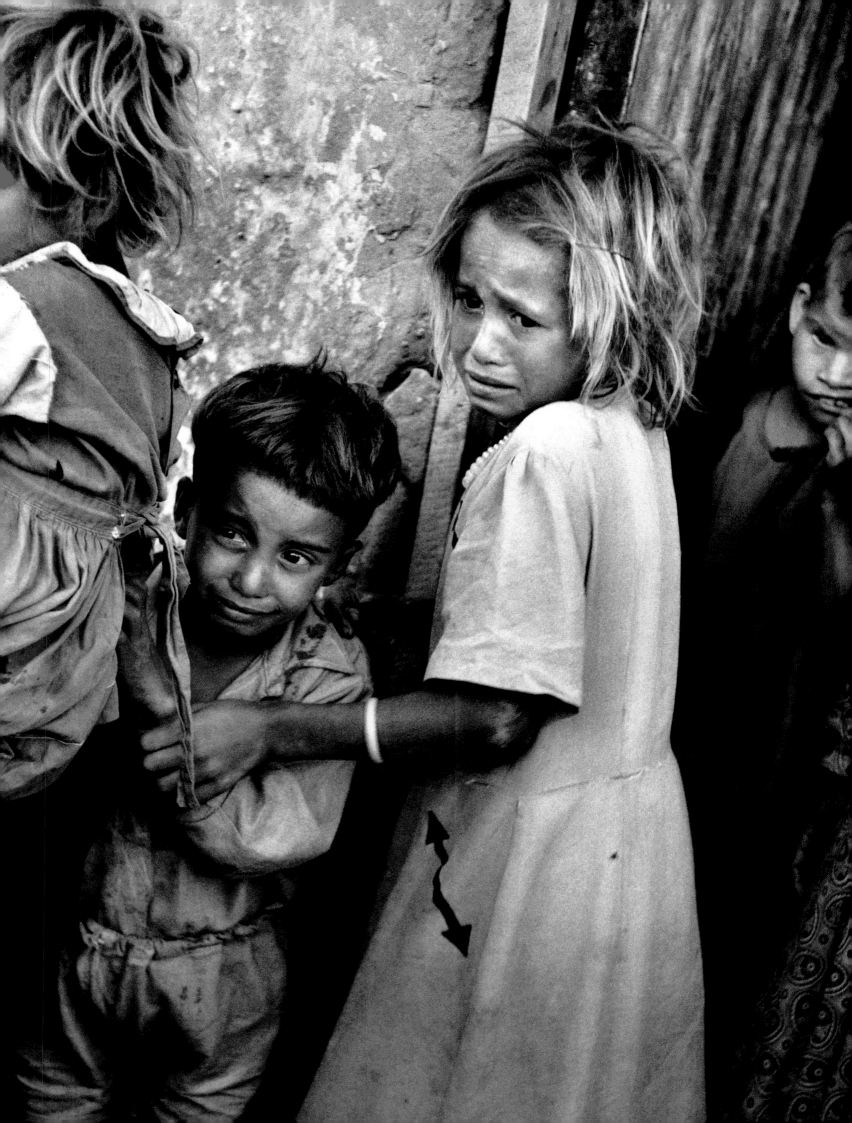

37 A boy flees
approaching tanks
on the streets
of Port Said during
the Anglo-French
Suez campaign
David Seymour 1956

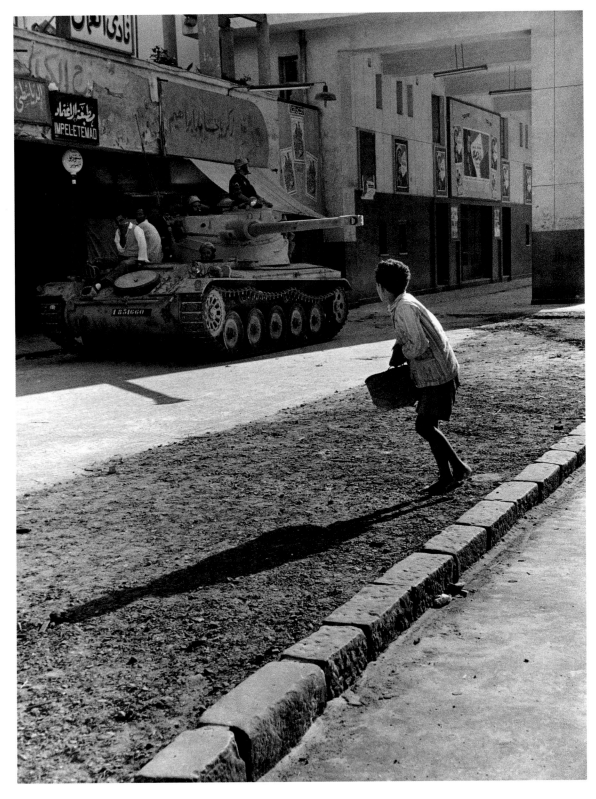

38 A dead Egyptian
and his truck left
in the wake of
the Israeli advance
through Sinai
Burt Glinn 1956

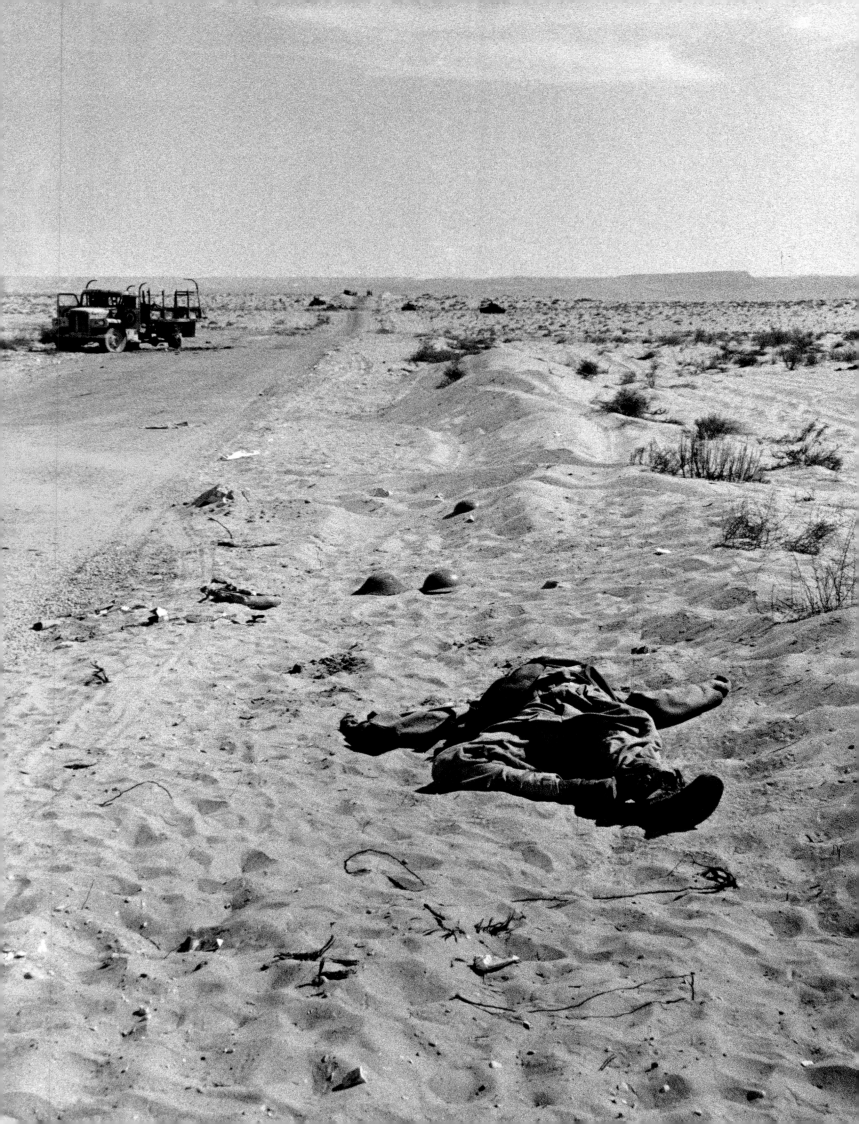

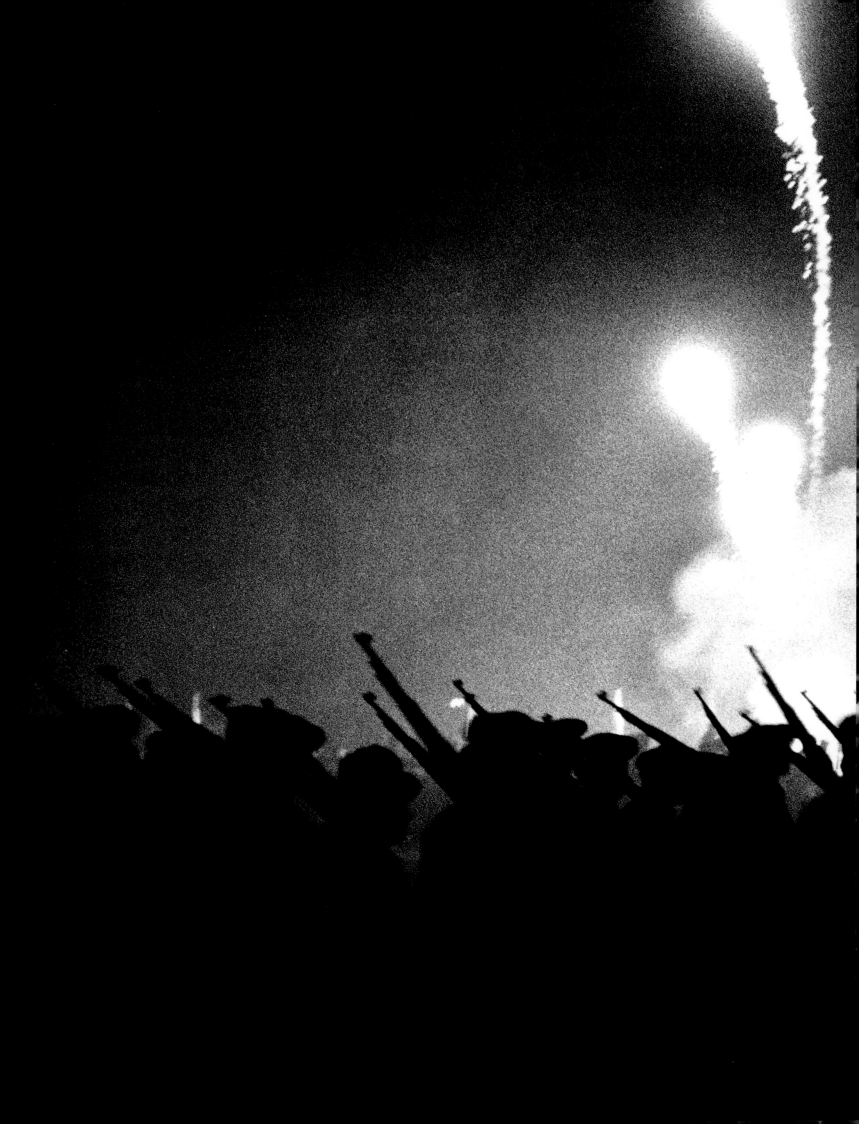

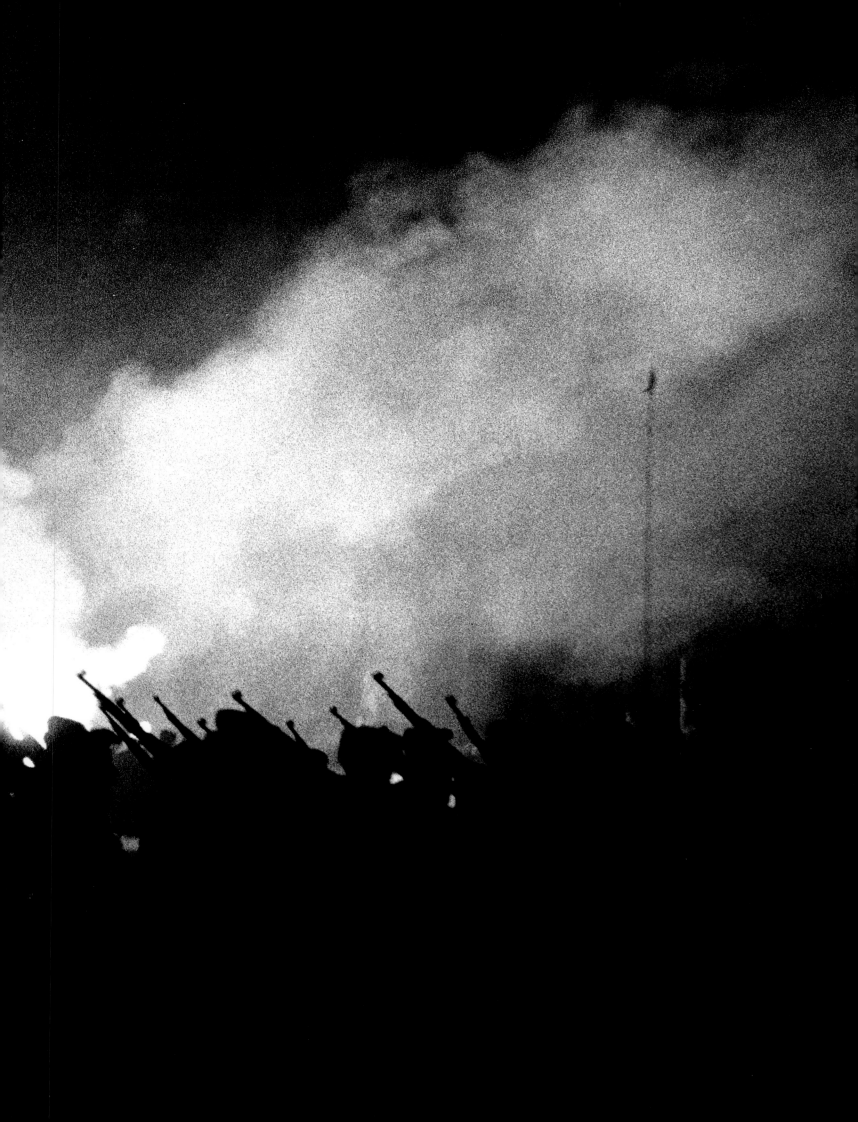

40 Students talking
in the newly built
campus of the
Hebrew University
Burt Glinn 1957

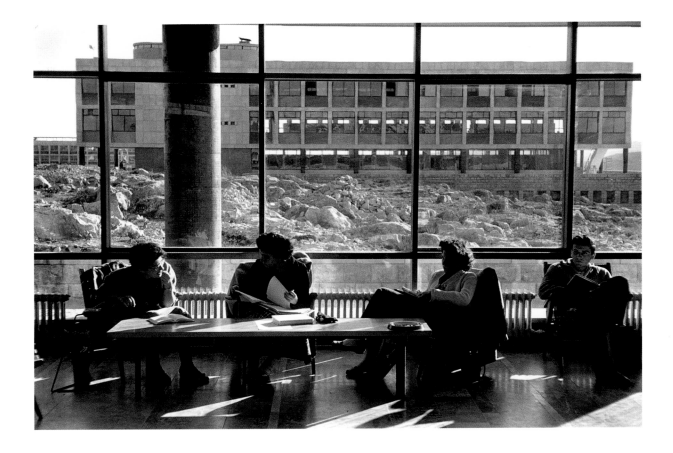

◄
39 Israeli infantry
brigade, parading
at night after the
Sinai campaign
Burt Glinn 1956

41 An American
 volunteer doctor,
 Eva Landsberg,
 in the Arab village
 of Abu Gosh near
 Jerusalem, where
 she offered free
 medical services
 to the women
 Burt Glinn 1956

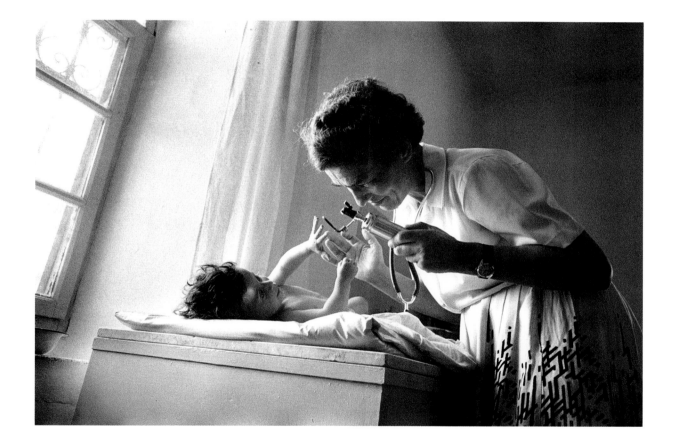

42/43 **A Yeshiva school, Mea Sharim district, Jerusalem**
Burt Glinn 1956

The children of newly arrived Egyptian Jewish immigrants
Burt Glinn 1957

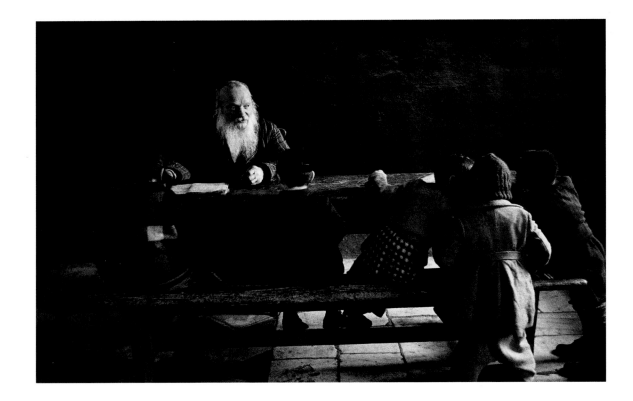

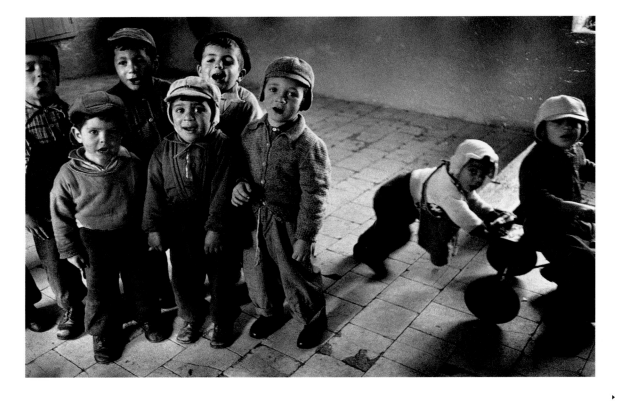

▸
44 **Jerusalem**
Inge Morath 1956

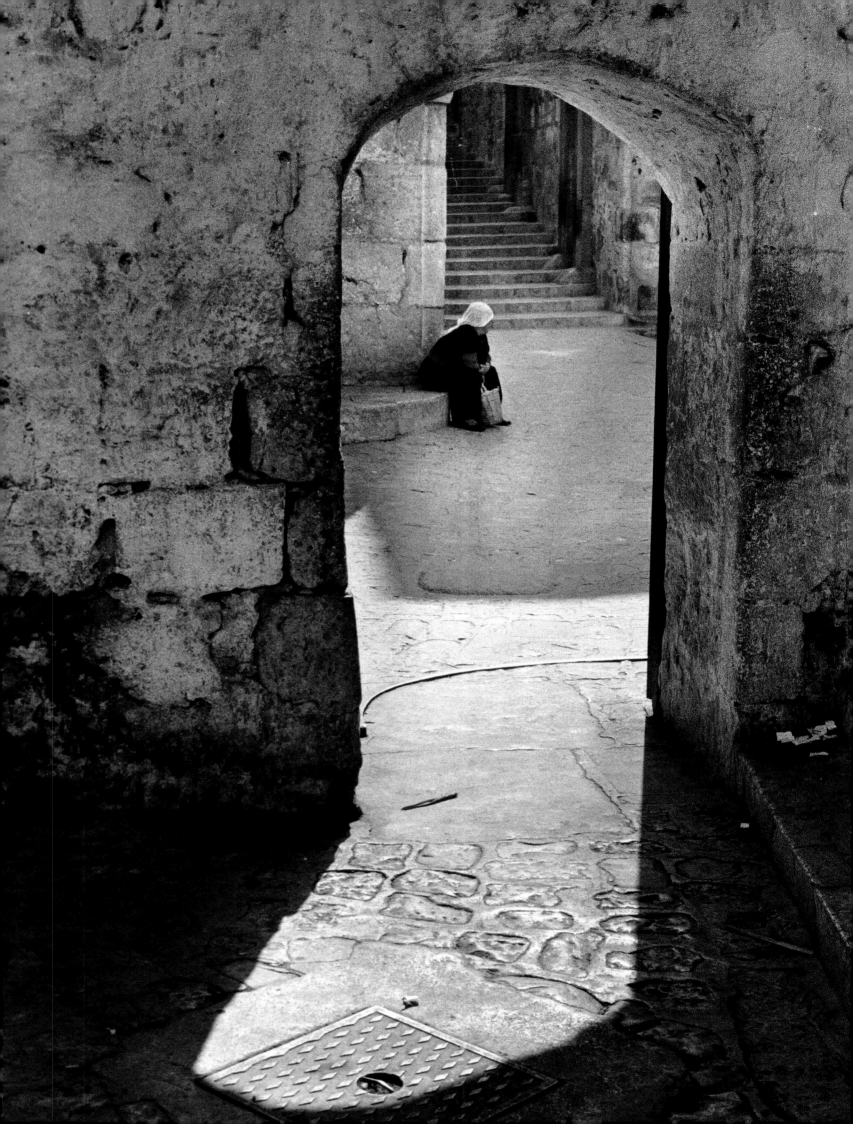

A Palestinian child in the Muascar refugee camp - Inge Morath 1959

In one room in the Muascar Refugee Camp, Jerusalem, I find three families, 15 people. The oldest one is Abed Judeh, who sits on the bed and smokes a pipe. He was wounded in the Palestinian war, and lost the use of one leg. His crutch, made out of a wooden stick and a piece of cloth wound round the top, leans next to him. Other inhabitants of the room are Abed Judeh's two sons, their wives (sitting on the floor) and their children. The bedding is kept in the niche in the wall and spread over the stone floor at night. This kind of accommodation is typical enough, the Judehs still must consider themselves lucky to have a window. Most of their fellow refugees in Muascar Camp are cave dwellers, their only source of light being a small kerosene lamp.

Inge Morath 1959

On most of my photographic assignments it has been simple to keep my function as photographer separate from that of the private person. Except in Israel; where every time I have been there the two parts have become inextricably intertwined.

I was born in Germany in 1922 and I had every expectation that I would live there my whole life. But that was not to be; as soon as the Hitler regime began in 1933 the alternatives which faced us could not have been simpler: leave Germany (if you can) or we will destroy you in one way or another.

The question, the ever more urgent question, was where we could go, what country would have us. I remember long and anxious conversations among the grown-ups at the dinner table. The dream that we dared hardly dream was to be able to emigrate to the United States, but the one obvious and available – and risky – possibility of escape for us Jews was Aliyah, the illegal and hazardous immigration to what was then Palestine. Several Jewish organisations recruited actively among the Jews still living in Munich with offers of training in the trades that would assure us a living there and that were badly needed in the emerging Jewish State. In the end my parents' energies together with a kind fate realised the dream and enabled us five and some of our belongings to take a ship to the United States.

Hence I have never been in Israel as an immigrant in search of a new home – and never as a photographer alone. Every time there I have wondered what my life would have been if we, if I, had 'made Aliya' and would now be a citizen of Israel. That was the question which was always present no matter what I saw or photographed there, and it is with the same question (to which there cannot be an answer) that I look at the resulting photographs. They are not only a photographer's documents of life in a fascinating place, evidence of an intense mixture of success and crises, but these photographs are at the same time my personal notes of a country and a people with whom I am bound up in a common Jewish-ness although I am not bound up in their Israeli-ness. For me being in Israel is like being with an extended family of whom I am a distant member. We share common memories and affection and we share, too, the disputations and strife of Meshpocheh, of family.

Erich Hartmann 1961

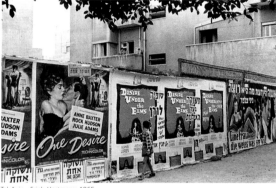

Tel Aviv - Erich Hartmann 1965

As the Israelis increased their fire, we edged forward into an area of little stone houses in very narrow streets, some barely more than a yard wide and obvious death traps. We took the widest we could find. Suddenly a Jordanian soldier ran out in front of us with his hands up. He did not appear to be armed, but everyone was jittery because of the snipers, and we all hit the ground. The Jordanian was blown to bits. The officer told them to cease firing, and soon after another young Jordanian and an old man came out of our house to be taken prisoner. The unit was moving further down the street when the lead man was shot dead, and a few yards later the next man received a bullet through his chest. A doctor came up to me and started screaming for a knife to cut away the man's clothing, though I failed to understand the torrent of Hebrew until someone said 'knife' in English and I fumbled for mine while the man died. Then the soldier just behind me was shot by a sniper from behind a wall. He was stretchered off with a handkerchief over his face.

The weight and speed of the Israeli attack was beginning to tell.

1958-1967

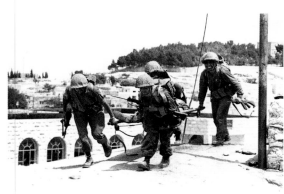

Israeli casualty being evacuated, Jerusalem - Don McCullin 1967

More people started to surrender, among them a large number of men in pyjama suits. Jordanian soldiers wore them instead of uniform, hoping to be mistaken for civilians. The Israelis were laughing and making fun of them, but I saw no Israeli soldier mistreat anyone. They all seemed to venerate the city, and there was no looting or desecration. On more than one occasion I watched Israelis hold their fire when sniped at from the roofs of religious buildings of any persuasion.

Outside the city walls a tank battle could be heard raging. The Jordanians had taken their tanks to high ground and were pouring shells into the city as Israeli armor moved forward to engage them. It was soon all over.

I slumped down, immobile after all the hectic action. I had no thought of what to do now.

'Why are you sitting there?' an Israeli soldier called to me. 'History is being made, my friend. You must go to the Wailing Wall.'

'What's the Wailing Wall?' I asked.

Don McCullin 1967

'To CAPTURE the spirit' is the challenge and aim of all journalists, writers, sculptors, painters, and photographers. To capture the spirit of Jerusalem was a dream of mine which began shortly after the Arab-Israeli war of 1967. I happened to be an eyewitness to that war, and it made me aware of the important contribution photography could make toward an understanding of what makes this city so very special to its residents and to so many people all over the world.

Physically, Jerusalem is a very compact city. Within its ancient stone walls, everyday scenes are recreations of familiar Bible illustrations; outside, it is a bustling, growing, twentieth-century city which is also Israel's capital.

The city is in a dramatic state of growth and transition. Jet travel and Jerusalem's unification have brought tourist-pilgrims in droves, giving many the chance to settle in the place of their spiritual longing. When everybody's dream has come true Jerusalem may lose its dreamlike quality, but I have not met a resident – be he native or one who just arrived 'yesterday' – who was not apprehensive about such a possibility (or loss?).

Jerusalem is not a physical repository of spiritual values, a museum of dead artefacts, a curio shop for tourists. It is a living city – a queen whose loyal subjects of many races and religions jealously guard their love for her, each looking over his shoulder with suspicion for threatening manifestations of another's affections.

This is the oldest modern story ever told: Jerusalem, the City of Stones, is really the seat of man's deepest emotions.

Cornell Capa 1967

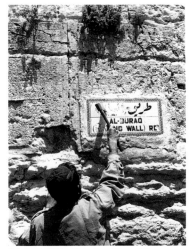

Claiming the Wailing Wall - Cornell Capa 1967

IT WAS the week the war ended. For the first time in almost two thousand years, Jerusalem, the holy city, was once again guarded by

a Jewish army. An ungovernable delirium possessed the population as hundreds of thousands made their pilgrimage to the western wall of the Temple Mount, the holy of holies. No longer would the Jews be wailing in lamentation for their lost temple. The Israeli army liberated the wall, and the yeshiva students took it in

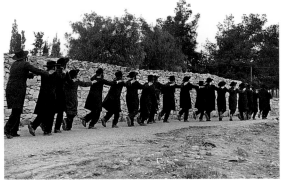

Jerusalem after the Six Day War - Leonard Freed 1967

their possession. They danced and prayed at the wall. They organised the separation of the men and the women, and they gave out yarmulkes. Day and night they returned to the wall, smiling, singing, dancing. And even when they were exhausted, they formed lines and danced up and down the hills in jubilation, for miles and miles, until they reached their homes.

Leonard Freed 1967

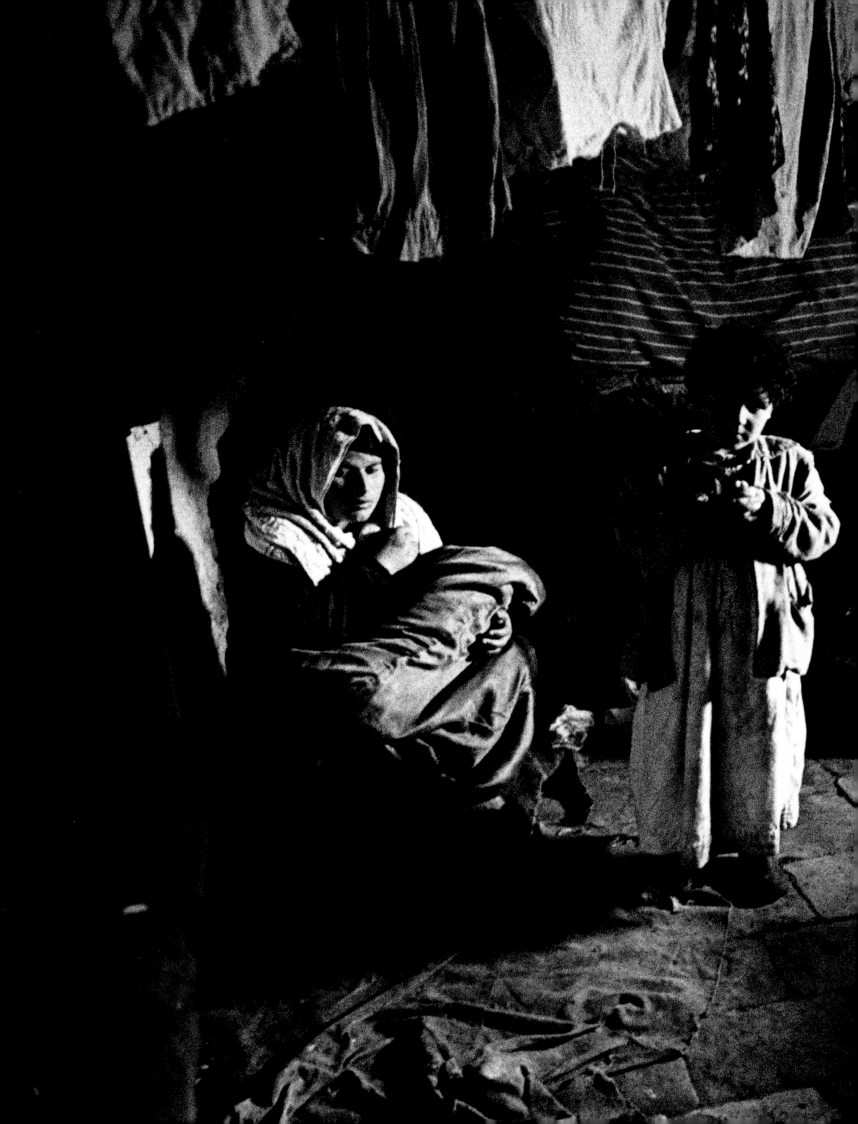

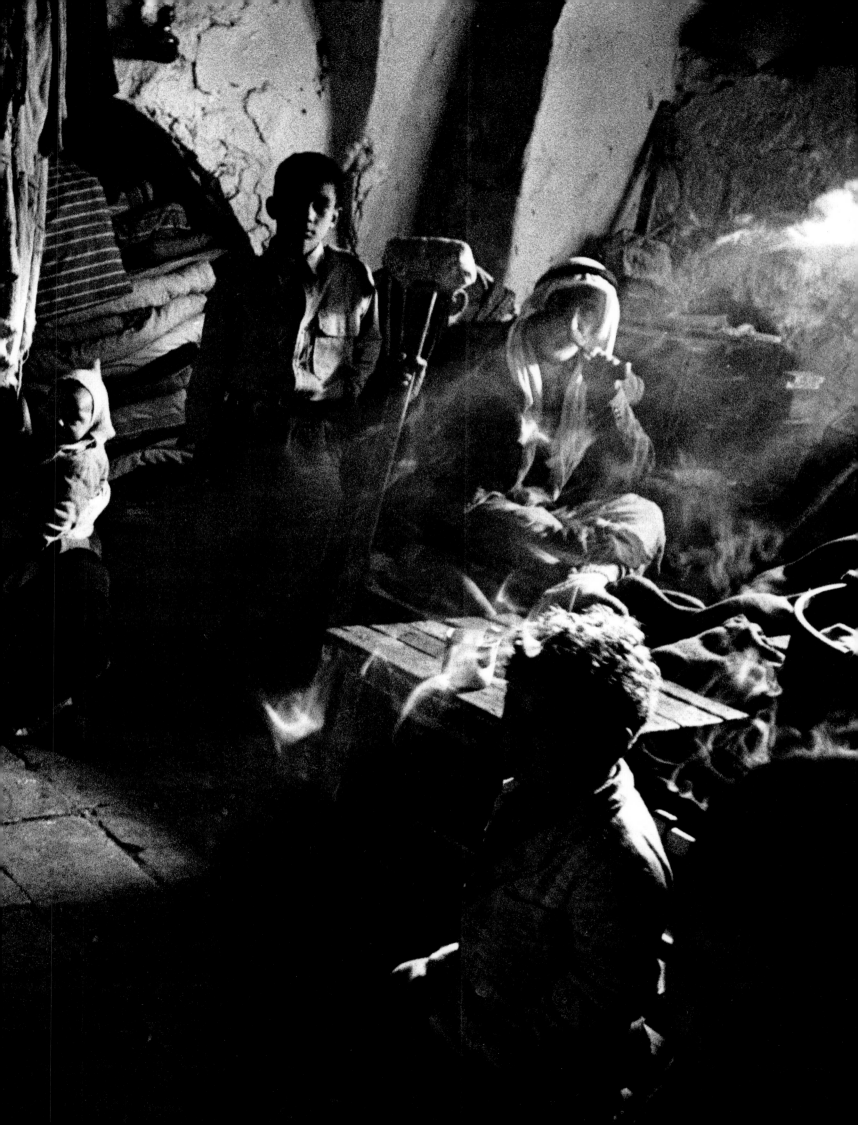

46 **Tel Aviv**
Erich Hartmann 1961

45 **Three families of**
 Palestinian refugees
 occupy one room
 at Muascar Camp,
 near the Old City
 of Jerusalem
 Inge Morath 1960

47 **Mea Sharim,**
 Jerusalem
 Erich Hartmann 1961

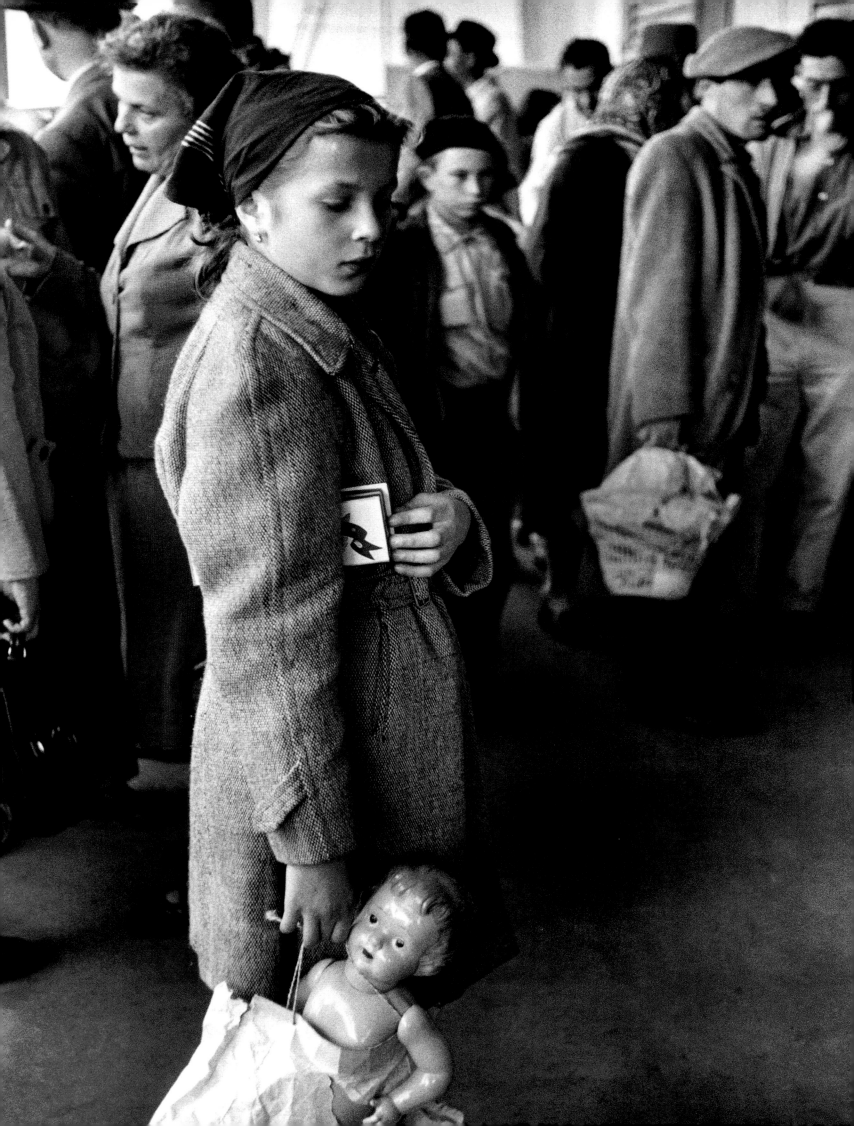

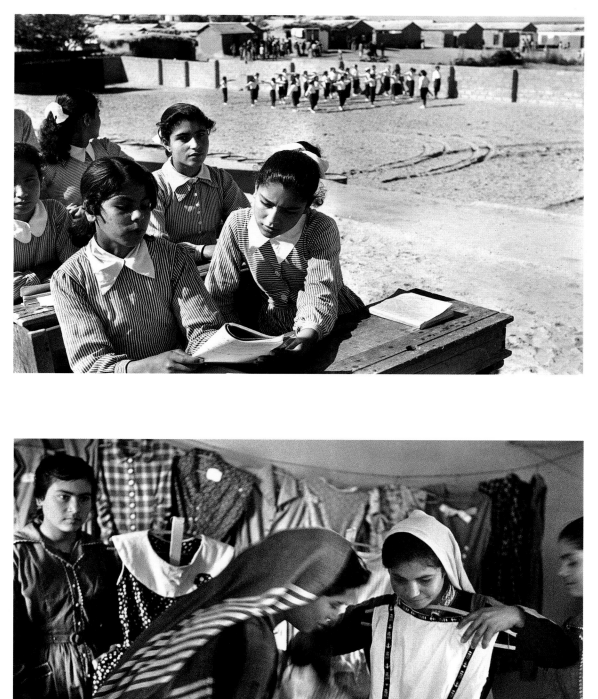

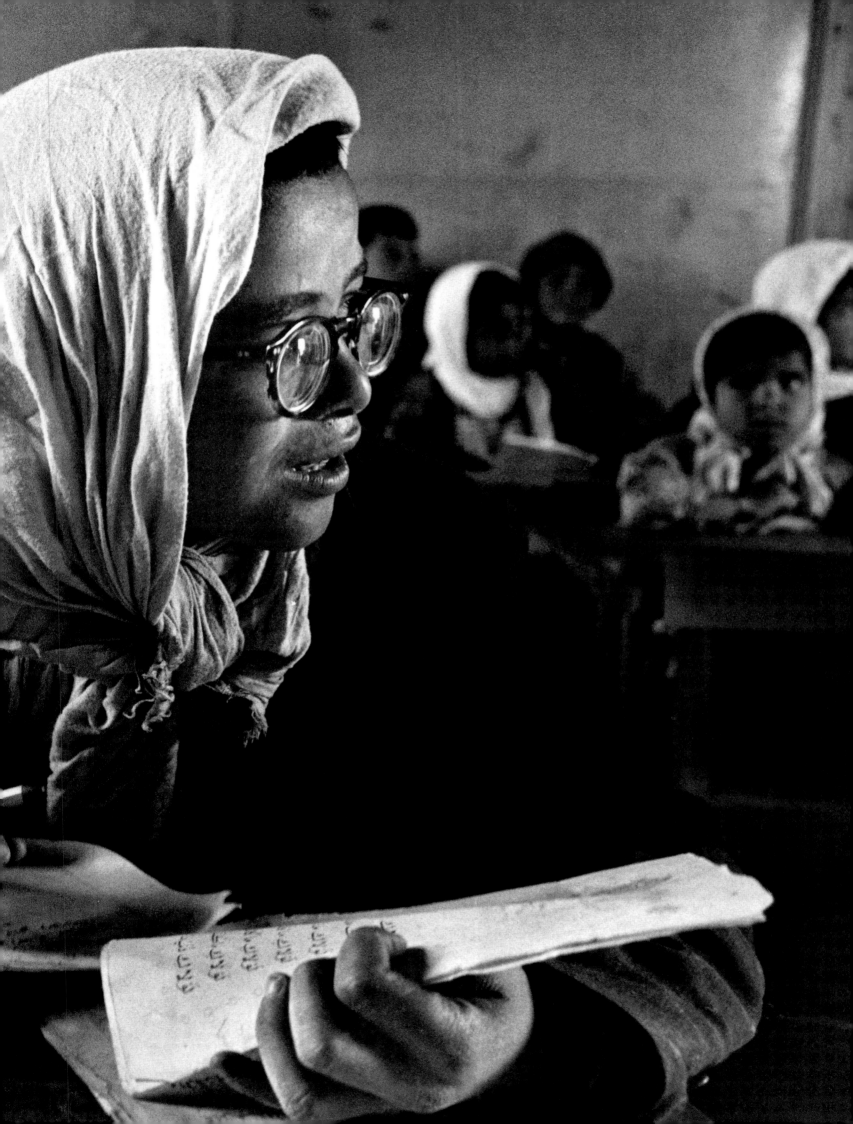

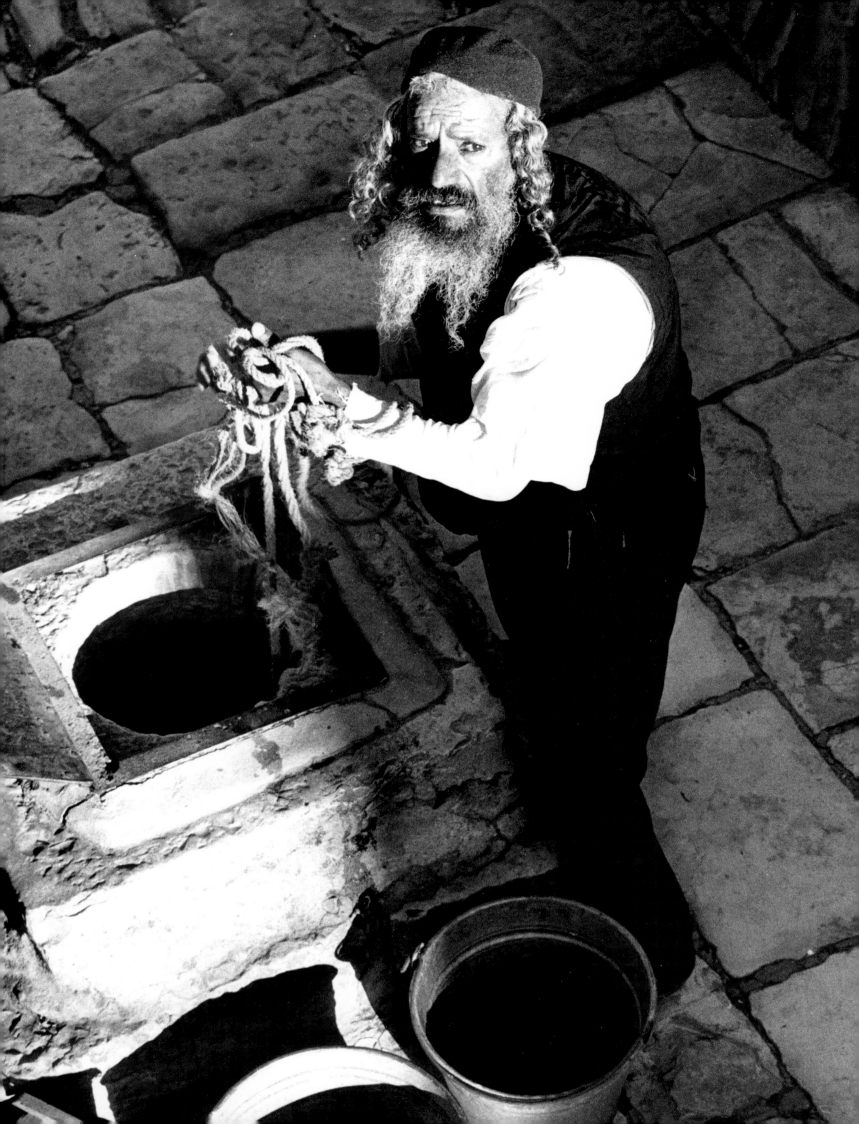

55 **The Dedication of Yad Vashem, the Holocaust Memorial, Jerusalem**
Erich Hartmann 1961

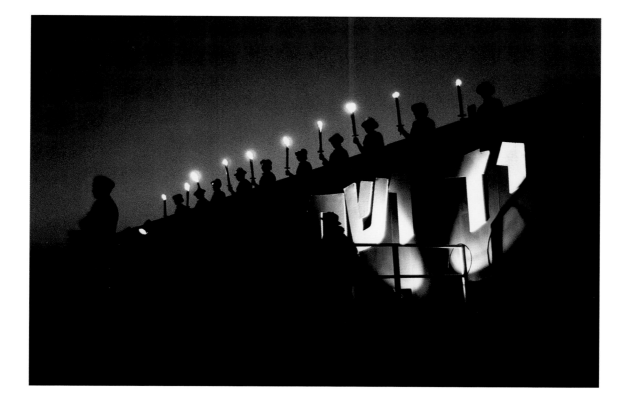

◄

54 **A Yemenite Rabbi in Mea Sharim, Jerusalem**
René Burri 1963

►

56 **The train from Tel Aviv to Jerusalem**
Leonard Freed 1962

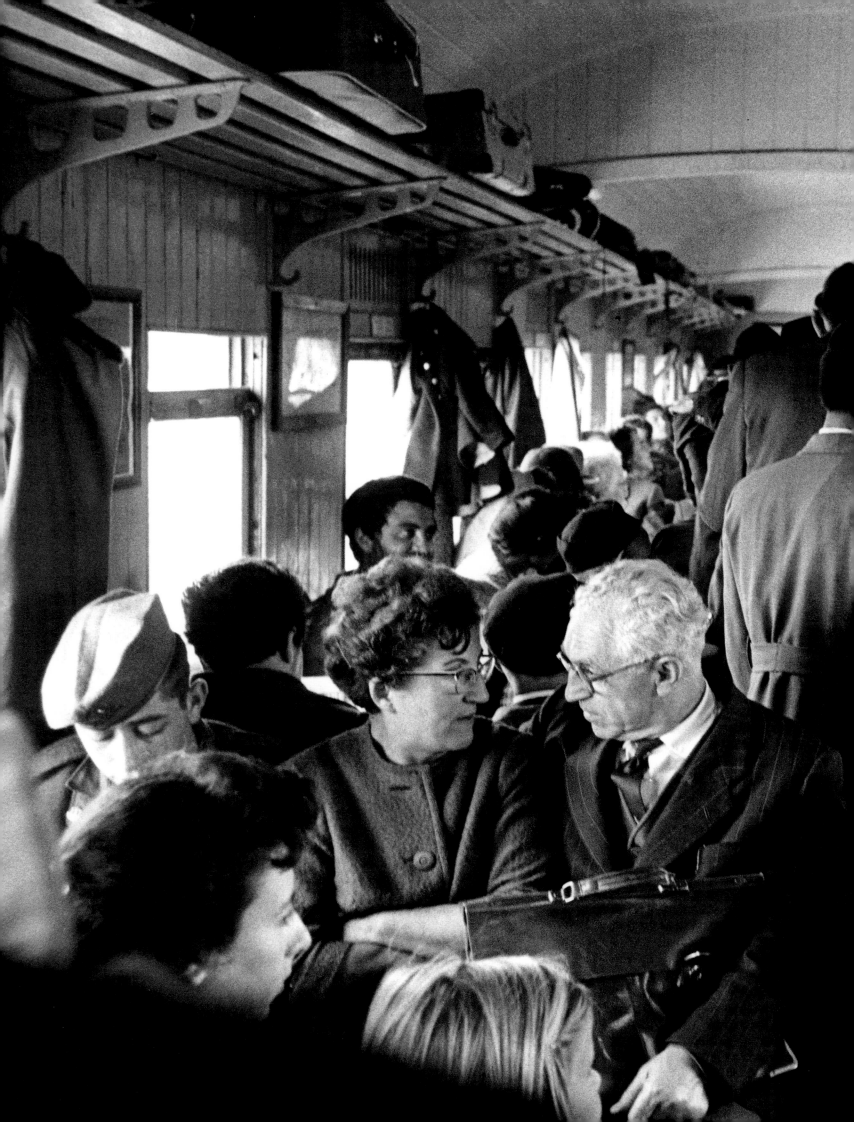

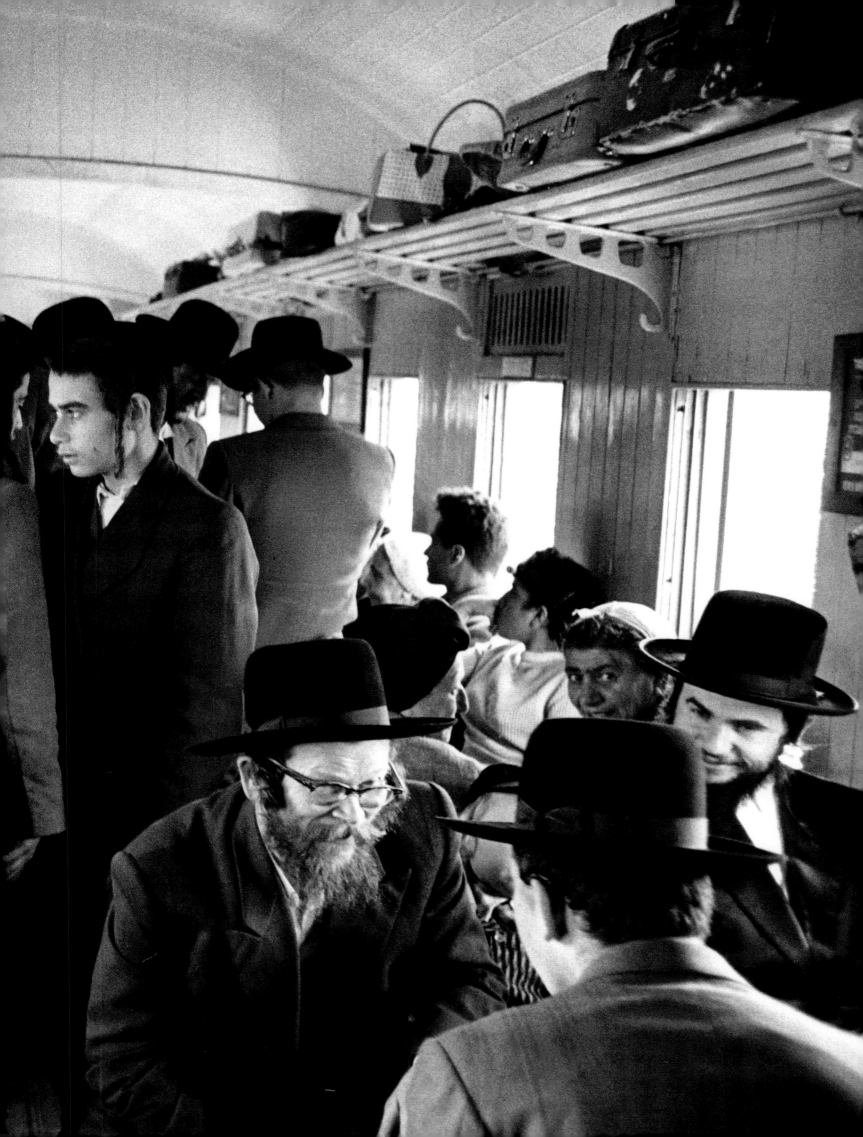

57 **Tel Aviv**
Elliott Erwitt 1962

58 **Picasso exhibition with audience, Tel Aviv Museum of Art**
Micha Bar-Am 1966

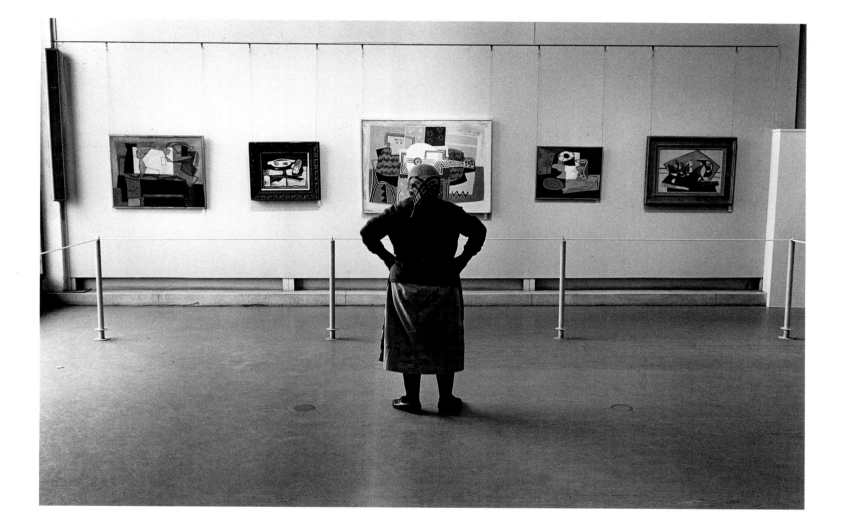

▸
59 **Orthodox wedding, Jerusalem**
Elliott Erwitt 1962

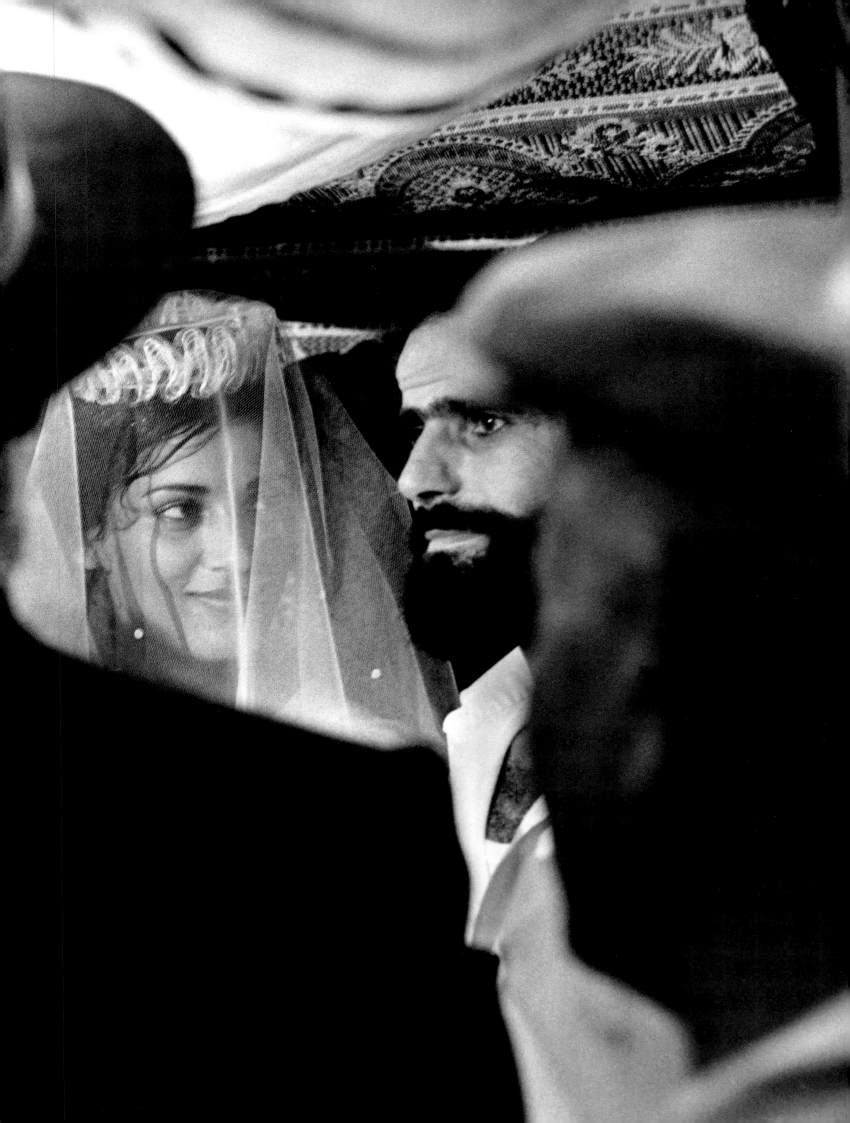

60 **A mother preparing to take her children to her house after working hours on Kibbutz Ashdot Yaaquov**
Leonard Freed 1962

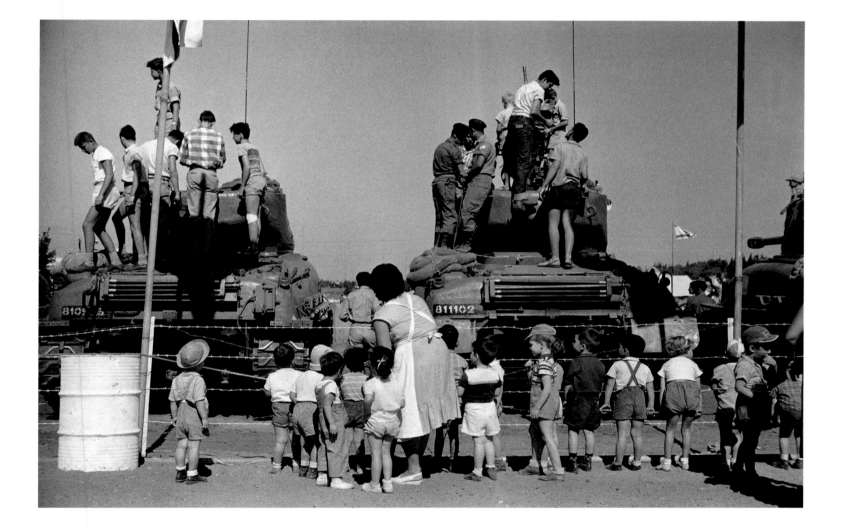

▸
62 **Konrad Adenauer, the
ex-German Chancellor,
on a private visit to
Israel in deep
conversation with
David Ben-Gurion in
the dining room of his
kibbutz, Side Boker**
Micha Bar-Am 1966

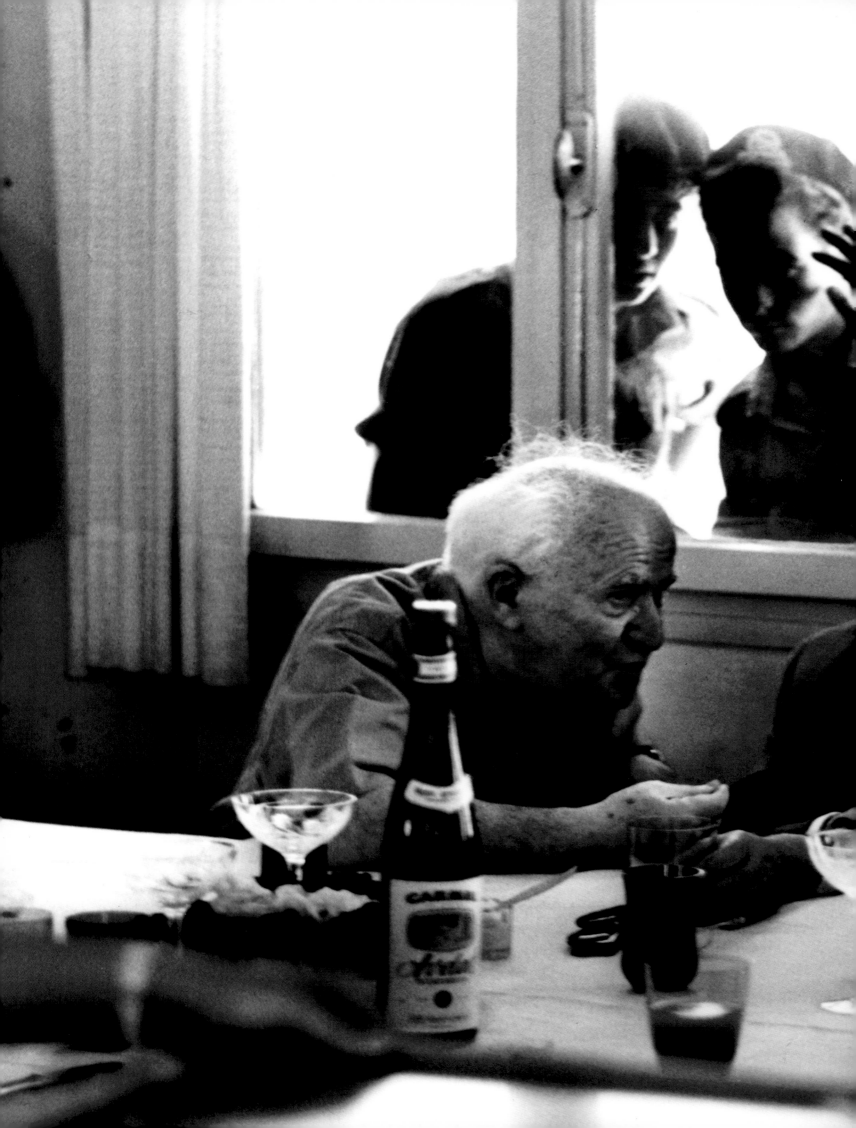

63 **The Billy Rose**
Sculpture Garden
in the Israel Museum,
Jerusalem
René Burri 1966

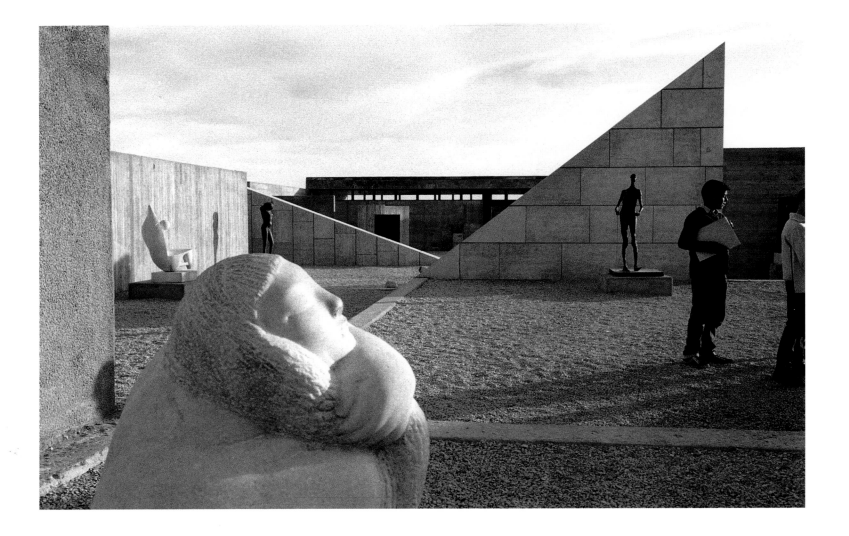

▶
64 **A Bedouin boy**
anticipates
vaccination against
tuberculosis given
by a visiting Israeli
doctor in the Negev
Leonard Freed 1967

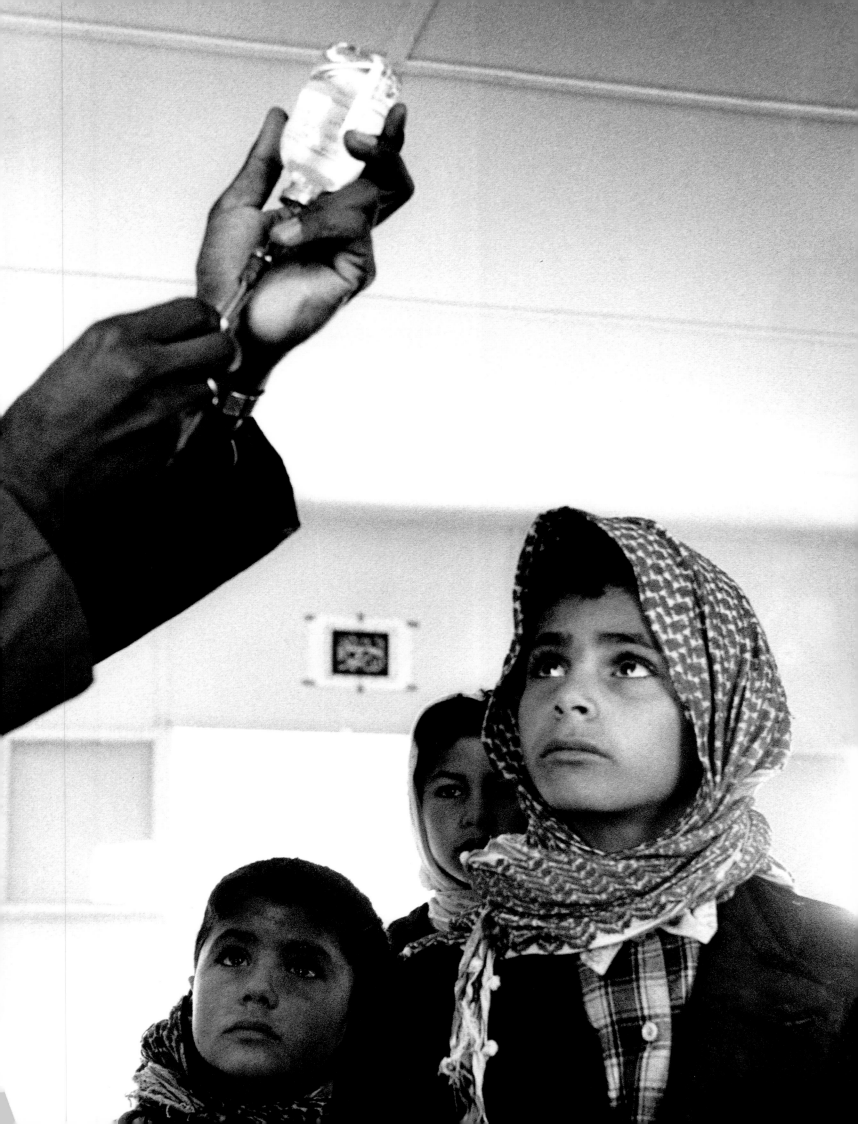

1958-1967

66 **Tel Aviv**
Erich Hartmann 1967

▶

67 **Schoolboys**
Erich Hartmann 1958

68 **Otto Preminger**
 seeking locations
 for filming *Exodus*
 Burt Glinn 1958

▸
69 **Old and young on**
 the Jerusalem train
 Leonard Freed 1962

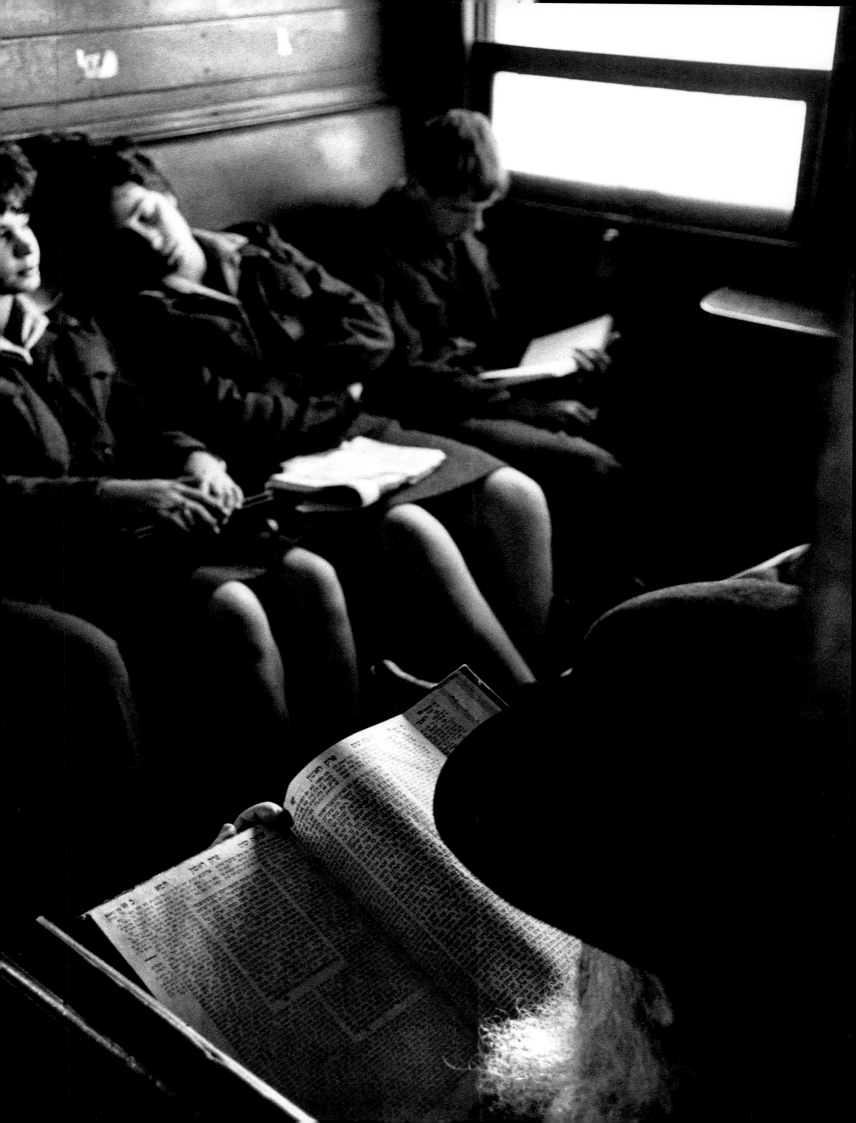

70 The devastation
inflicted on the
Egyptian Air Force
at the beginning
of the Six Day War
is typified by the
molten remains at
the Egyptian base
of Bir Gufgafa
René Burri 1967

▸
71 Israeli soldiers
cleaning weapons
in an occupied
house in the
Egyptian city
of El Kantara
René Burri 1967

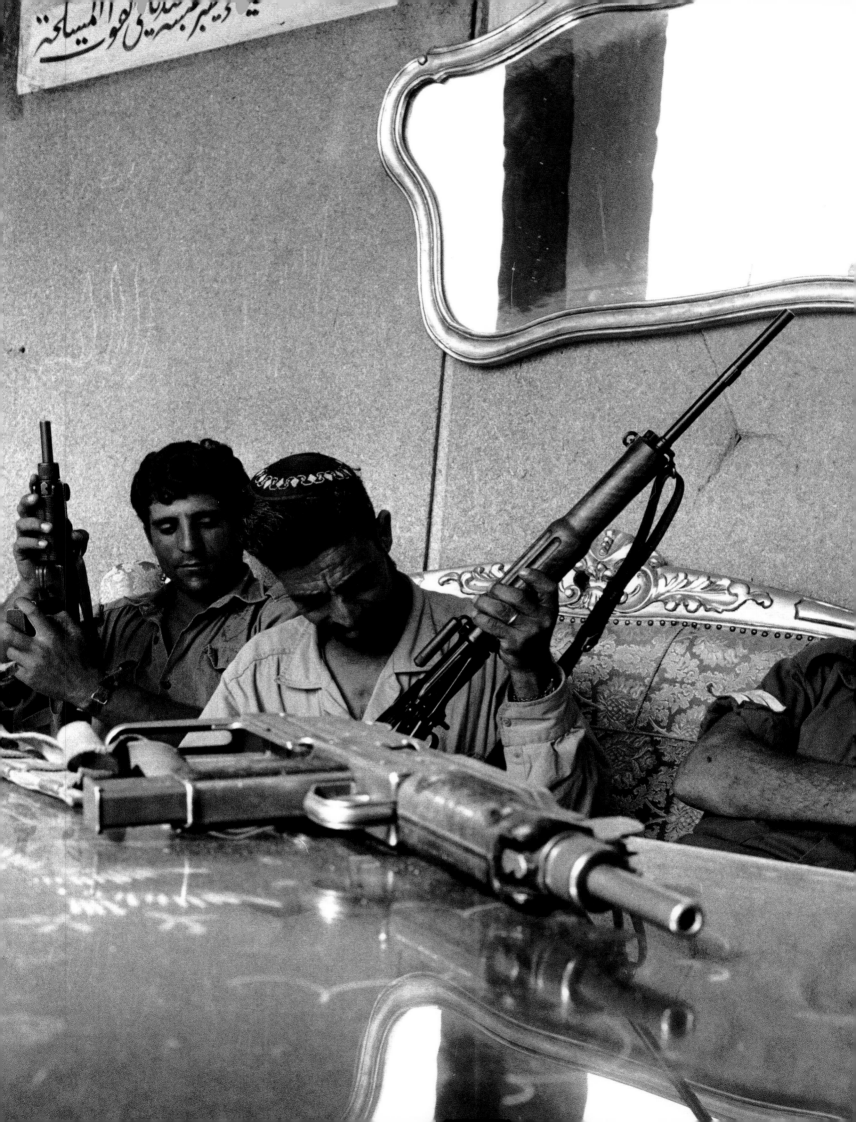

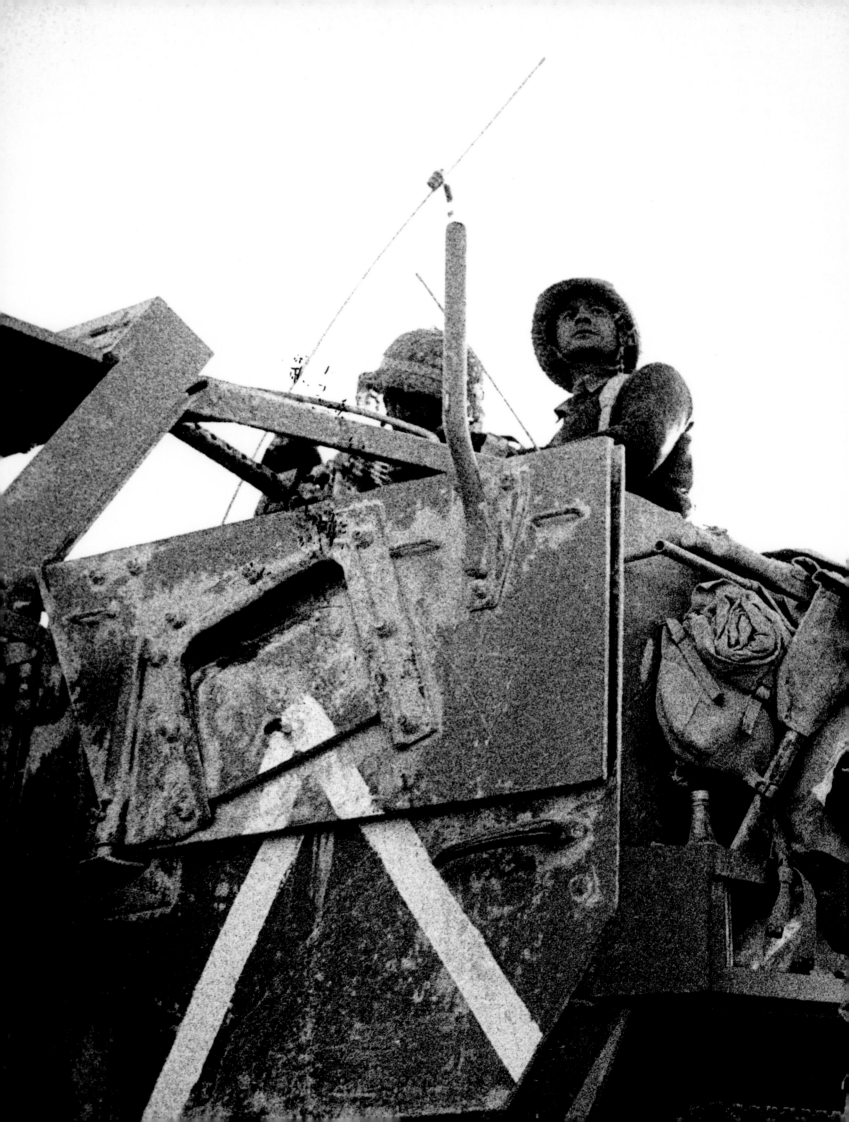

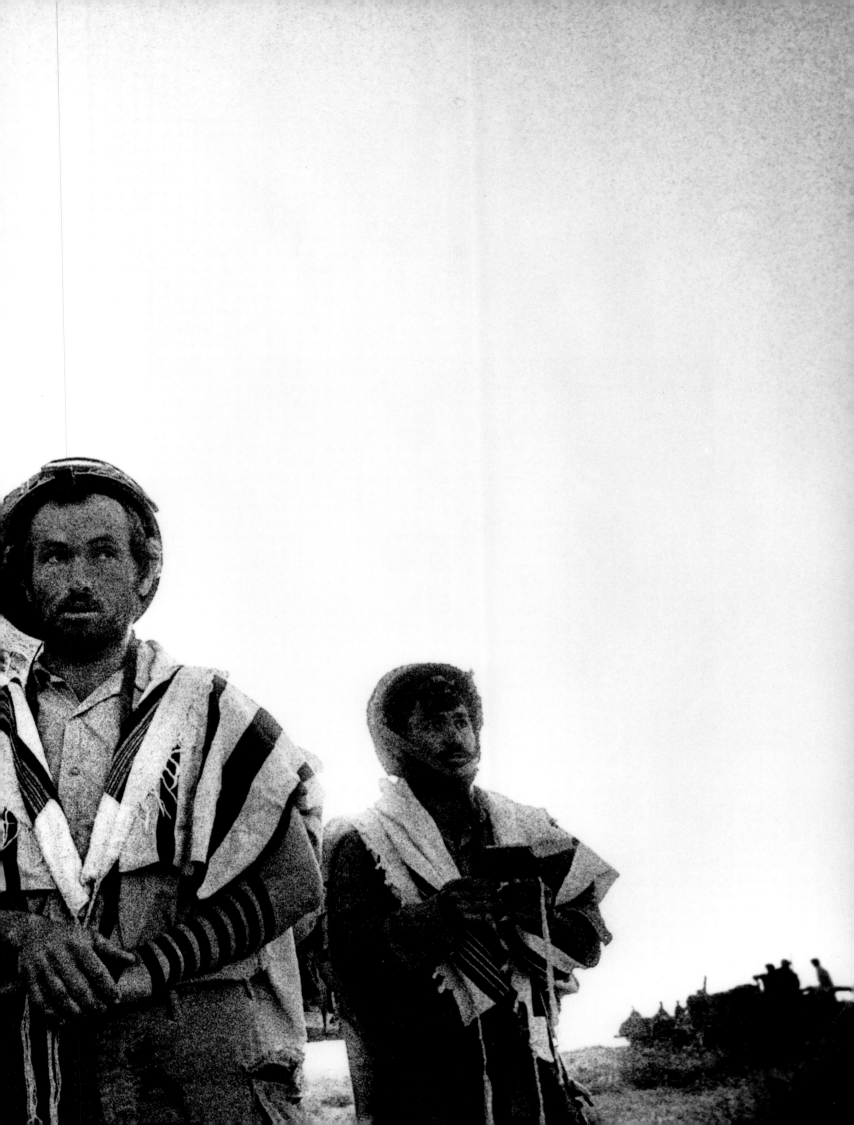

73 **Bound and
blindfolded, an
Egyptian prisoner
placed under a truck
for shade**
René Burri 1967

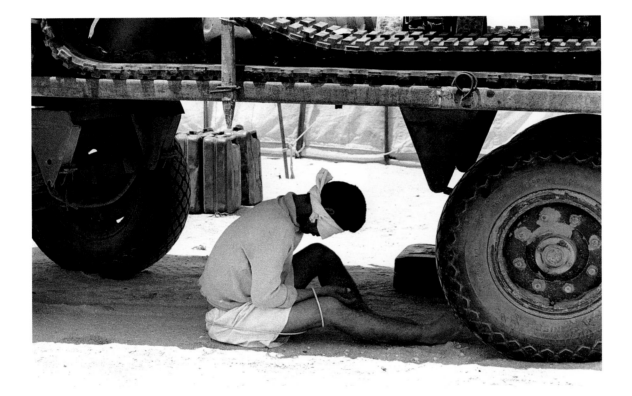

◀
72 **Israeli soldiers
praying at dawn
as Egyptian aircraft
approach their unit
in the Sinai**
Cornell Capa 1967

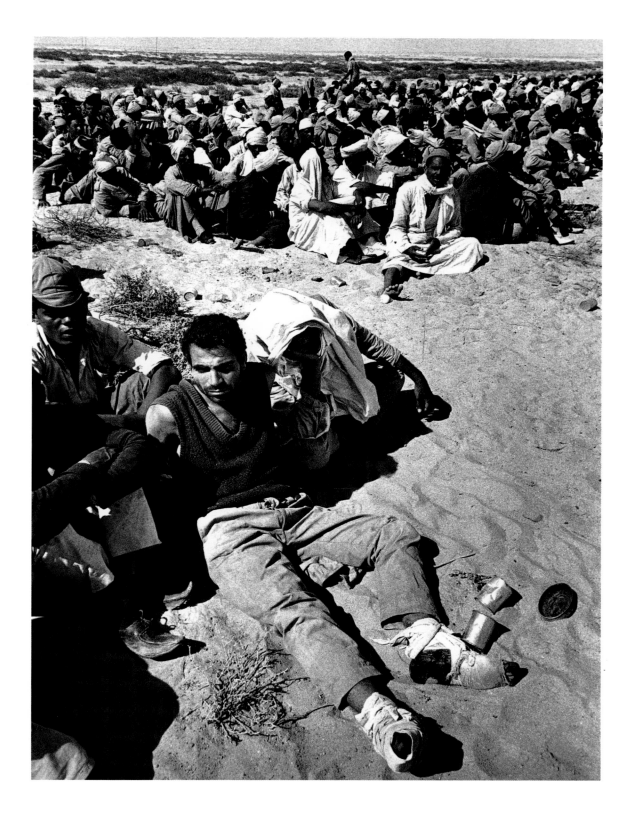

75 Two destroyed
 Egyptian tanks
 in the vastness
 of the Sinai. Over
 500 tanks were
 destroyed by the
 Israeli fighter
 bombers in the
 Sinai campaign
 René Burri 1967

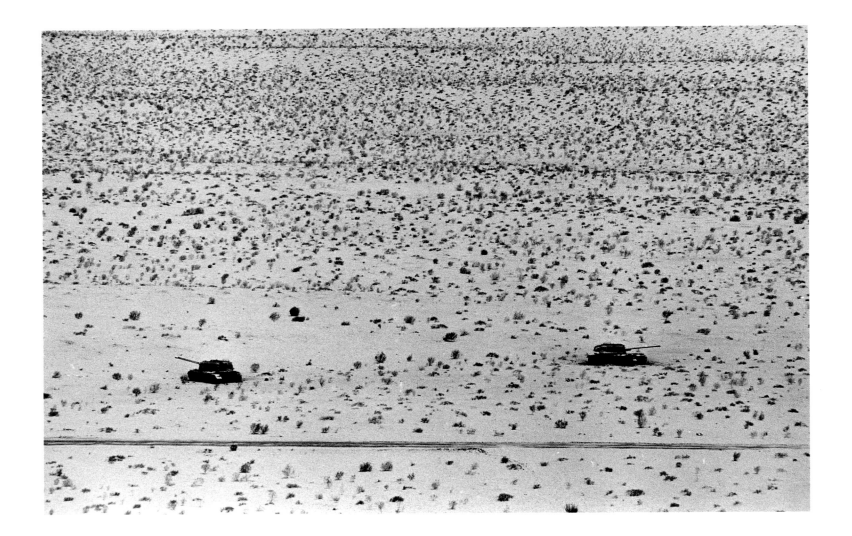

76 Israeli soldiers
 advancing through
 East Jerusalem
 reacting to sniper
 fire
 Don McCullin 1967

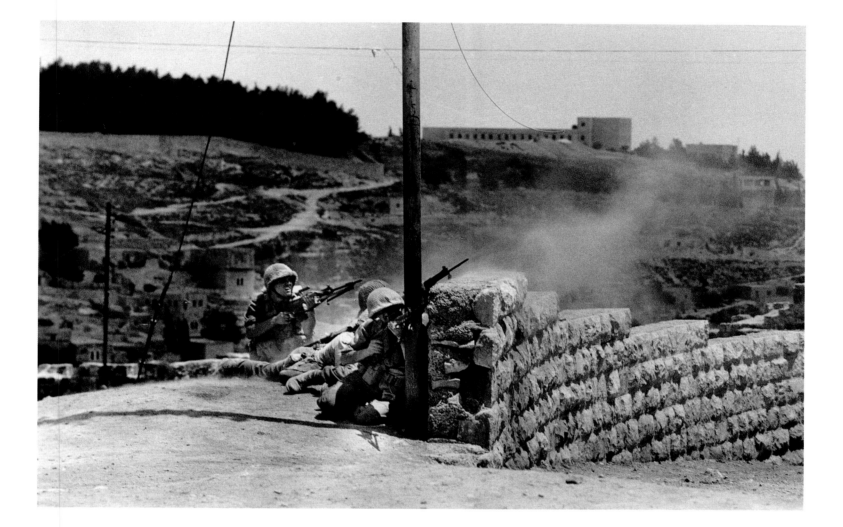

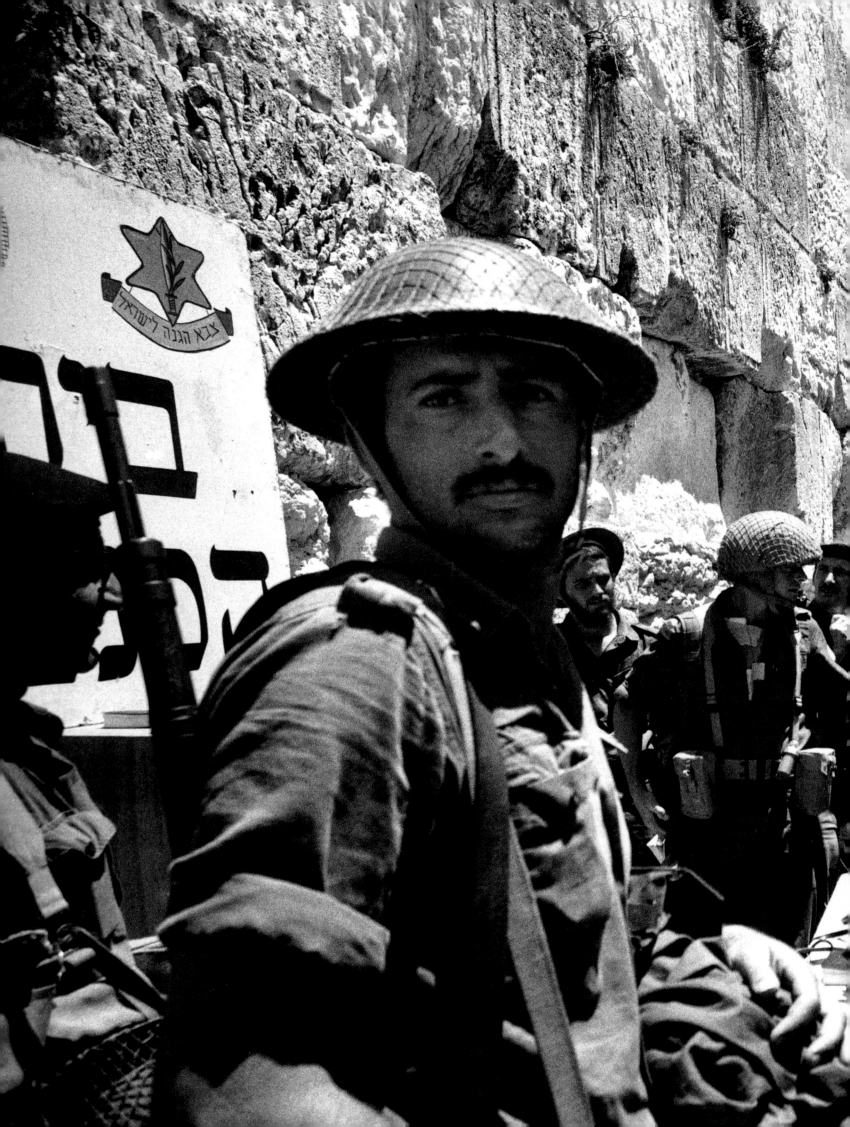

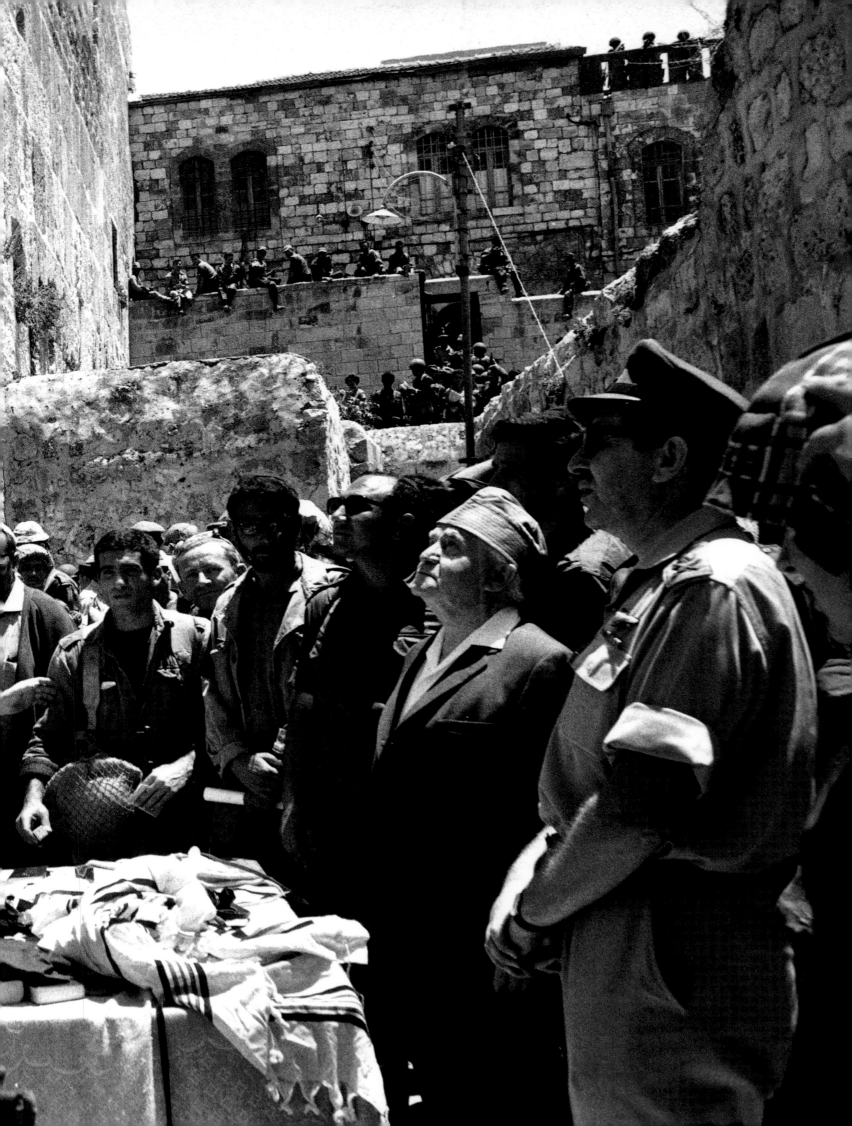

79 **A North African**
 Jew preparing to
 pray at the Wailing
 Wall, Jerusalem
 Leonard Freed 1967

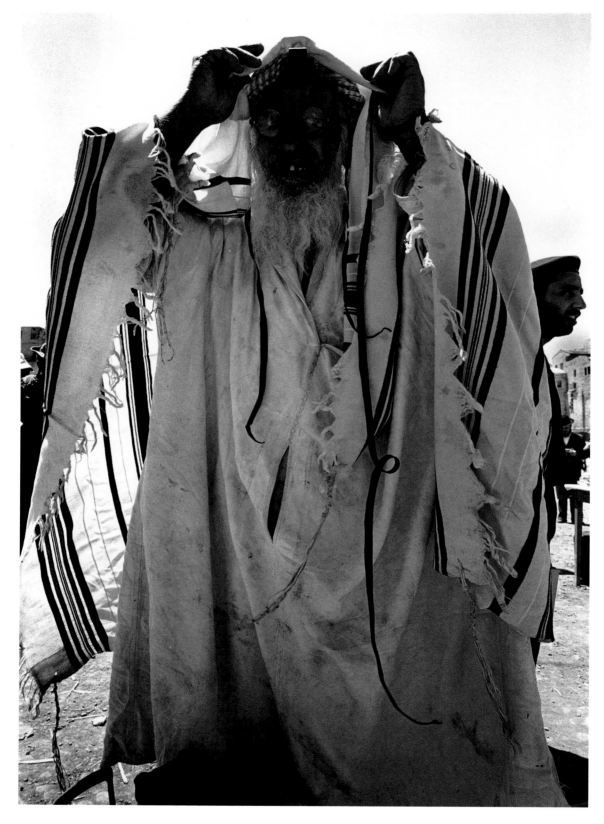

◀

78 **David Ben-Gurion**
 at the newly liberated
 Wailing Wall
 Micha Bar-Am and
 Cornell Capa 1967

▶

80 **Food distribution**
 to refugees by the
 UNRWA, near
 Allenby Bridge
 Cornell Capa 1967

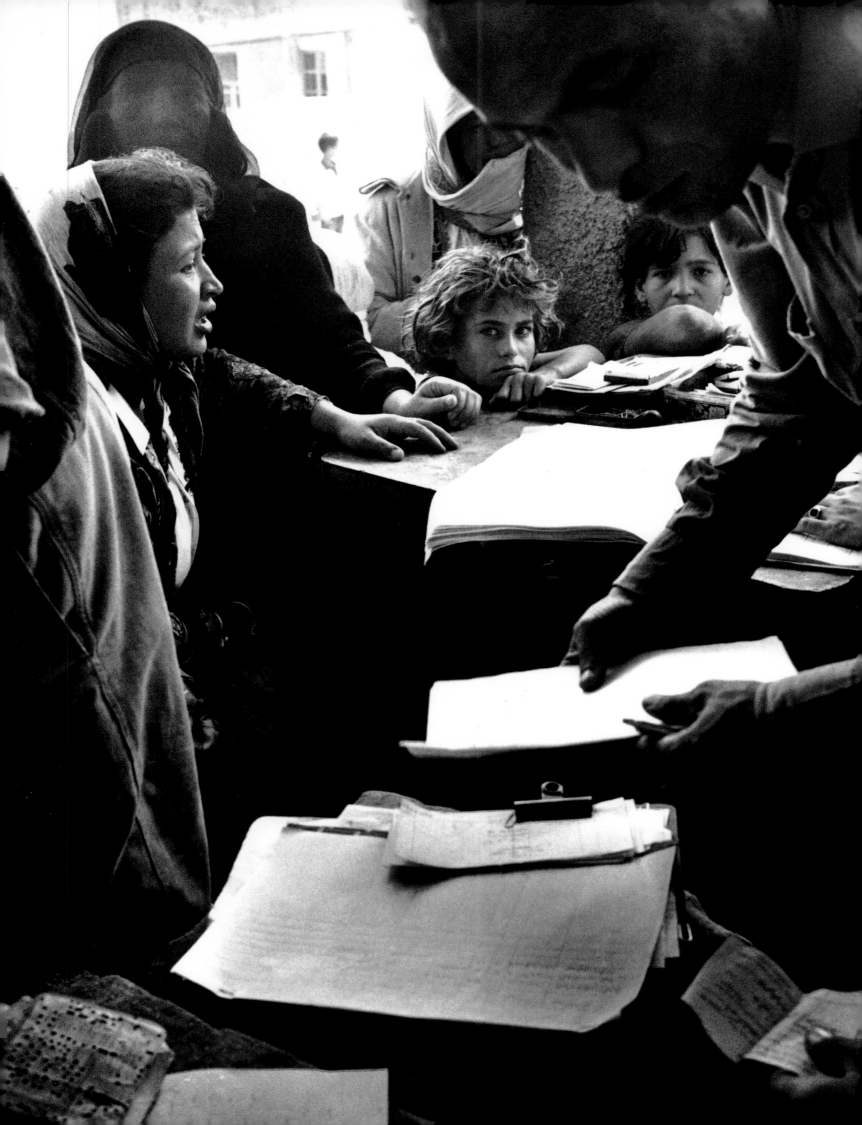

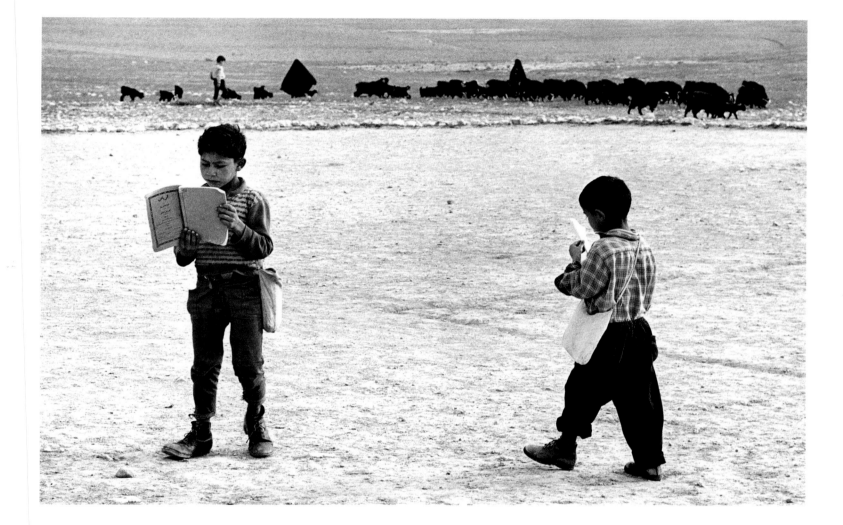

◄

87 **A schoolroom**
Erich Hartmann 1958

88 **Bedouin boys in the Negev reading from their schoolbooks while their sisters tend the sheep**
Leonard Freed 1967

▶

89 **A collaborator, hooded for disguise, aboard an Israeli truck in an Arab village, identifying the men responsible for a raid on a nearby kibbutz**
Micha Bar-Am 1967

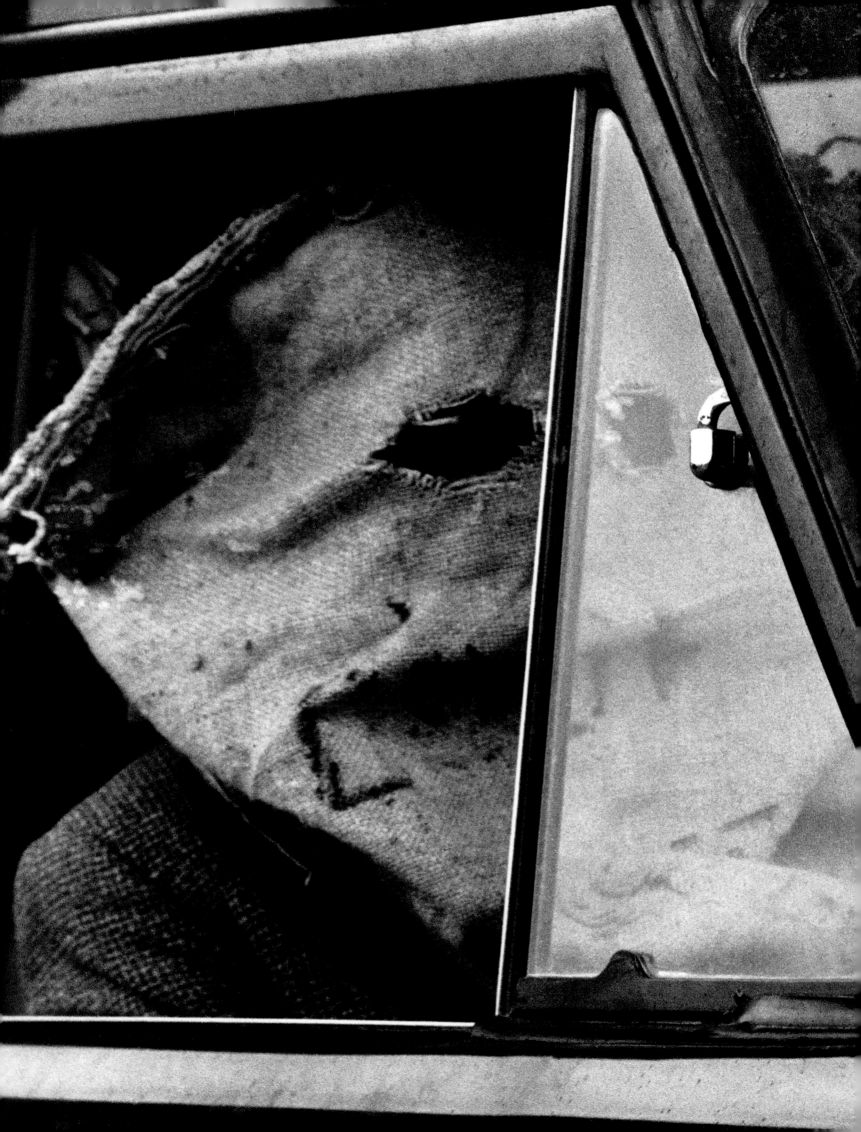

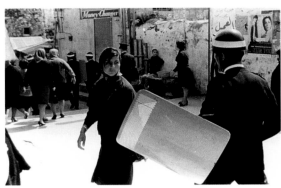

Troops break up a funeral procession - Ian Berry 1969

I WAS on an assignment that didn't seem to be working out. Bruno [Barbey] was working with the Palestinians, going with them on a raid, and I was supposed to shoot the Israeli counter patrols. I guess that I shouldn't have been surprised that the Israelis weren't too keen to take me along.

After one or two unsatisfactory forays, I found myself dragged into a completely different story. A Palestinian mayor approached me and asked me to come and have breakfast with him. When I arrived, I was shown the house that the Israelis were about to blow up as a reprisal. It was so totally predetermined that I was able to hide and wait and take shots of it happening. The word reprisal always brings a chill.

I became more embroiled in what was happening in the occupied territories; I have an immediate sympathy for the underdog, and it also appeared that the situation was reminiscent of my South African experiences. I later witnessed a funeral of a shot Palestinian, and I found myself confused by the sight of Israeli troops wading in to disperse a funeral procession – most of all, I was shocked by the outright violence against the women, who were trying to insist on the forbidden funeral. My feelings and thoughts about Israel were like those of many other people in the West, they are very much based on its creation out of so much suffering, and on the liberal ideology from which many of its institutions stemmed.

I have witnessed systematic racism over forty years in South Africa, but this situation didn't bear the marks of a racial tension. It was far more an ugliness that was inflicted on both sides: the unhappiness of the dispossessed, with no means to express themselves, and the dilemma of an authority too afraid to make concessions. It was uniforms, not skin colour, that separated these people.
Ian Berry 1969

IN JERUSALEM, I walked and walked, and I looked.

I saw stones worn by the sun and the wind – beautiful stones worn by centuries of conquerors and pilgrims. I saw shrines and graves, blending with the landscape because they had always belonged to it. I saw faces as worn as the stones – beautiful faces of many different races, revealing a faith, whatsoever the creed, and revealing a dignity no matter what the humiliation. I understood how these faces, these stones – whether Jewish, Moslem or Christian – make the soul of Jerusalem, and how deeply that soul is rooted there.

But I saw also the sudden superimposition of an ultra-modern civilisation not rooted there, the bulldozer and the crane becoming as common as the pilgrim, a new skyline foreign to this sky and this land. Speed and efficiency are the new rites. The rhythm of centuries, Jerusalem's own pace, is being accelerated to the tempo of the assembly line.

This frantic race to anchor – with steel and concrete – new roots on an old land has to brave the dignity of a large group of people. As on so many faces, I saw humiliated pride in the eyes of two Palestinian women. A bulldozer smashed through their small orchard; the next day, the whole family was expelled from the stone house which had been theirs for generations. Offered a meager compensation, they lifted their heads and refused the alms. I understood how dignity is much dearer than an improved standard of living for the people of this land, and how Jerusalem belongs to this pride as much as it belongs to the pride of a courageous and victorious army.

But the builders of the new Jerusalem know it better than others.

What is built on humiliation seldom lasts long; the most unexpected can be expected from a humiliated people.
Marc Riboud 1972

Jerusalem - Marc Riboud 1972

THE WAR is on. Like most photographers, I prefer to get to the front lines on my own rather than be chaperonned by army guides. On my second attempt, I pass through the road blocks which cut off the Golan Heights. I had imagined these to be imposing mountains, yet I discover them to be deserted hills swept by autumnal winds. A column of Israeli soldiers pulls to a halt there. Suddenly there is a clamor along the line, a noise which increases. I realise then that there must be an important personage reviewing the troops. A jeep passes by, in which I notice a figure with a black bandeau over one eye. It's Moshe Dayan, the legendary Defence Minister. I follow him.

Moshe Dayan visits the front line, which he inspects through his binoculars from the vantage point of a bunker captured from the Syrians. One of their shells has just hit our bunker. I wonder whether or not they are going to repeat this lucky shot, while Israeli television and I are filming and photographing from outside the bunker. In the final analysis physical courage is not a complicated matter, all it needs is a lack of imagination.

Through the concrete window, which has received a direct hit, Moshe Dayan declares: 'Today, the Syrians are going to learn that the road which goes from Damascus to Tel Aviv is the

1968-1977

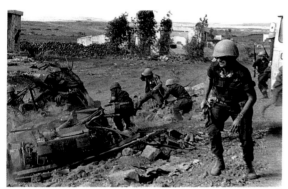

Israeli troops advance in the Golan against Syrian artillery - Abbas 1973

same one which goes from Tel Aviv to Damascus.' In fact, after the surprisingly disorderly retreat of the first few days, the Israeli army has pulled itself together and is now leading its own counter-offensive.

Abbas 1973

I RECALL my first visit to Israel, nine years ago. Naturally, being German, I was quite apprehensive during my two-week stay. I had been nine years old when the war ended and we had begun to see tormenting and haunting images from unspeakable places like Bergen-Belsen and Dachau. I did not comprehend the images at the time, but they surfaced in my dreams, in my nightmares.

Despite misgivings, everything went smoothly, this seemed to be just another country where I could try to take photographs, the usual red tape, the usual frustrations and the occasional joy at making a good picture. Then, one evening I had found myself in a kibbutz in the Negev. There was a nice lady who cooked for me, and when we sat down I saw the tattooed number on her arm. She said that she had grown up in Breslau and that she had not spoken a word of German for nineteen years, and thought that she would never want to use her native tongue again. I don't recall everything that we talked about over her excellent dinner, but I know that at the end we were both speaking German and that on my departure the next morning she embraced me with great fondness, even with tears in her eyes.

Now I am shooting an essay on the 25th anniversary of Israel, and I have approached it like any other country story, trying to cover several angles: modern city life, the girls of Tel Aviv, new agricultural technologies, army life. I recently visited the Suez Canal Zone, accompanied by a young and flashy looking Israeli army press officer. I took some pictures of him as he was sunbathing next to his Uzi, behind sandbags. In the evening we drove back to Jerusalem. As we approached Gaza, my chaperon told me to dim the headlights, and drive fast; there could be snipers on the roofs, and we shouldn't attract attention. Gaza turned out to be a dark and deserted place, probably under curfew. In the seat next to me, my press officer was dozing after a long hot day in the sun, but I was feeling pretty tense after his warning. Then: a sudden, deafening shot. My ears ringing, I drove on as fast as I could. After a while I realised the shot had come from the Uzi that was leaning against my right shoulder. The brave soldier dozing in the car had pushed the trigger in his sleep. Nothing else happened. Gaza was still dark and deserted. A hole had been blown in the roof of the car. My portrait of my trigger-happy friend ended up as the cover of *Life* magazine's special issue on Israel's 25th anniversary.

Thomas Hoepker 1973

Tel Aviv - Thomas Hoepker 1973

THE FIRST time I visited Jerusalem's Mount Zion it was a labyrinth of barbed wire, pill boxes and soldiers facing their enemy only yards away. I was there again during the Six Day War, viewing the carnage, the dead and the still smoldering military equipment hurled about haphazardly. When a Talmud school was opened on the mountain, I went to stay there with the students. Evenings on the mountain were peaceful. The tourists were gone, and the place was left to its custodians. One of the students suggested that

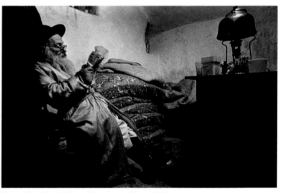

Tomb of King David, Mount Zion - Leonard Freed 1972

I photograph a particularly interesting old man who lived in a cubby hole that guarded the tomb of King David. His door was of ancient wood and stood slightly ajar. I knocked, and then knocked again. Not a sound. So, knocking yet again, I gave the door a push. The old man was reading. Again, I knocked, and again, there was no reaction. When, at last, he turned a page I felt relieved. At least he was still alive. This time I entered the room as I knocked, and, as the minutes rolled by, his eyes never looked away from the page. He was turning another page as I left, and I half expected that the sound of my footsteps would bring the old stones of the building tumbling down, burying us both, together.

Leonard Freed 1972

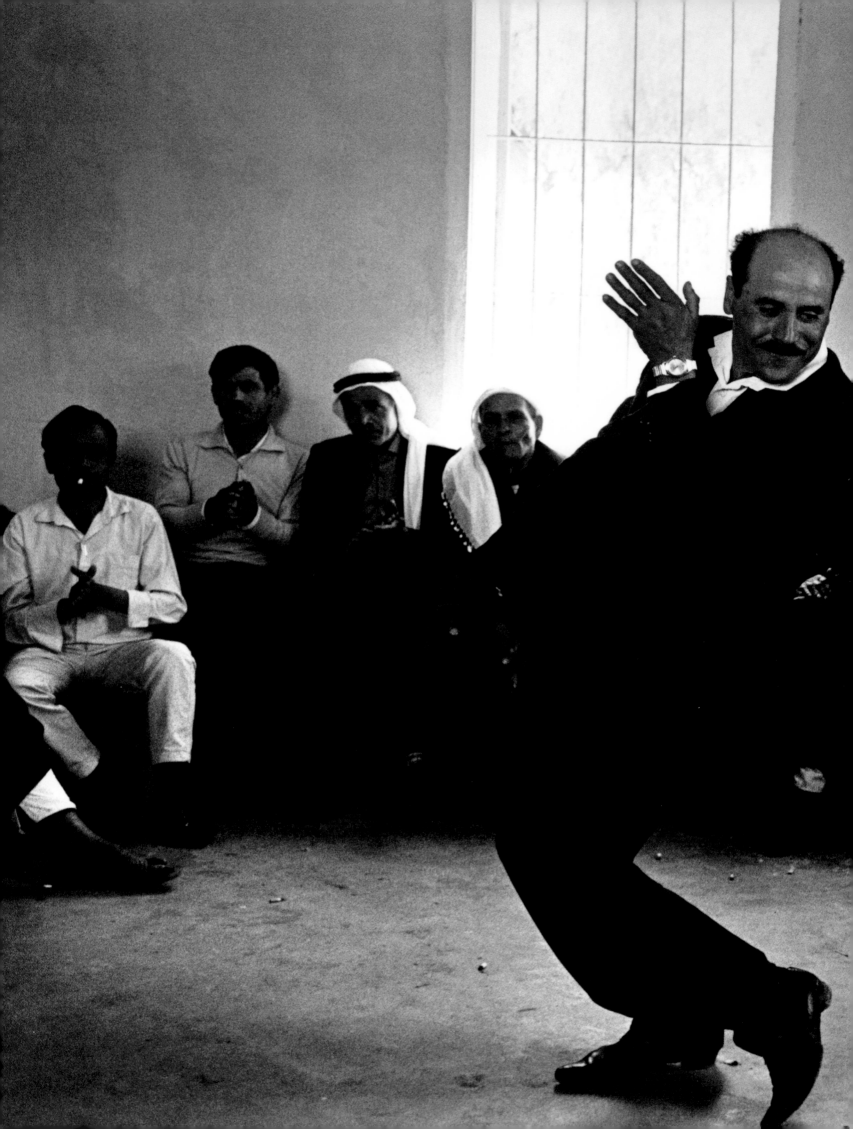

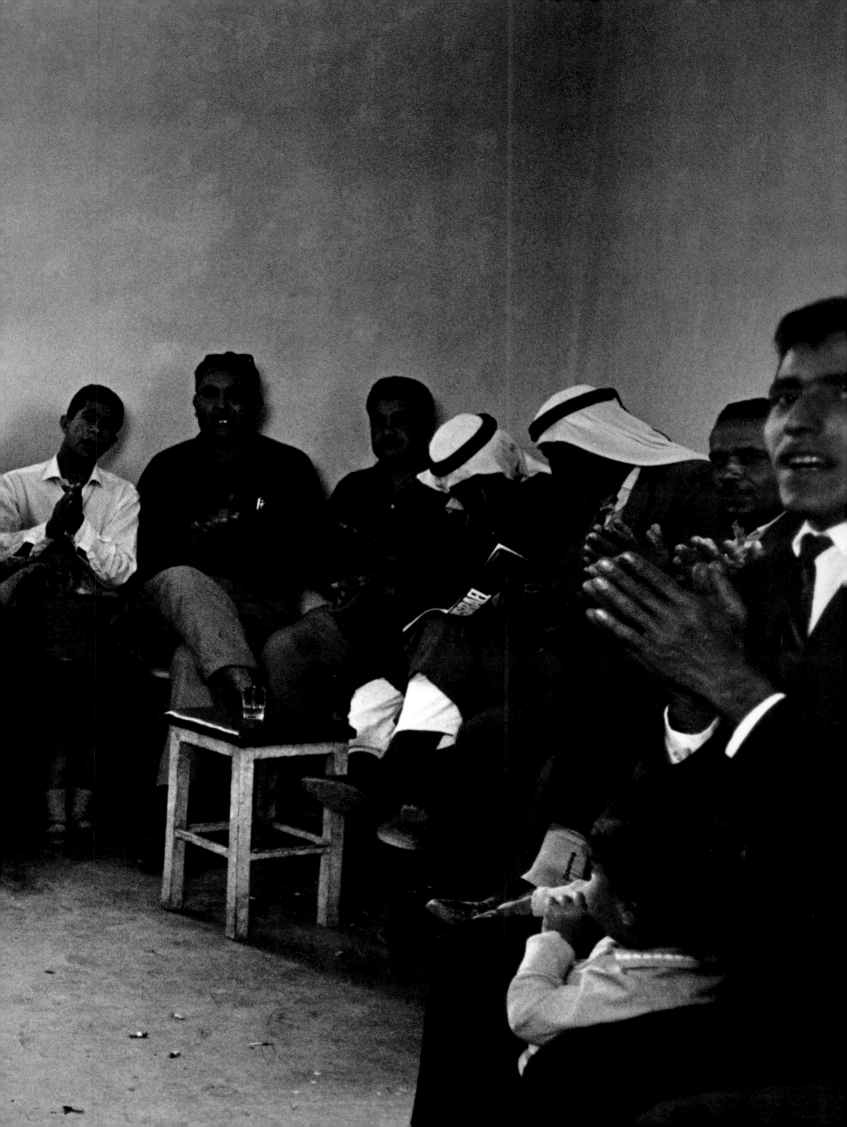

91 **An Israeli soldier
 stands guard over
 the Damascus Gate
 in the Old City of
 Jerusalem**
 Marc Riboud 1973

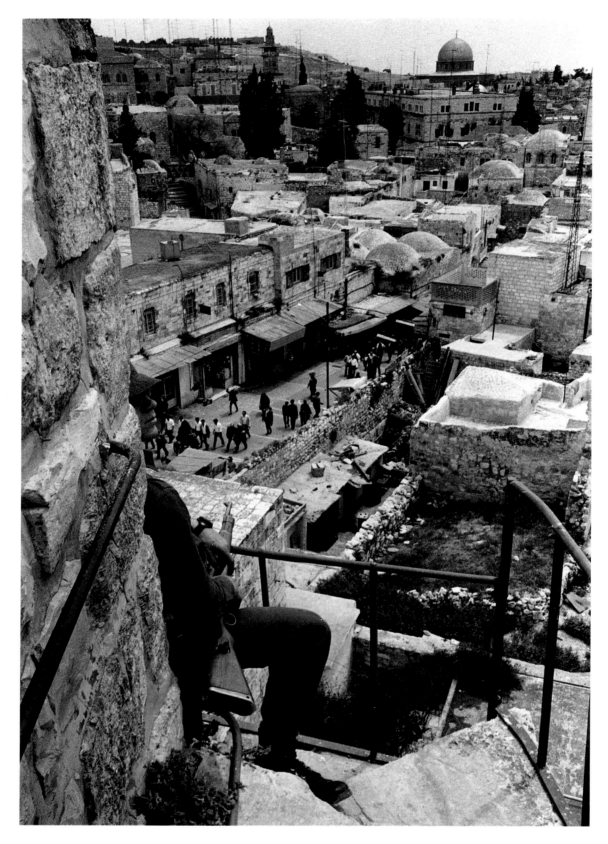

◄

90 **Arab dancing at
 a wedding party
 in Majd El Qurum**
 Leonard Freed 1968

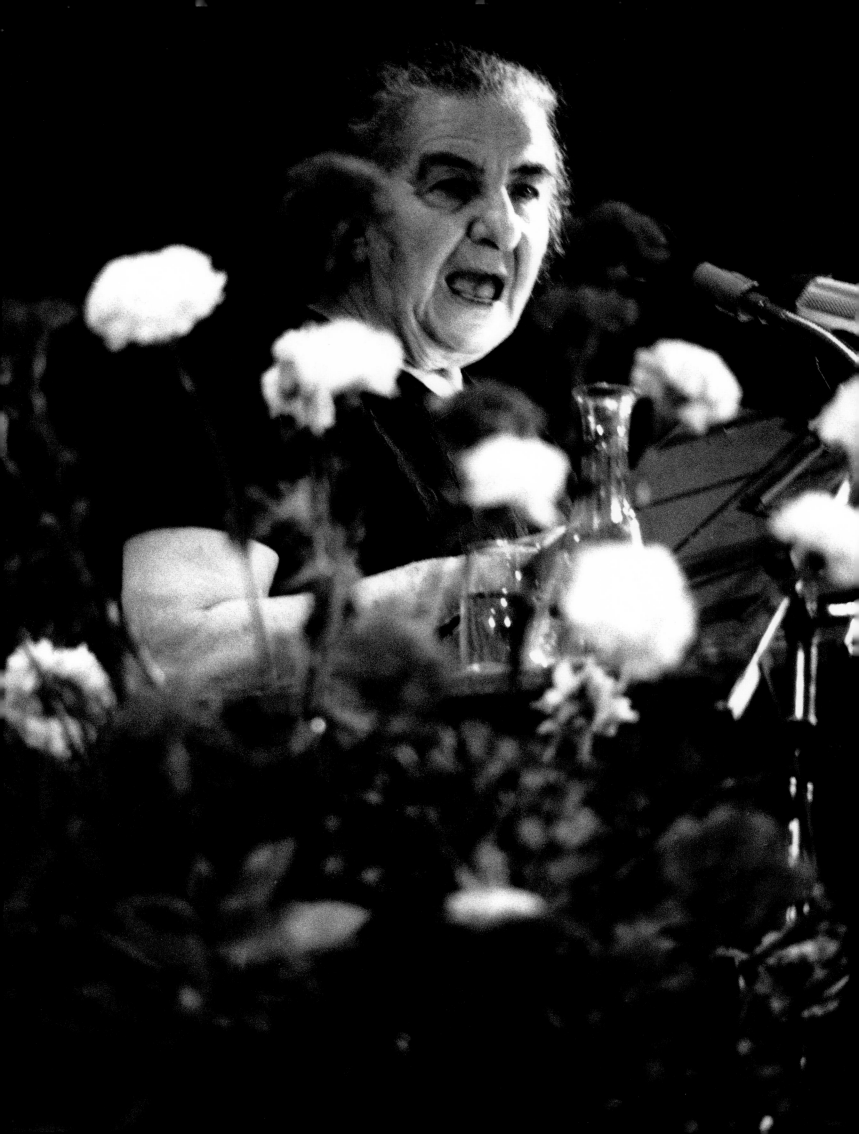

94 **Arab bride displaying
 her trousseau**
 Leonard Freed 1968

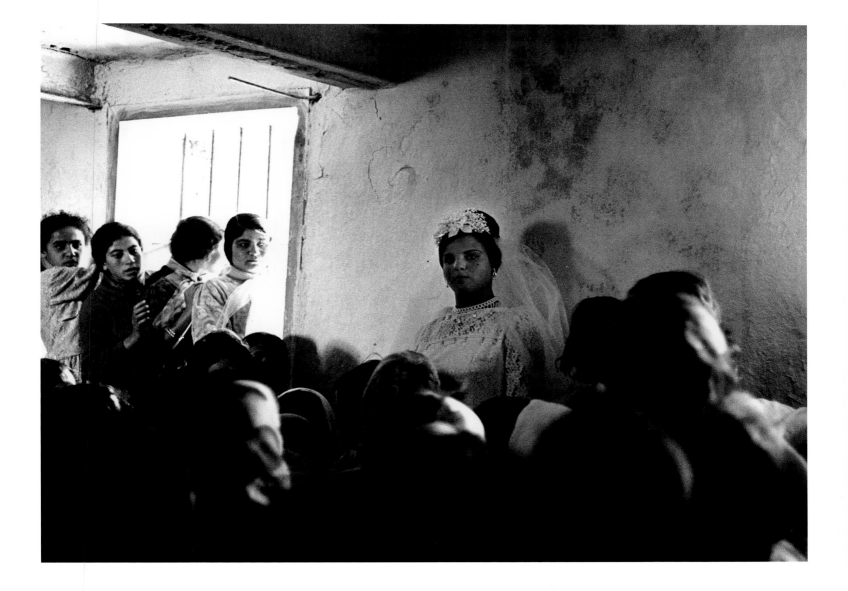

◄
93 **Mrs Golda Meir
 attending the
 International
 Congress of
 Socialist Parties
 in Vienna**
 Erich Lessing 1972

▶
95 **The machine shop
 of a factory on the
 Dead Sea**
 Leonard Freed 1968

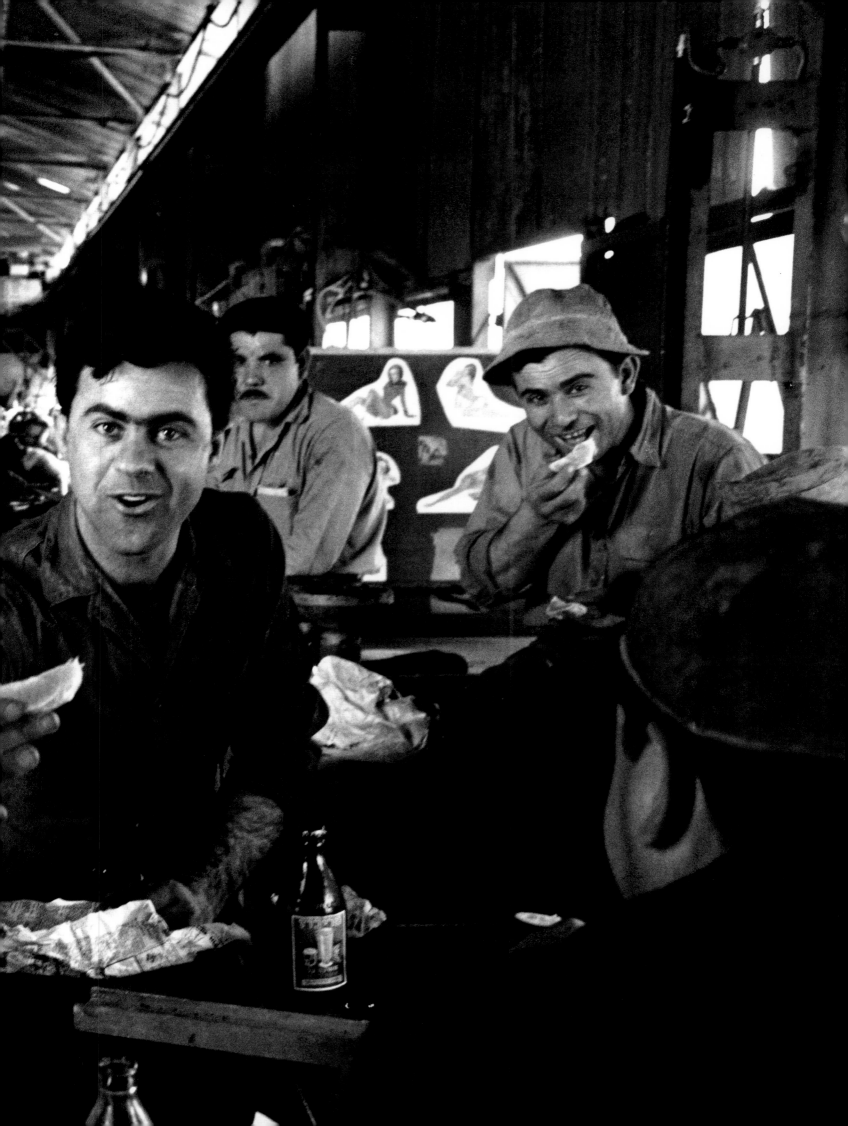

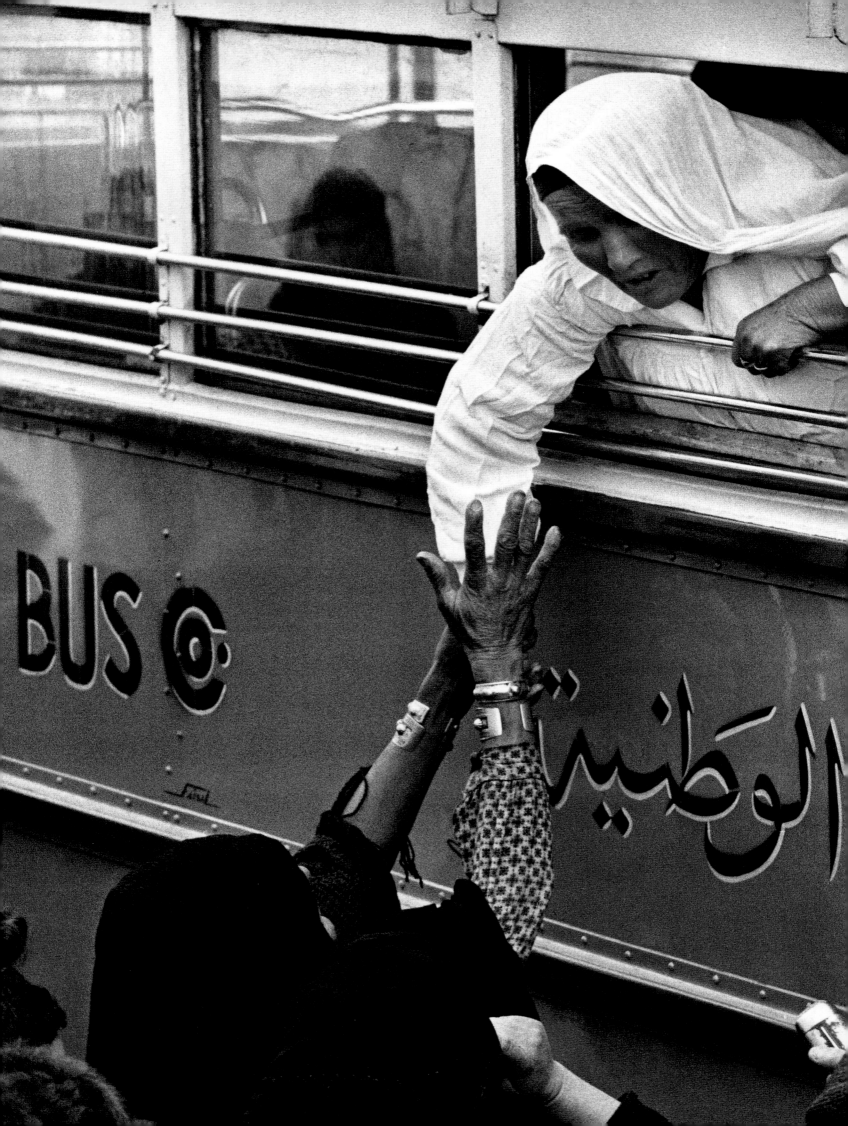

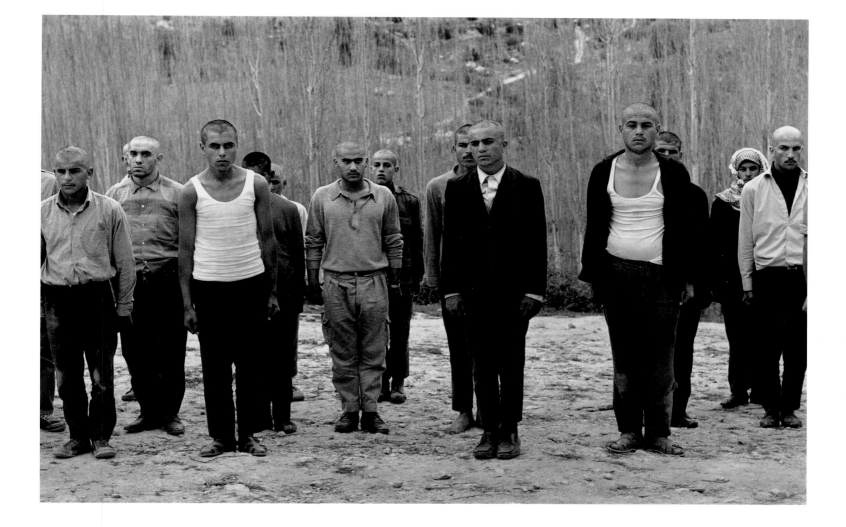

98 **Israeli army**
 maneuvers in
 the Judean Hills
 Micha Bar-Am 1971

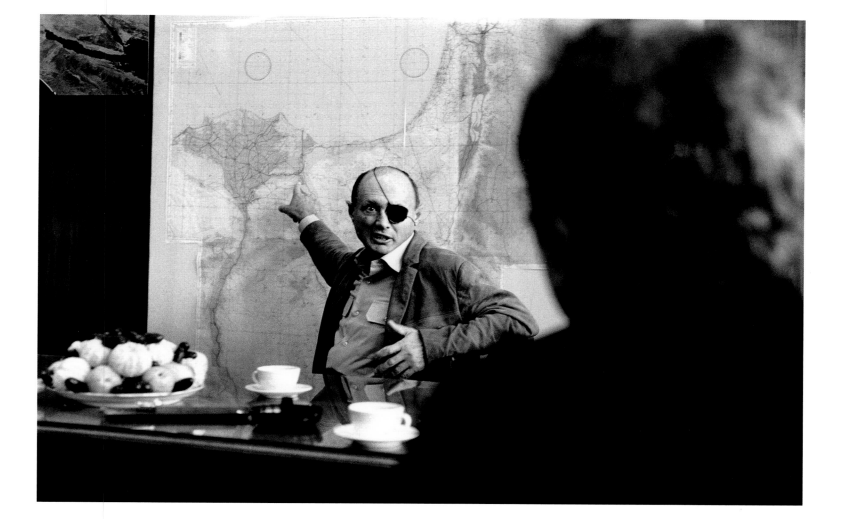

100 El Fatah raiders,
tracked down and
killed by Israeli
army units. The
raiders had crossed
the Jordanian
border to make
an attack and
had been hiding
out near Jericho
Micha Bar-Am 1968

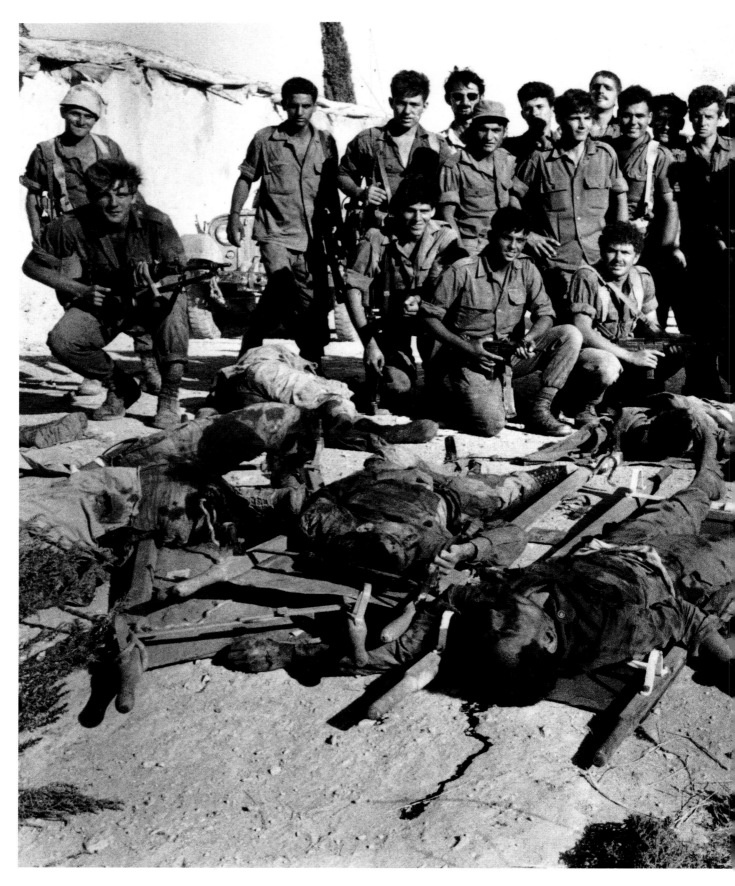

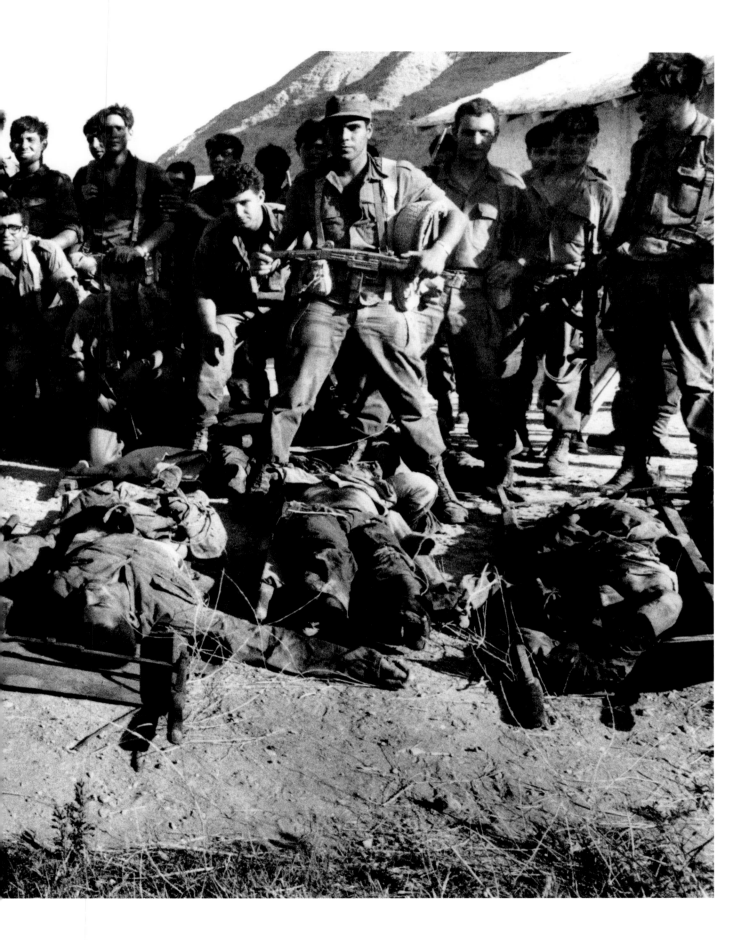

101 **Olive groves in**
Galilee
Erich Lessing 1968

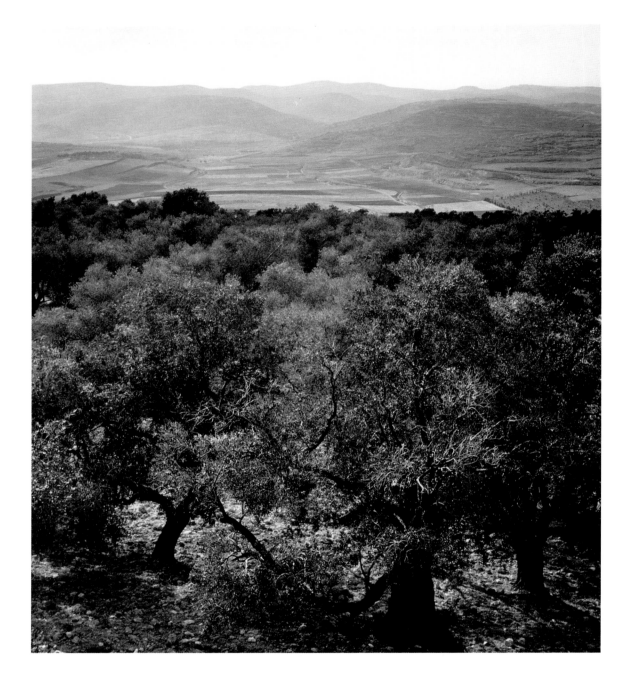

▸
102 **A prisoner in a**
solitary confinement
cell, Beer Sheba
Micha Bar-Am 1971

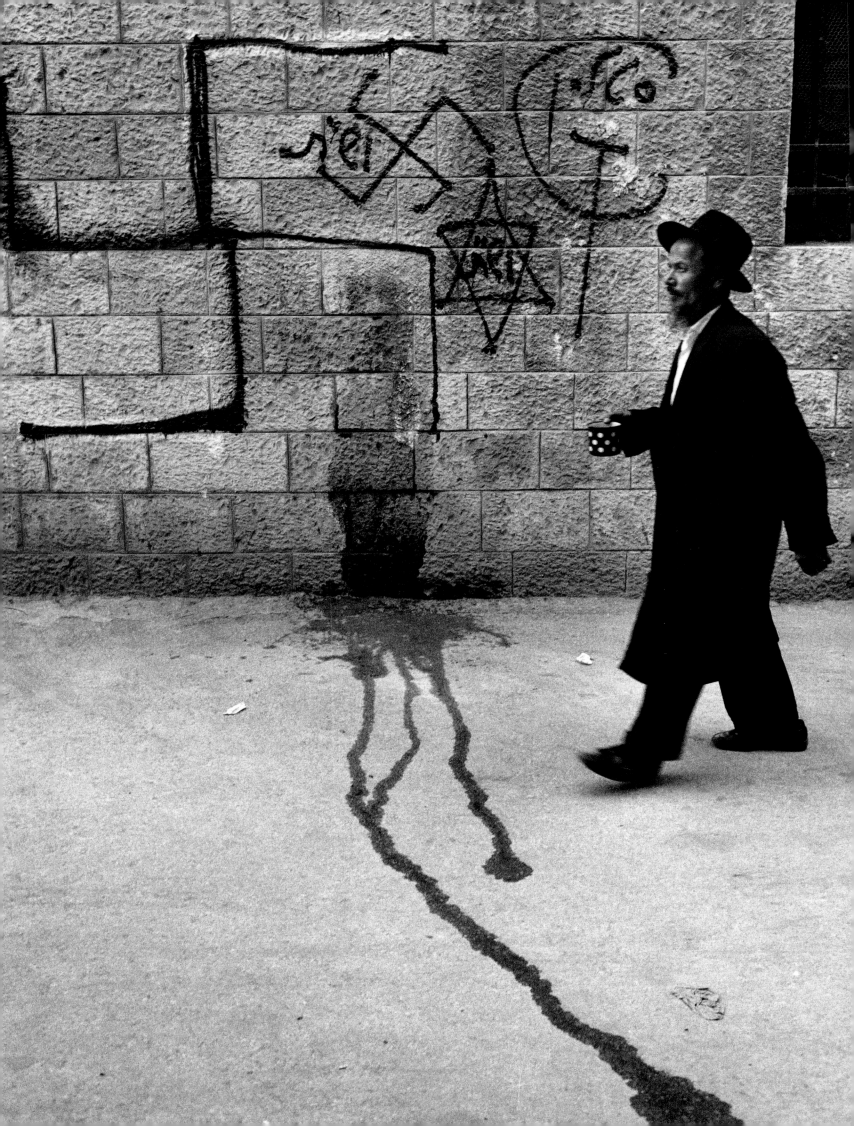

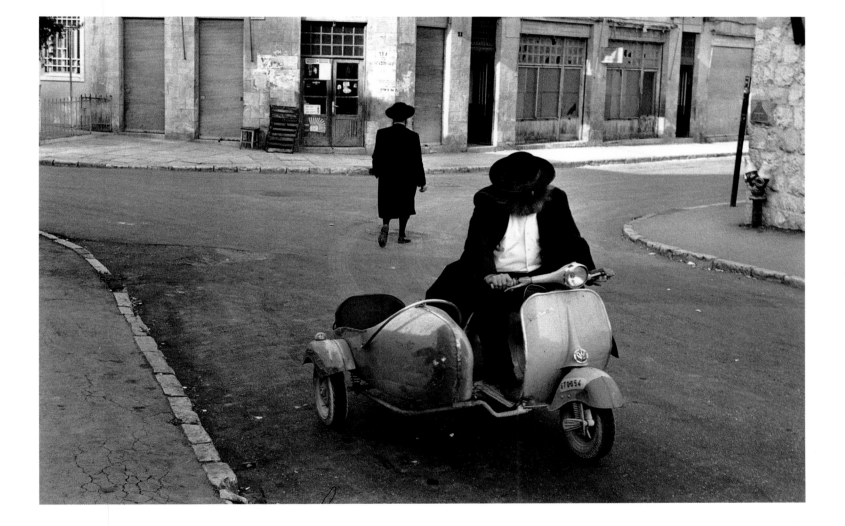

►
105 **An El Fatah patrol**
in the mountains
near Jerash in Jordan
Bruno Barbey 1971

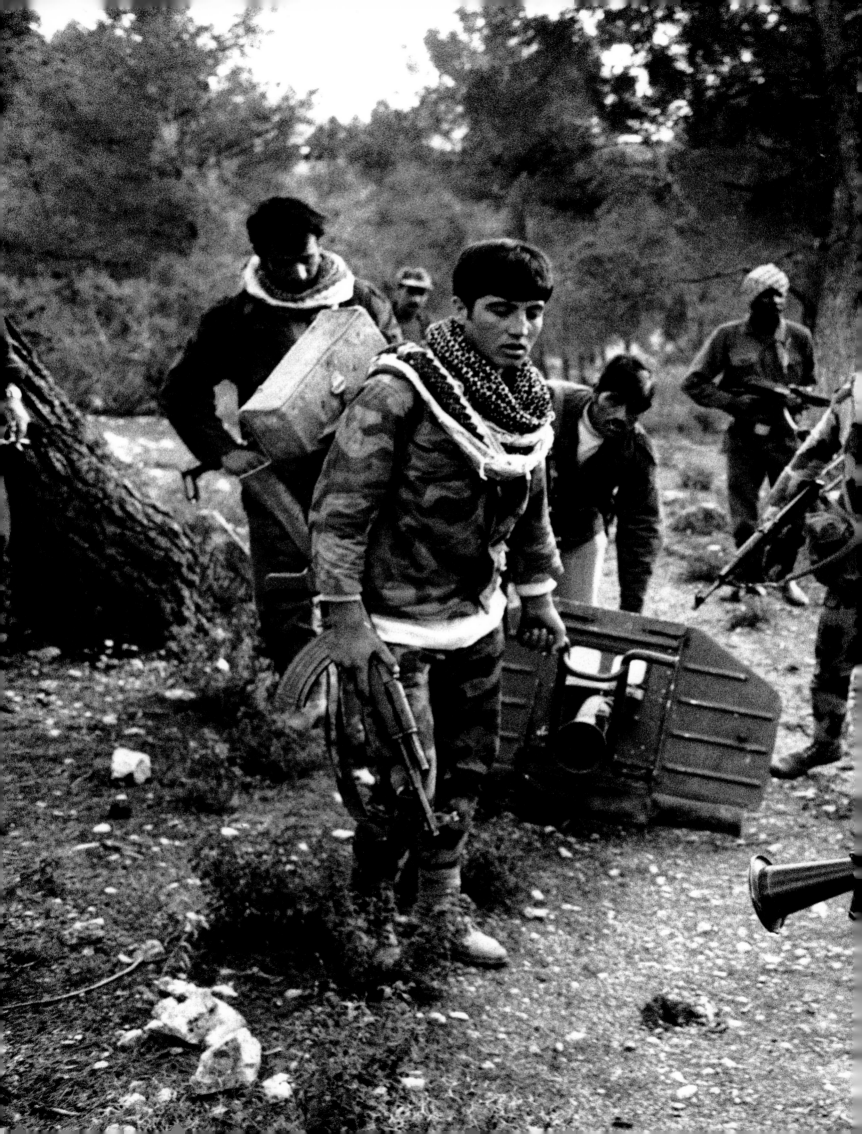

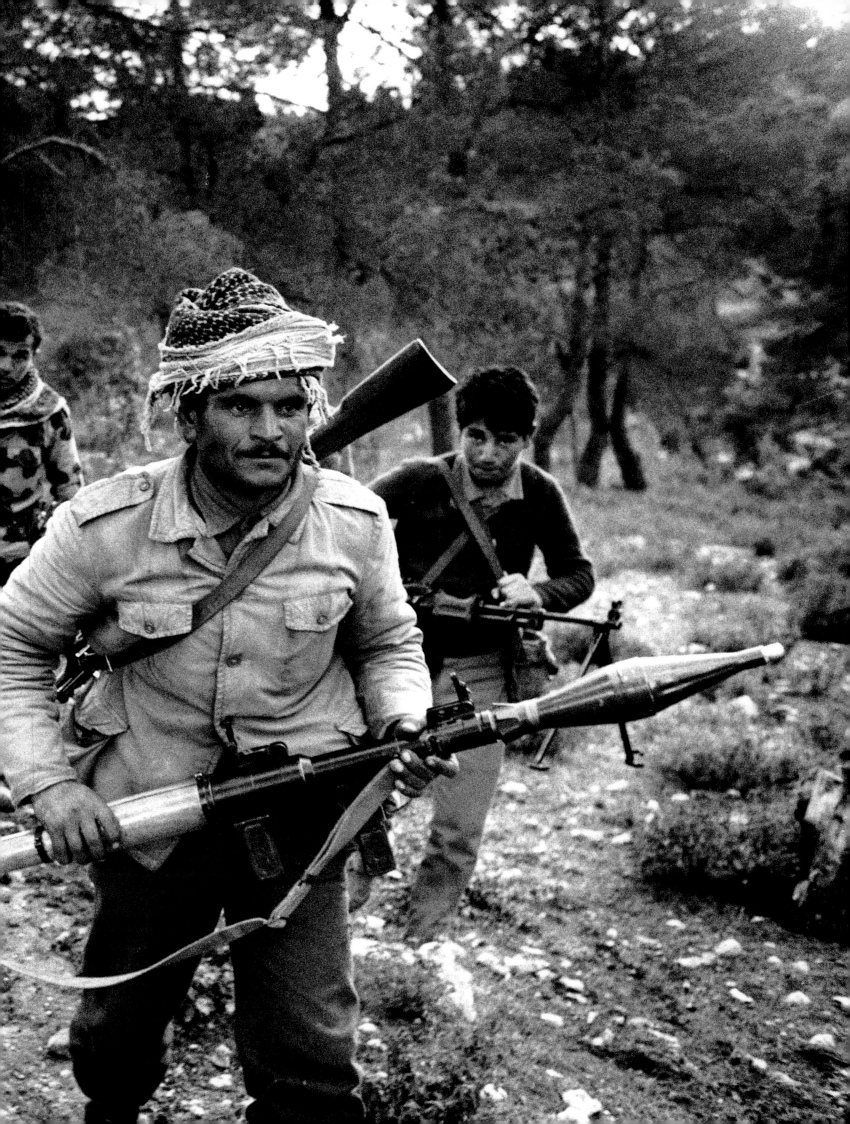

106 **Greek Orthodox pilgrims awaiting the Easter celebrations in the Old City, Jerusalem**
Micha Bar-Am 1972

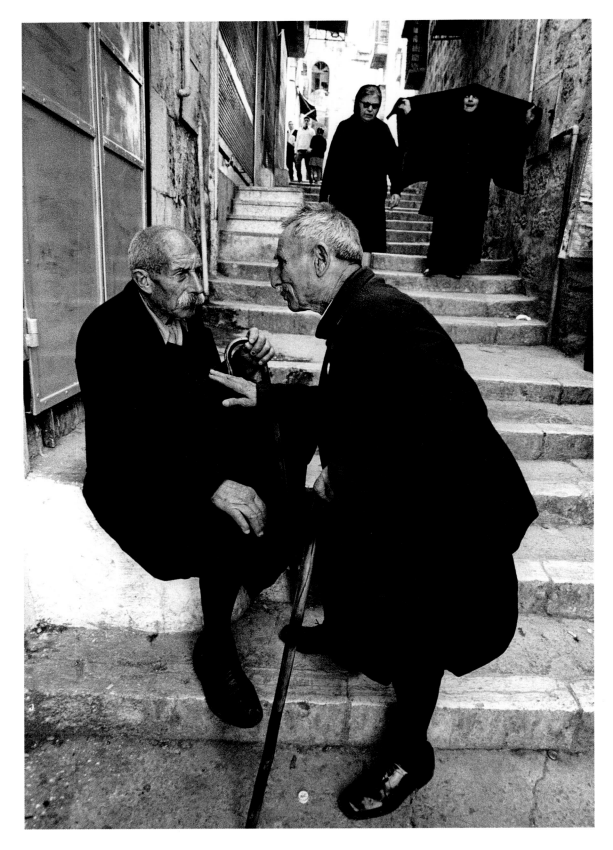

107 **Young Sabra
(native-born
Israelis) at a café
terrace in Tel Aviv**
Marc Riboud 1973

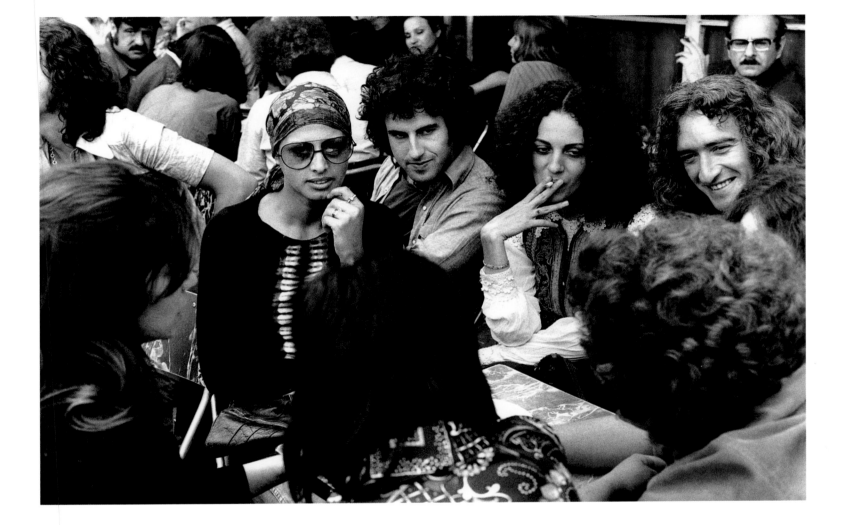

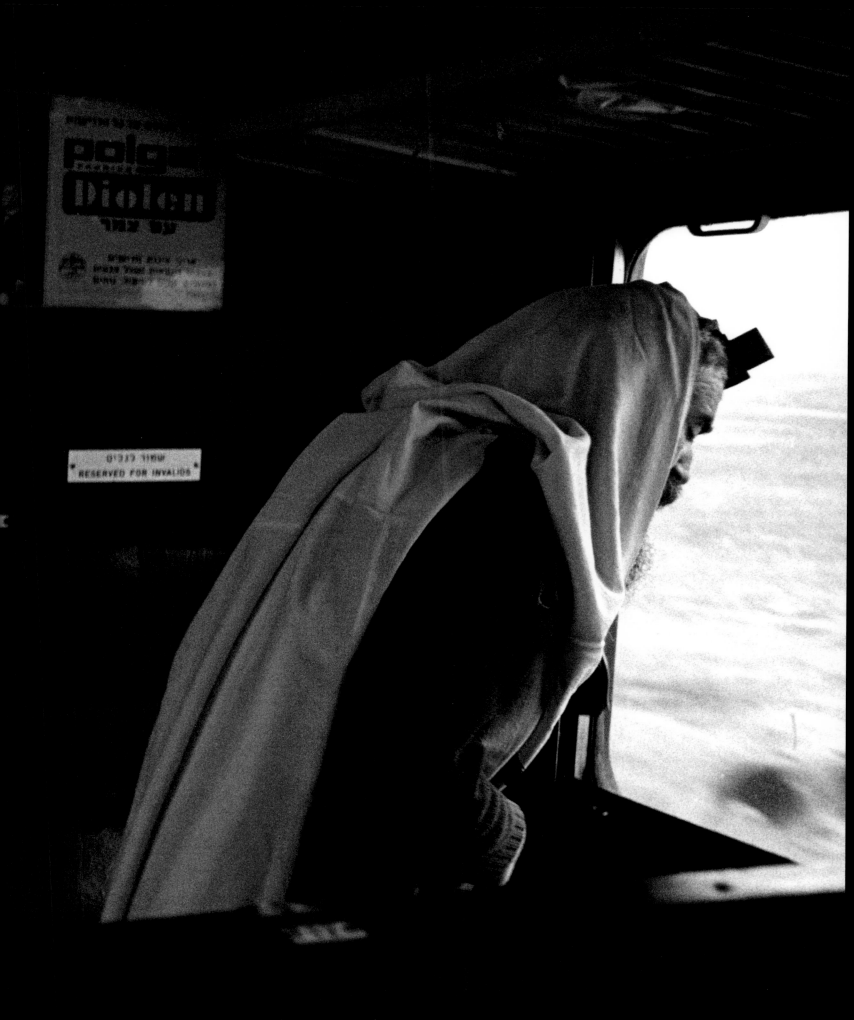

109 **Jerusalem**
Marc Riboud 1972

111 **Inside a Talmud
school, Jerusalem**
Leonard Freed 1972

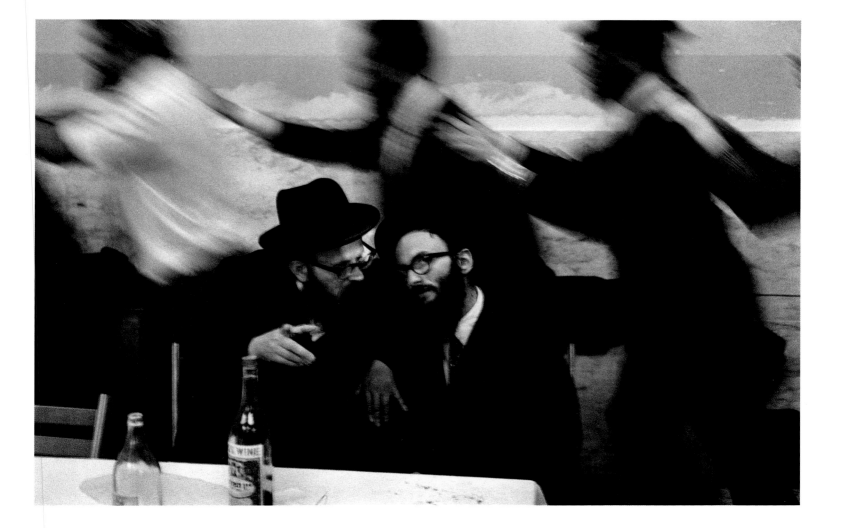

114 Israeli soldiers with
Egyptian prisoners
of war under
Egyptian artillery
fire during the Yom
Kippur War, Sinai
Micha Bar-Am 1973

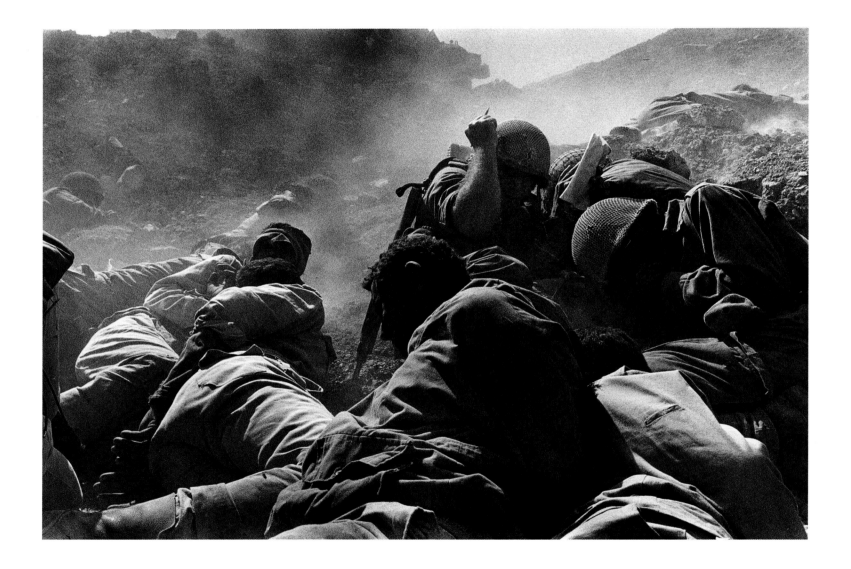

115 Israeli prisoners
captured during the
Syrian attack on the
Golan Heights, bound
and blindfolded
being taken for
presentation to the
international press
Bruno Barbey 1973

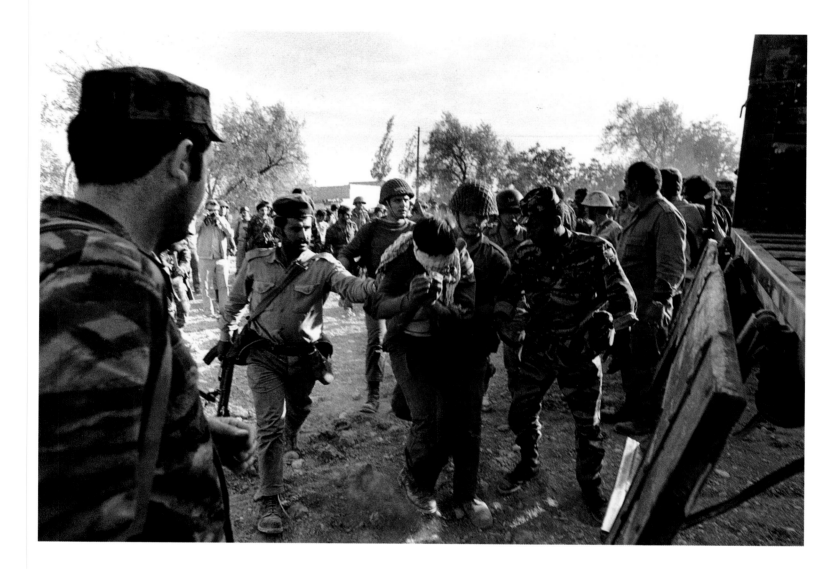

▶
116 Moshe Dayan in
a command bunker
during the Israeli
attack on the Golan
Abbas 1973

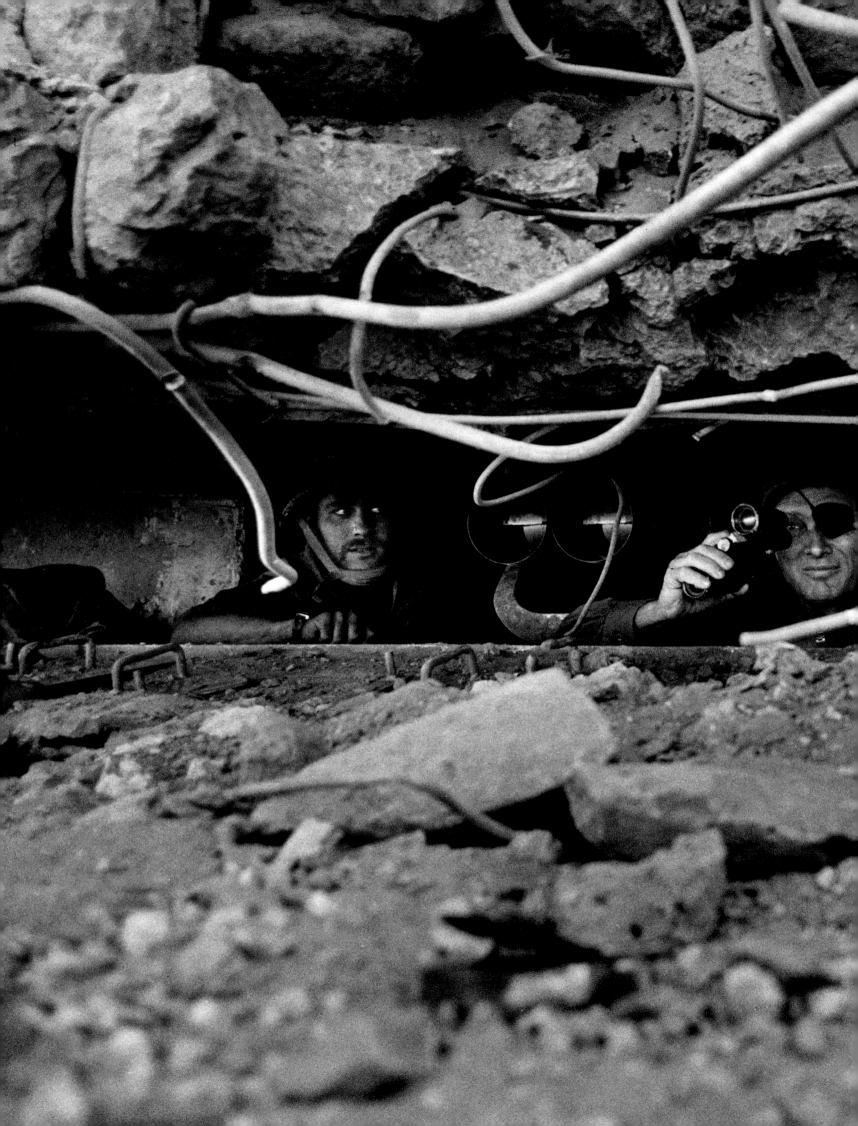

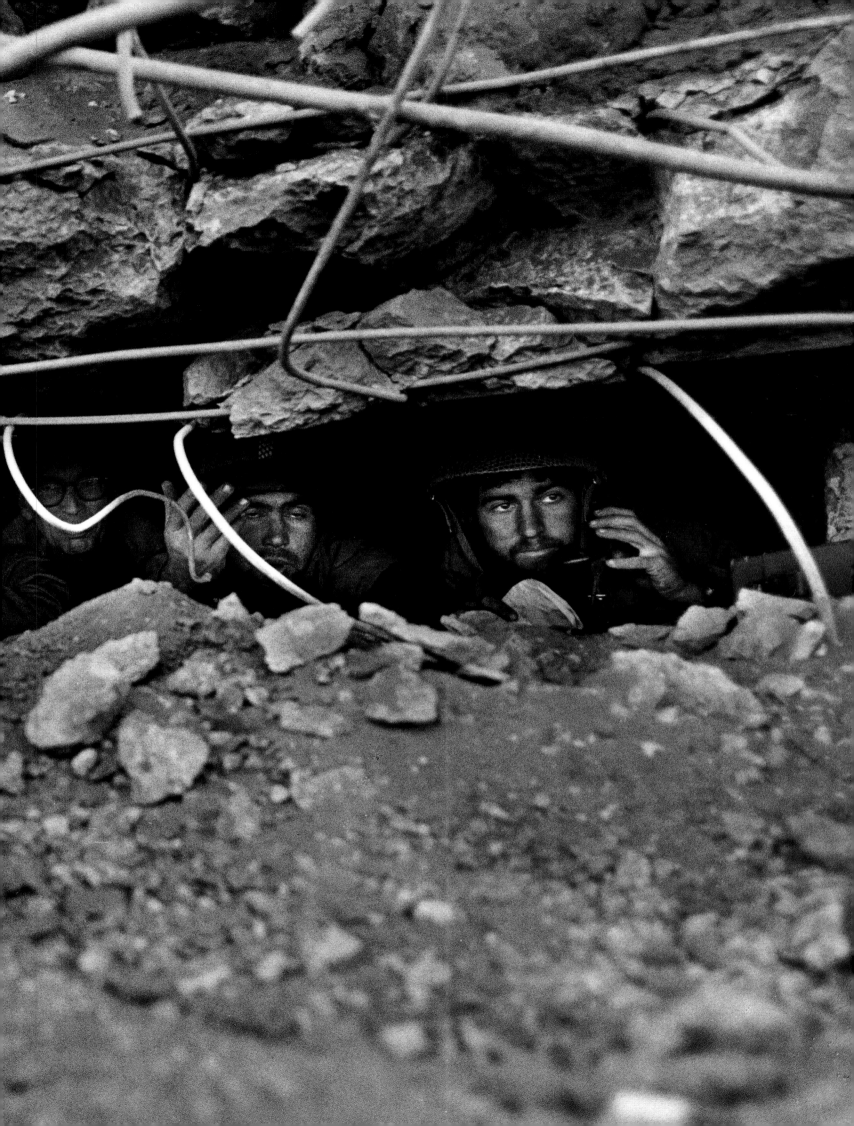

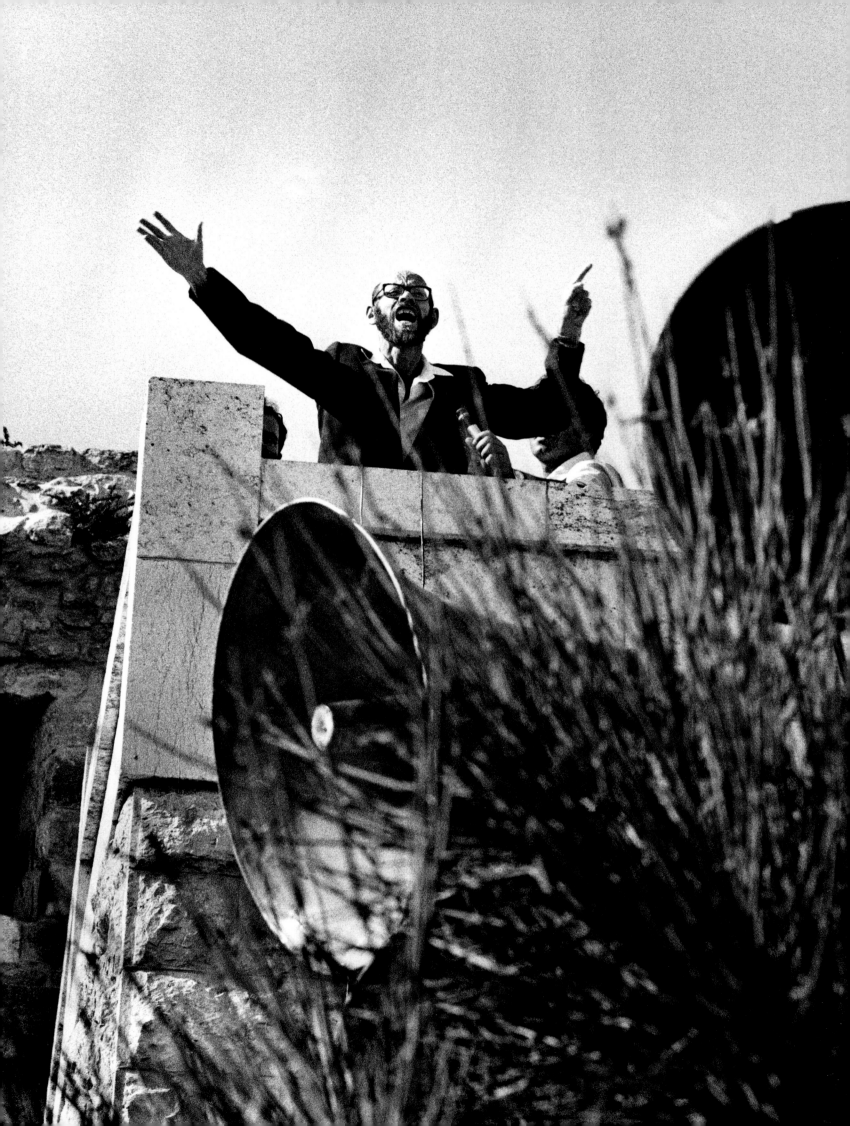

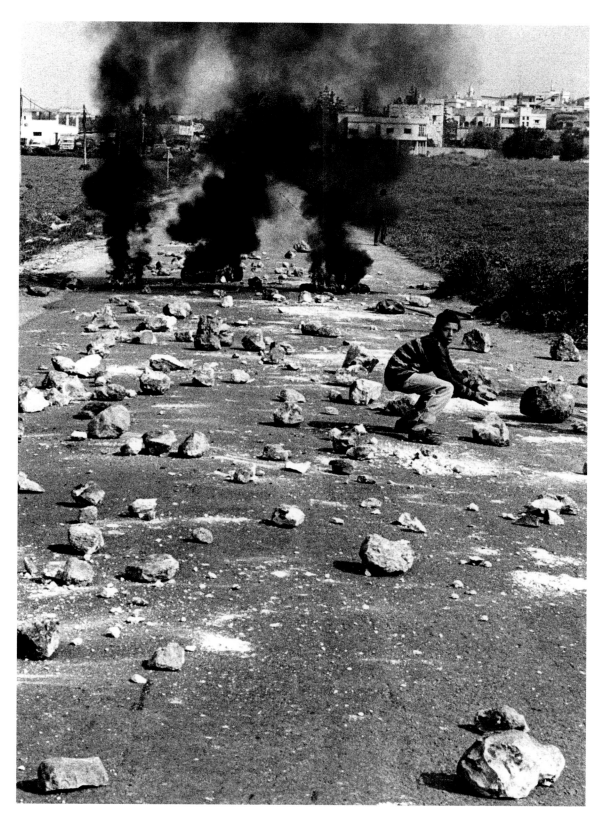

118 **Arab 'land day' demonstration – the road being blocked at Baka el Gharbiye village**
Micha Bar-Am 1977

◄

117 **Rabbi Moshe Levinger, the fanatical leader of Jewish settlers in Hebron, addressing his followers**
Micha Bar-Am 1976

119 **A bus station**
 in Jerusalem
 Thomas Hoepker 1973

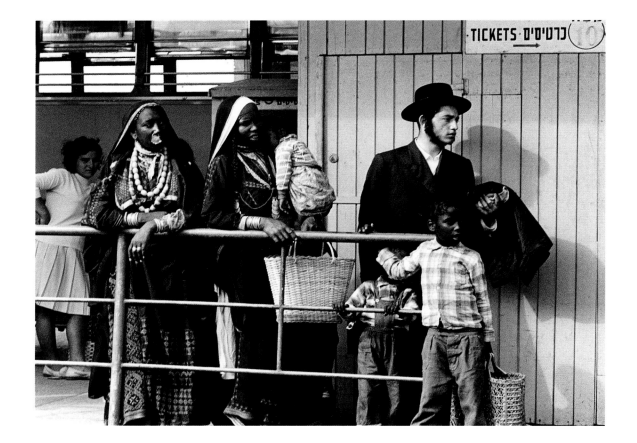

▶
120 **Watermelon vendor,**
 Tel Aviv
 Micha Bar-Am 1974

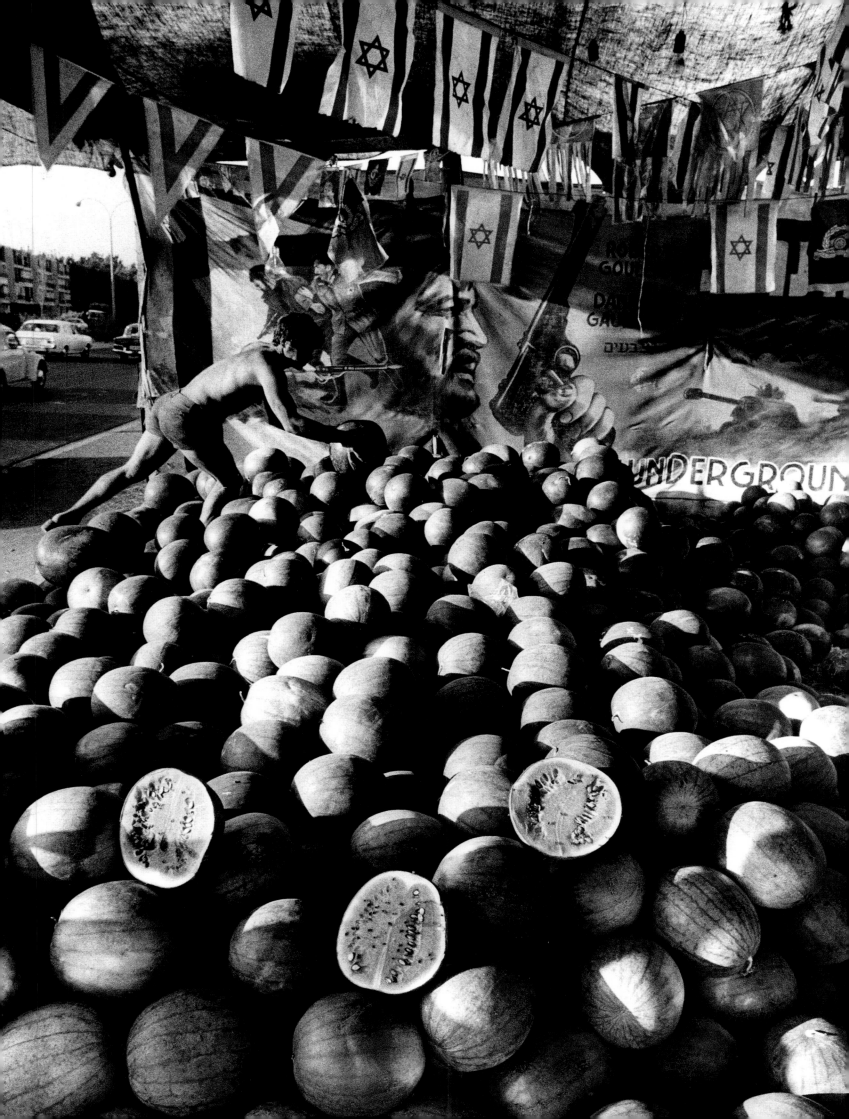

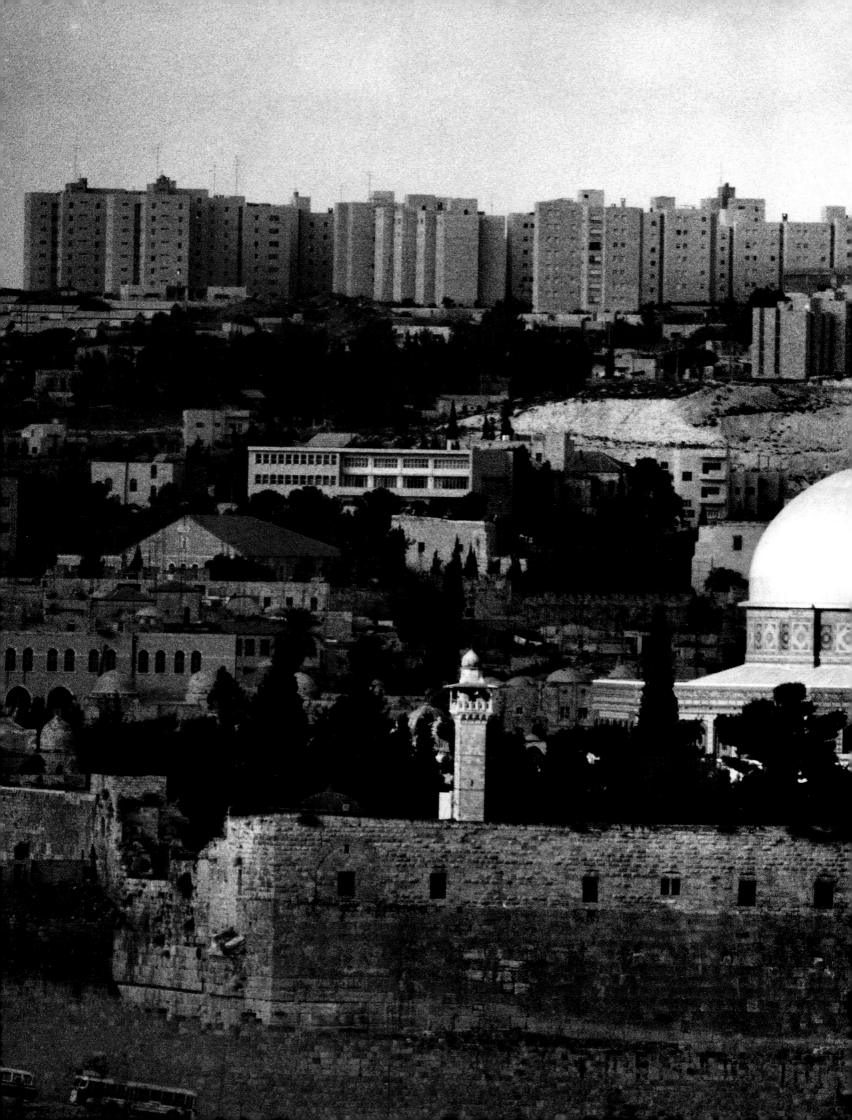

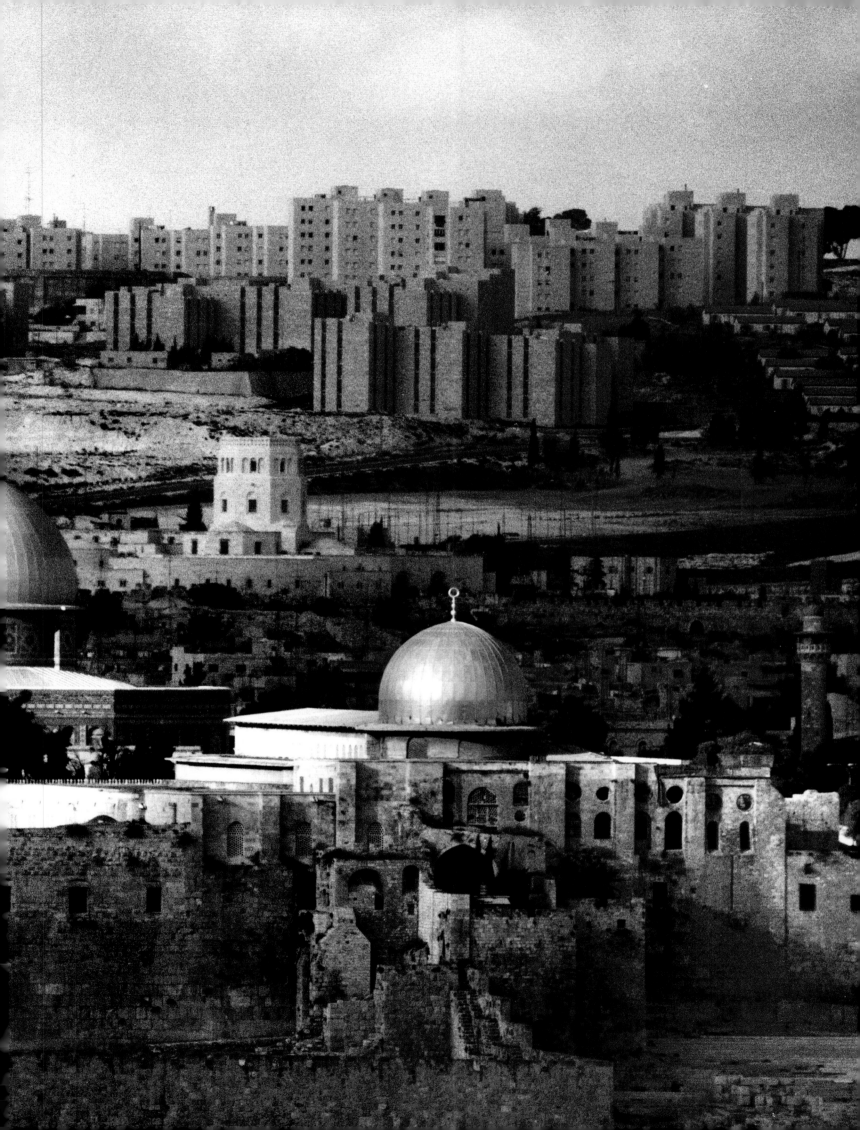

122 **Children at a**
 UN-funded school
 in Nablus
 Raymond Depardon
 1974

◄
121 **New building in**
 East Jerusalem
 dominates the
 skyline over the
 Old City
 Raymond Depardon
 1974

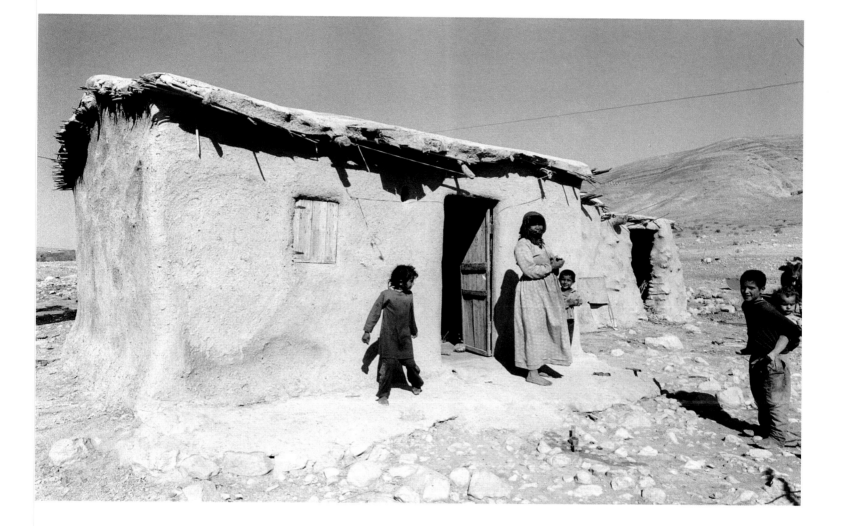

▸

124 **A retaliatory raid**
by Israeli Army
units on the village
of Hibariya,
southern Lebanon
Micha Bar-Am 1972

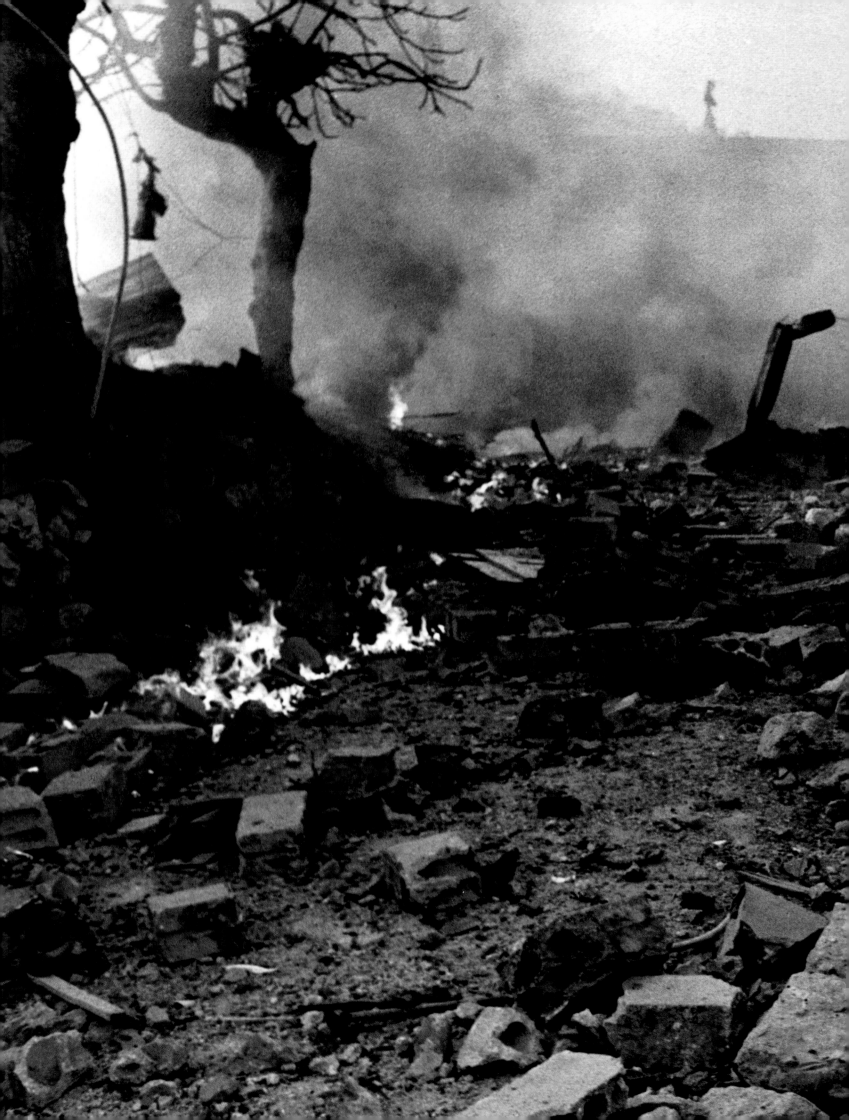

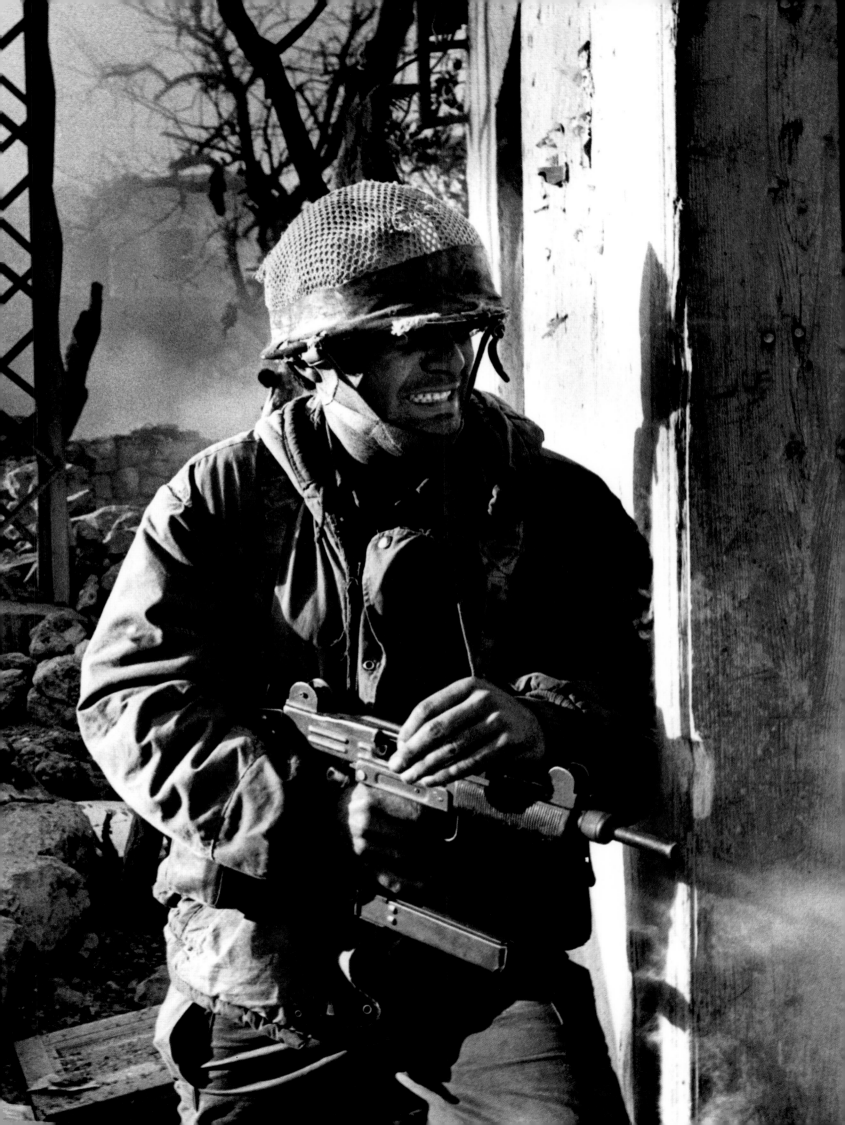

125 **Old City, Jerusalem**
Ian Berry 1976

▸

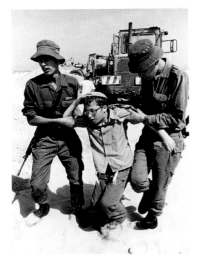

Settler under arrest at Yamit - Peter Marlow 1982

YAMIT is a settlement in the Sinai that has been signed out of existence by Camp David. I am staying in a house commandeered with seven other photo-graphers. We have all been waiting for something to happen. When I drove in, at night, I could hear the disembodied voices of two rabbis who had walled themselves inside a concrete bunker meant for artillery. It was eerie. The sound of the Torah, the night, and the army attempting to get them out.

For a while the army tried to be rid of us: they were aware that the world was watching their commitment to the peace process. We hid in the house managing to issue communiqués to the BBC about the freedom of the press; we felt we had a right to observe what was about to unfold. We knew it was about to start when we saw the army practising an assault on a nearby rooftop similar to the one the settlers had occupied as their last stand. We were witnessing siege warfare in the middle of the Egyptian desert in the late 20th century.

As soon as the action started we emerged from hiding. I had lost Jim, [Nachtwey, who was also covering the story for *Time Magazine*] but I soon saw him. I took a position on the building opposite the occupied rooftop, and Jim was there with the settlers, in the thick of the action.

The level of violence surprises me, both sides are determined, but it is clear

the settlers do not have a chance. Firstly the army spray the whole roof with foam; this gave the whole scene an extraordinary look. But what seemed like a game was a very serious and violent struggle, with an inevitable result; the settlers were finally overcome and lifted from the rooftop in steel cages, to be dragged off to waiting buses.

Partway through this whole scene, Holocaust Memorial Day occurred. On that day a siren sounded and momentarily all activity stopped. Suddenly Jews who were unafraid to exercise violence against each other in the cause of the preservation of Israel as they saw it, were united in a collective memory of greater horrors. During the minute silence, I saw a man with a long beard in a window, quietly and respectfully observing the silence. It was only when I lifted my camera to take a photograph that I realised it was Micha Bar-Am [also taking pictures for Magnum].

The sight of Micha, as well as the strangeness and solemnity of the situation made me stop and reflect on journalistic involvement. I could view and report all I liked on this conviction and this violence, I was free to find it 'interesting', but others, like Micha, as an Israeli, were living the experience.
Peter Marlow 1982

I HAD been intrigued for some time by the Lebanon. The idea of this tiny country divided into so many little fiefdoms, each controlled by militias with allegiances to political or religious factions, yet somehow under a central government. Each faction seemingly in conflict with another and each constantly changing alliances so that everyone seemed to be fighting everyone at some time. How did people live under those conditions? The random shelling, the random car-bombings, the assassinations were so cruel and so pointless. Killing to kill.

The Israeli invasion upped the stakes exponentially. Much more killing power. Somehow, I had always seen the Israelis as the 'good guys' in the mayhem of the Middle East. I had not looked too closely at the history. But they had

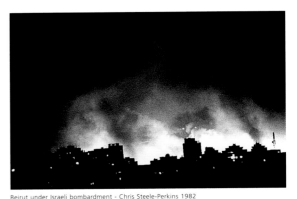

Beirut under Israeli bombardment - Chris Steele-Perkins 1982

won the Six Day War – fought off the might and aggression of the Arab world with heroic splendour. Now I was to witness Israelis randomly shelling, bombing, killing. I came to believe that they could never succeed in a search for peace by attacking their neighbors.
Chris Steele-Perkins 1982

THE FACT of my grandparents having been at Auschwitz had always remained an abstract concept for me. My father had never spoken to me about it. One simply knew – it was a slightly taboo subject, a somber period to which one ought not to look back – a mystery. I dived straight back into this mystery as the result of my experiences during a trip to Israel at the time of the first world gathering of survivors of the Holocaust. This took place in June 1981. Once there, I was driven by a desire to make a series of portraits of all these people.

Being there as a photographer was an extraordinary experience. These people had come to bear witness. They wanted to leave behind a trace of their history, and I, for my part, was there to record it.

It was an incredible summer. I saw the past reveal itself everywhere, as it were from beneath shirt sleeves. In the buses, when people lifted up their arms to catch hold of the stabilising straps, I would suddenly notice dozens of branded identification numbers.

There, I became aware of the fact that the old people's faces were the only faces that interested me. Those of the young people held no relevance. I was fascinated by the survivors because they

1978-1987

appeared to have a timeless quality.

In Israel, in France, or elsewhere, what is striking about these people is their past. This incredible past of which they will never be able to rid themselves. The present no longer matters.
I allowed myself be drawn by their expressions. I would go up to them and ask them if they wished to pose for me. Theirs was a peculiar attitude which was at the same time both exhibitionist and tragic.

A man asked me: 'Why do you want to photograph me?'

Straight away, I said 'You remind me of my father.' He thought that my father was dead, and he was very moved. And then, suddenly, I found myself opposite a close friend of my parents, a neighbor from our flat. Mrs Rosenfeld! She had been deported, and I had never known about it. My whole childhood became clear to me. I understood then that I had not only come to photograph survivors, I had also come to discover the likeness of my lost grandparents.

In 1940, my father went into the free zone by bike, with his cousin Louis. He had wanted his father to join them. His mother and his sister were supposed to stay in Paris. At that time it was said that the Germans would never touch women. My father organised everything. A friend of his, a friend from the bistro, was to accompany my grandfather by train to Lyon and help him to

Holocaust survivor - Patrick Zachmann 1981

break through the demarcation line. My grandfather spoke French with a terrible Yiddish accent.

When they arrived in Lyon, as soon as he had been paid, my father's friend denounced my grandfather to the Gestapo. My grandmother and my aunt, for their part, were denounced by the caretaker of their house in Belleville.

The three of them met in Drancy. My grandparents were transported to Auschwitz – from where they never returned.

I experienced all of this as a form of chasm that had opened up before me. I was no longer able to think of myself as French like the others. It was a friend from the bistro and a female caretaker who denounced them … Ordinary French people, anonymous people, like those with whom one mixes every day. I've been haunted by this idea: which ones amongst all the non-Jews that I know, which ones would denounce me?
Patrick Zachmann 1981

IN BEIRUT, the Christian Phalangist militias have massacred hundreds of Palestinian civilians, whose troops had just evacuated the town besieged by General Sharon. The Israeli army did not interfere, leaving them to their own devices. The names of Sabra and Chatilah – the two refugee camps – become synonymous with carnage.

I go to Israel to cover the demonstrations organised in response to protest against this massacre, for many civilians feel themselves morally responsible.

The debate rages in the street just as much as it does in the Knesset. There is no evidence of the 'gentlemanly pretence' as shown in the Parliament at Westminster. The deputies hurl abuse at each other passionately, insulting each other so vociferously that one could easily believe oneself to be in an oriental bazaar. The Israeli journalists are the most aggressive, concerned to reveal every aspect of the massacres as well as all of the details of their army's responsibility. Outside the Parliament, opponents of the war exhibit photos of children killed at Sabra and Chatilah. Is there any other

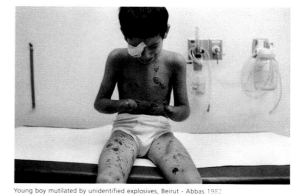

Young boy mutilated by unidentified explosives, Beirut - Abbas 1982

Middle Eastern country that exists under such a democracy?

It is at the Knesset's cafeteria that I discover, for the first time, the thousand faces which make up Israel; the Jew in a dusty black cape who appears to carry the weight of 3,000 years of submission upon his shoulders, and whose pale skin appears to reflect prolonged periods of prayer in the shadow of the Wailing Wall; the young blond, tanned soldier, so sure of his charm, whom one can imagine surfing as easily as handling a pistol or machine-gun … the gentle and expressive face of the old intellectual, who would not be out of place emerging from a Budapest library, and then the face of the young sabra, who pushes past him brusquely.

A remarkable country: one would have to invent it if it didn't exist already. How easy it would be to love Israel if it weren't for the Palestinians, exiled since 1948, then occupied and humiliated since 1967, in what the exponents of the Great Israel persist in calling 'Judea and Samaria!'

I might, myself, dream of rebuilding the splendors of the Persian Empire; does such a dream give me the right to recreate that Empire by force?
Abbas 1982

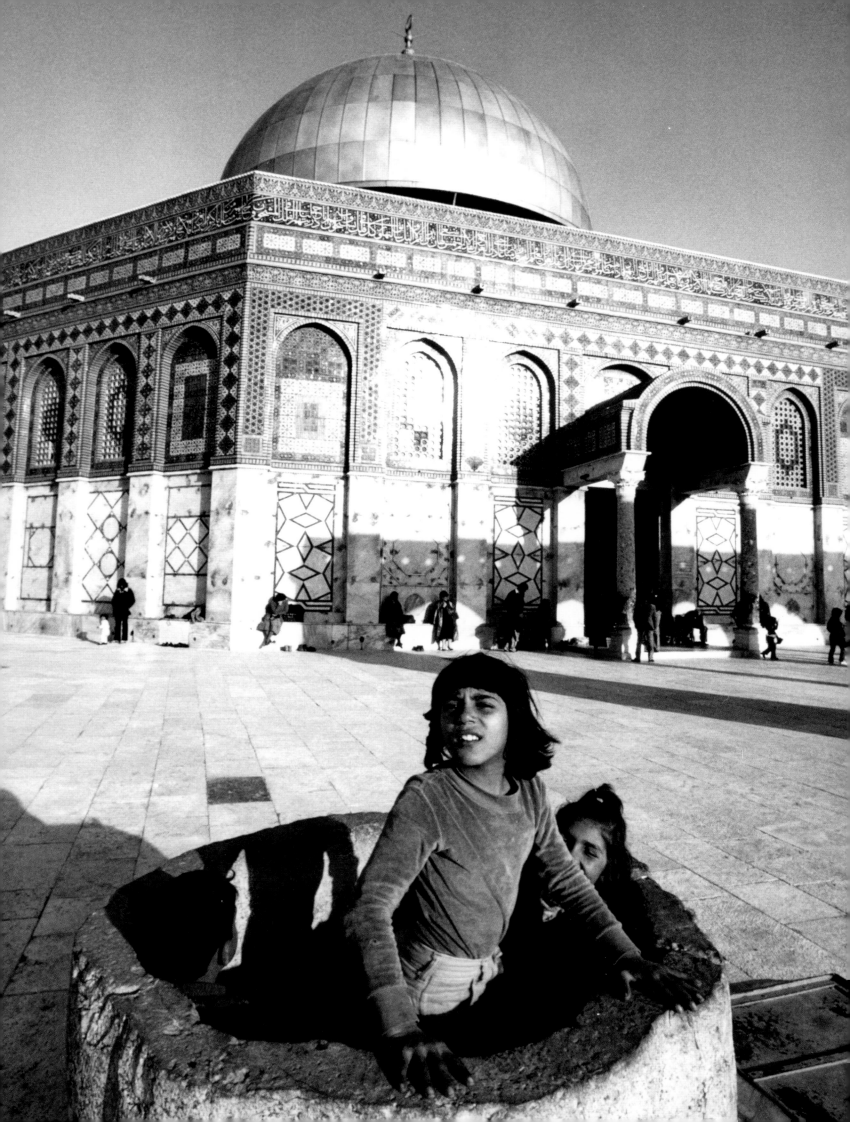

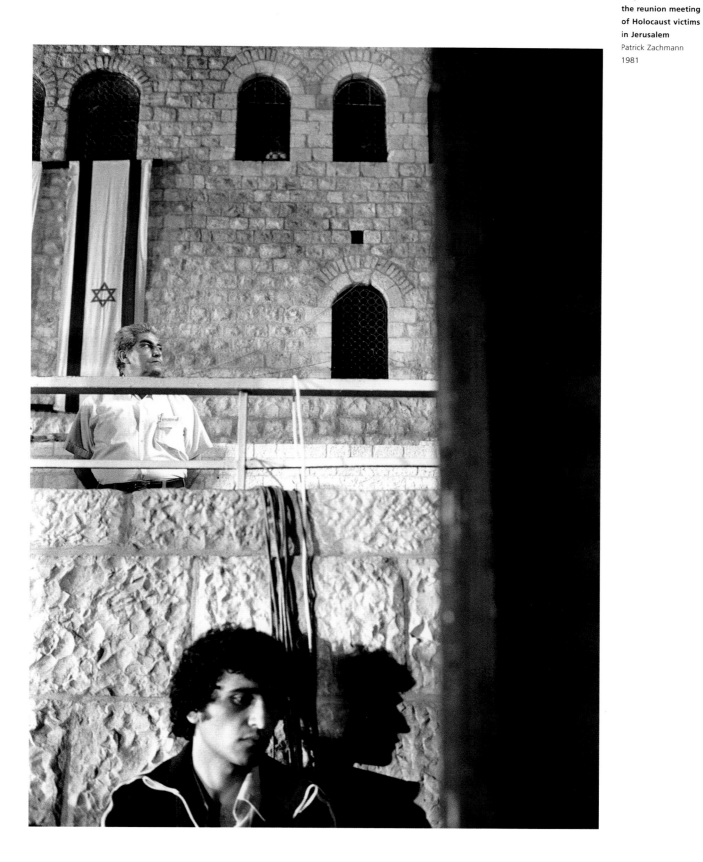

129 **Preparations for the reunion meeting of Holocaust victims in Jerusalem**
Patrick Zachmann
1981

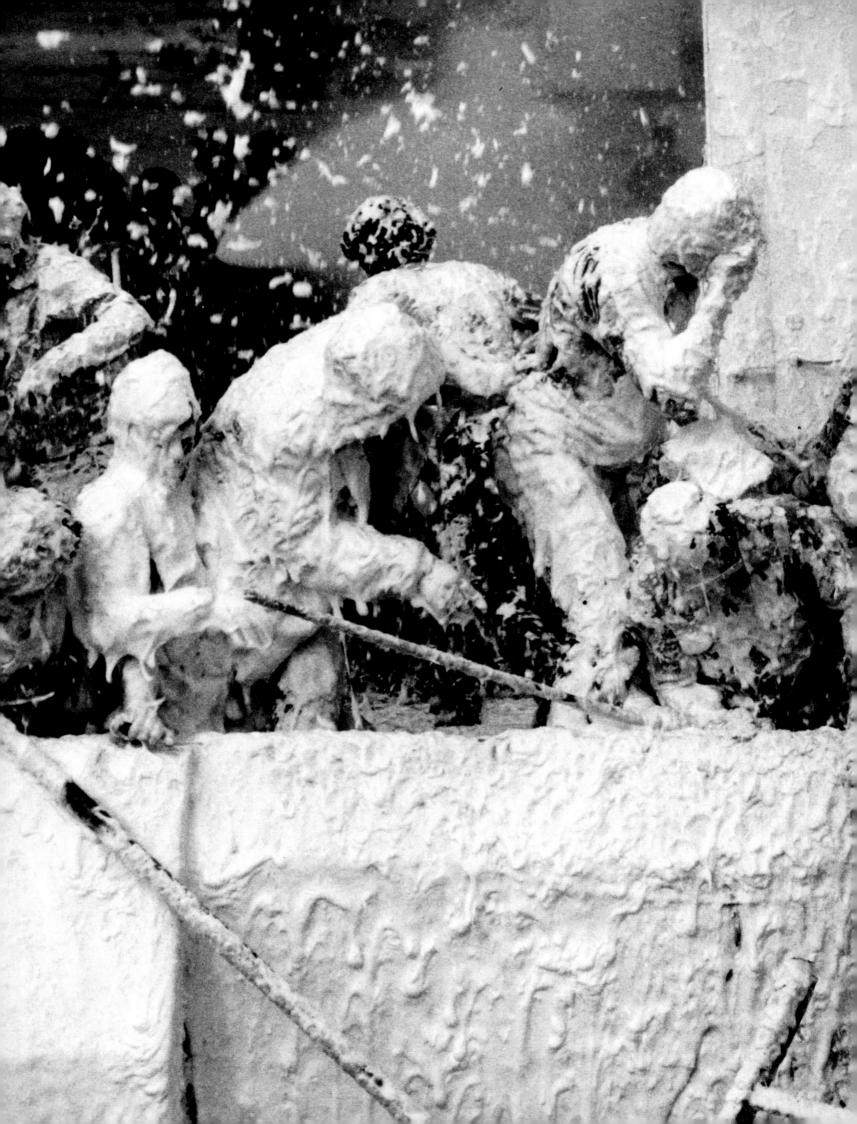

131 **Mea Sharim,**
Jerusalem
Peter Marlow 1981

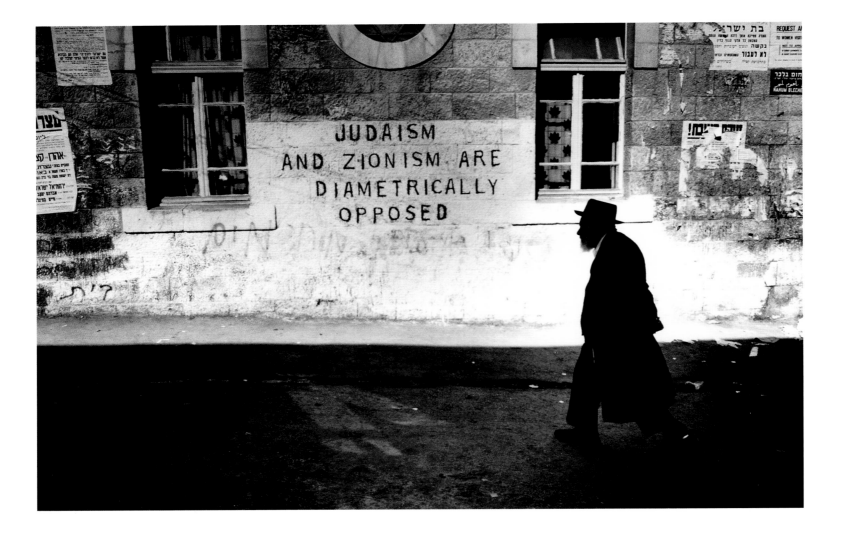

JUDAISM
AND ZIONISM ARE
DIAMETRICALLY
OPPOSED

132 **Head shaving to**
create side locks
during the festival
of Lag Baomer
Patrick Zachmann
1986

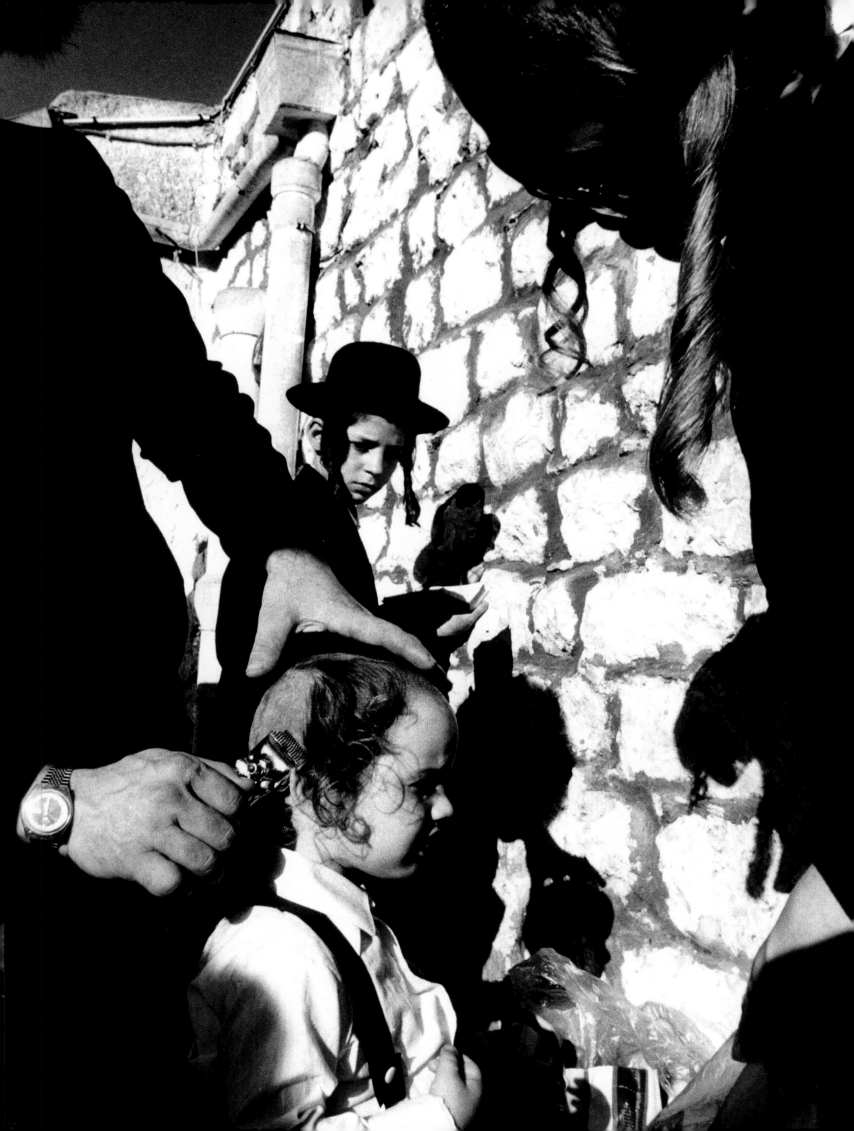

133/134 **Camp survivors at a reunion held for them in Jerusalem**
Patrick Zachmann
1981

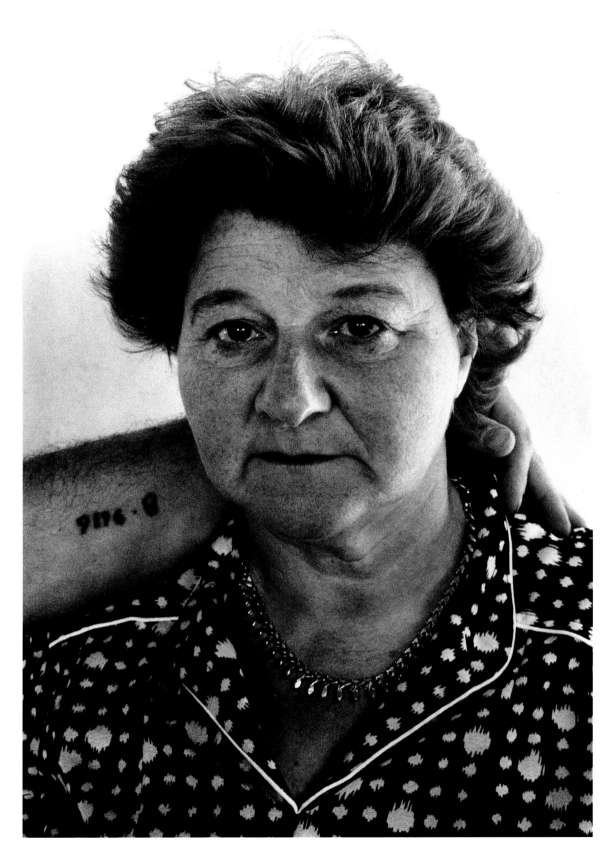

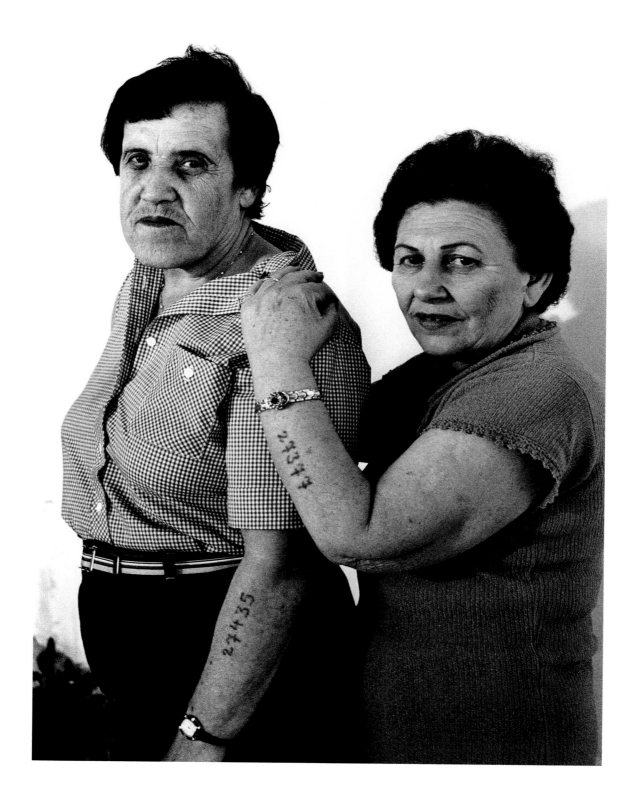

135 Hassidim, dressed
 in sackcloth, sitting
 and praying in
 protest against the
 desecration of tombs
 by an archaeological
 dig, Jerusalem
 Micha Bar-Am 1981

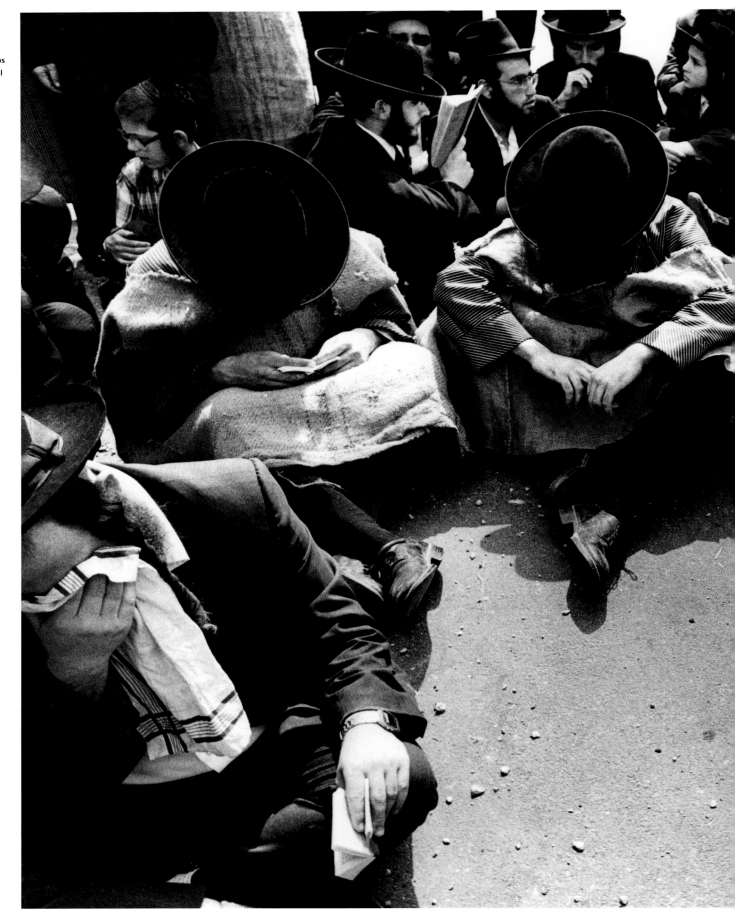

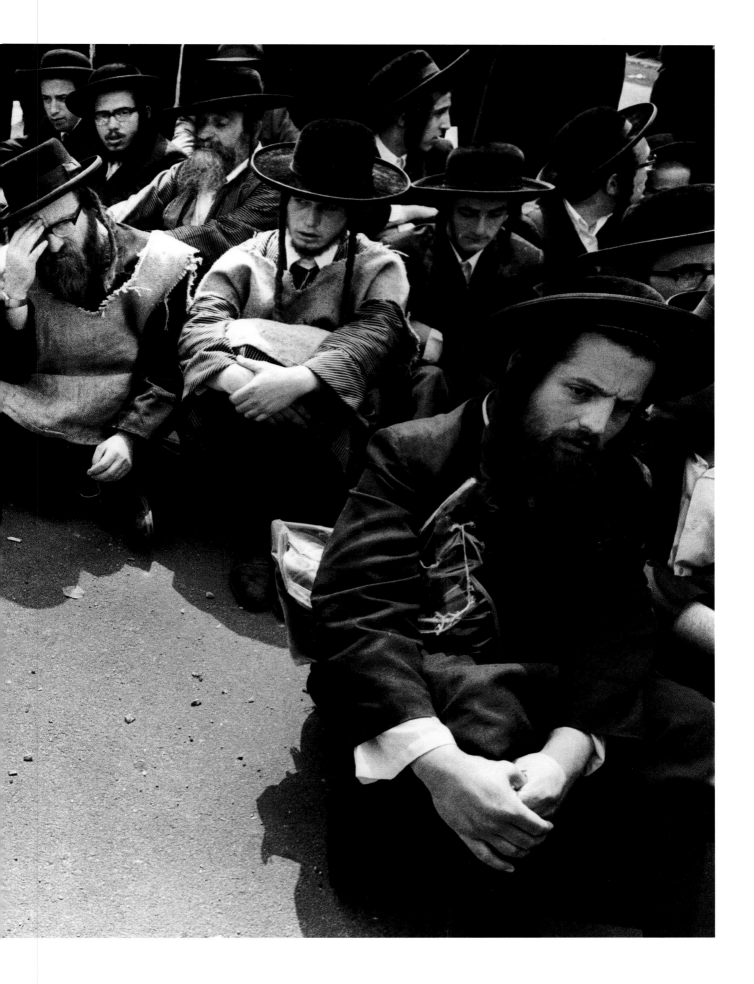

136 **An Israeli column
advances to invade
Lebanon**
Micha Bar-Am 1982

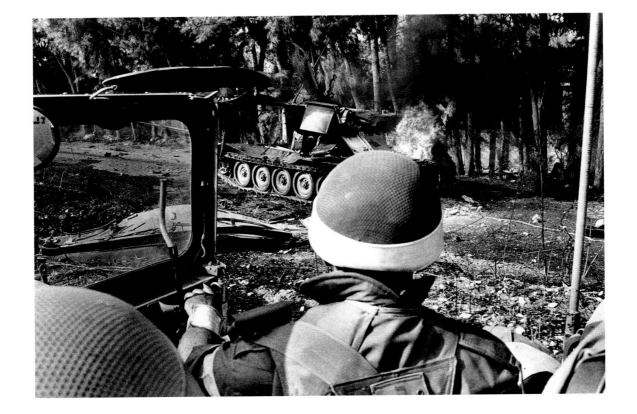

▶
137 **The Museum became
a crucial strongpoint
in the struggle for
control of Beirut.
The gun emplacement
had been controlled
by Syrians for four
years before being
taken over by the
Israelis**
Micha Bar-Am 1982

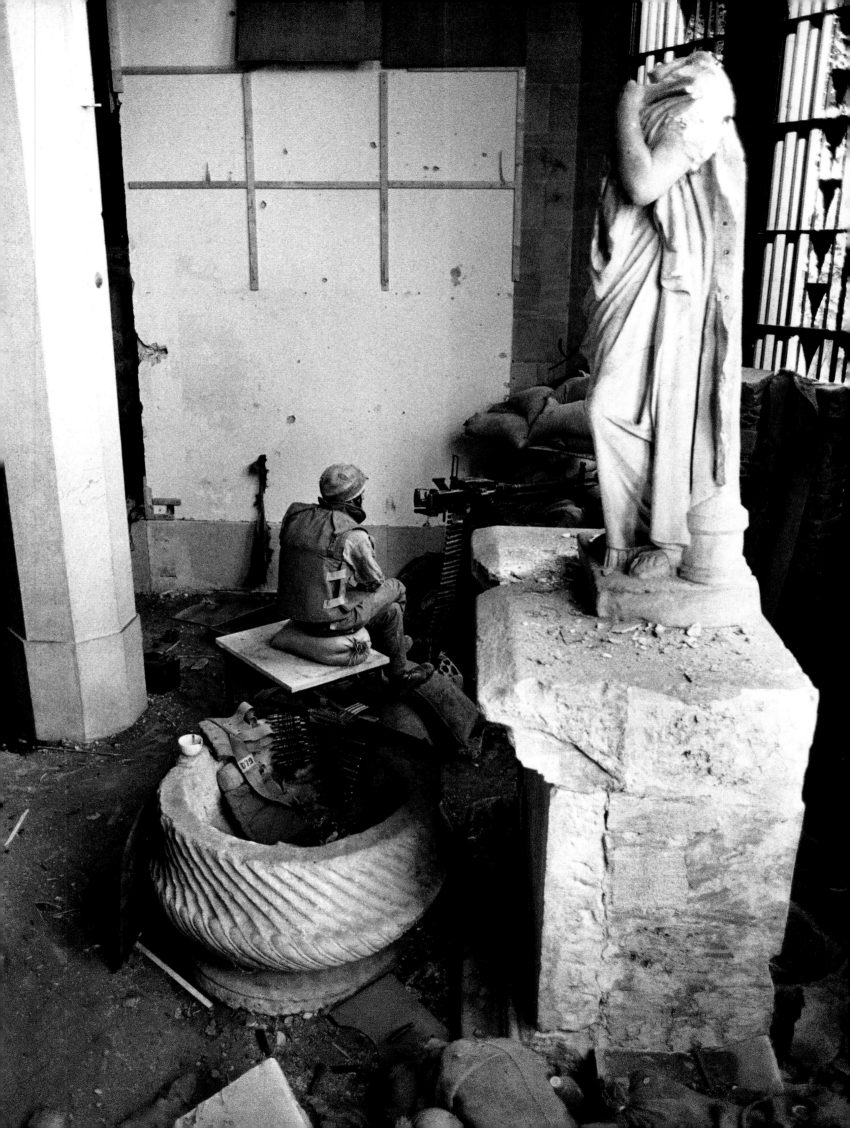

139 **Israeli troops
showing a Lebanese
Christian boy how
to shoot**
James Nachtwey 1982

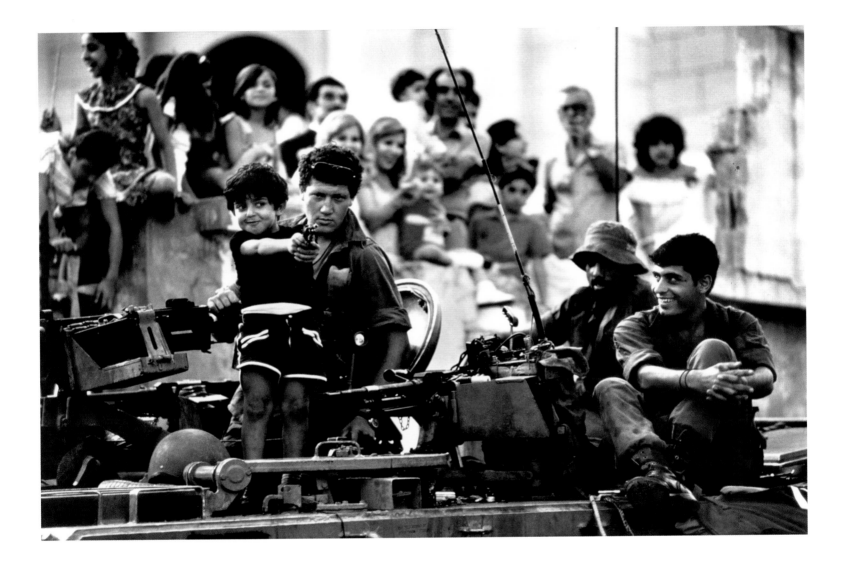

◀

138 **Sandbags at the
windows of a Beirut
hospital during the
Israeli shelling of
the city**
Chris Steele-Perkins
1982

140 **Lebanese refugees moving south, away from Beirut and the war zone, passing through Israeli lines, Lebanon**
Micha Bar-Am 1982

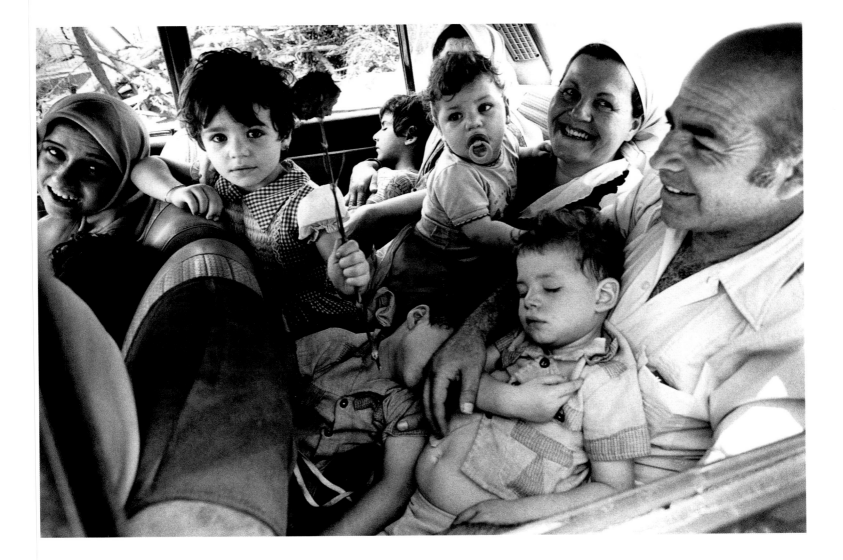

▶
141 **Shia militiamen celebrating the release of Israeli-held prisoners, Lebanon**
Chris Steele-Perkins 1985

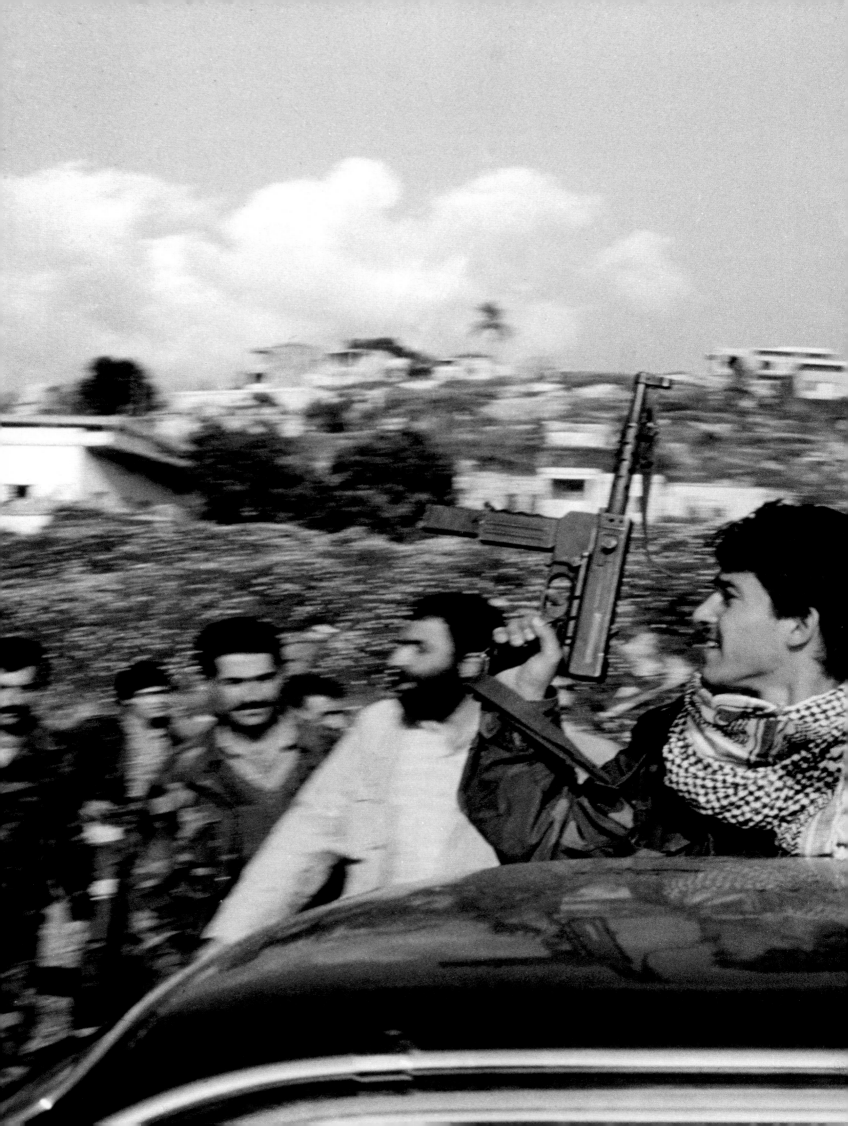

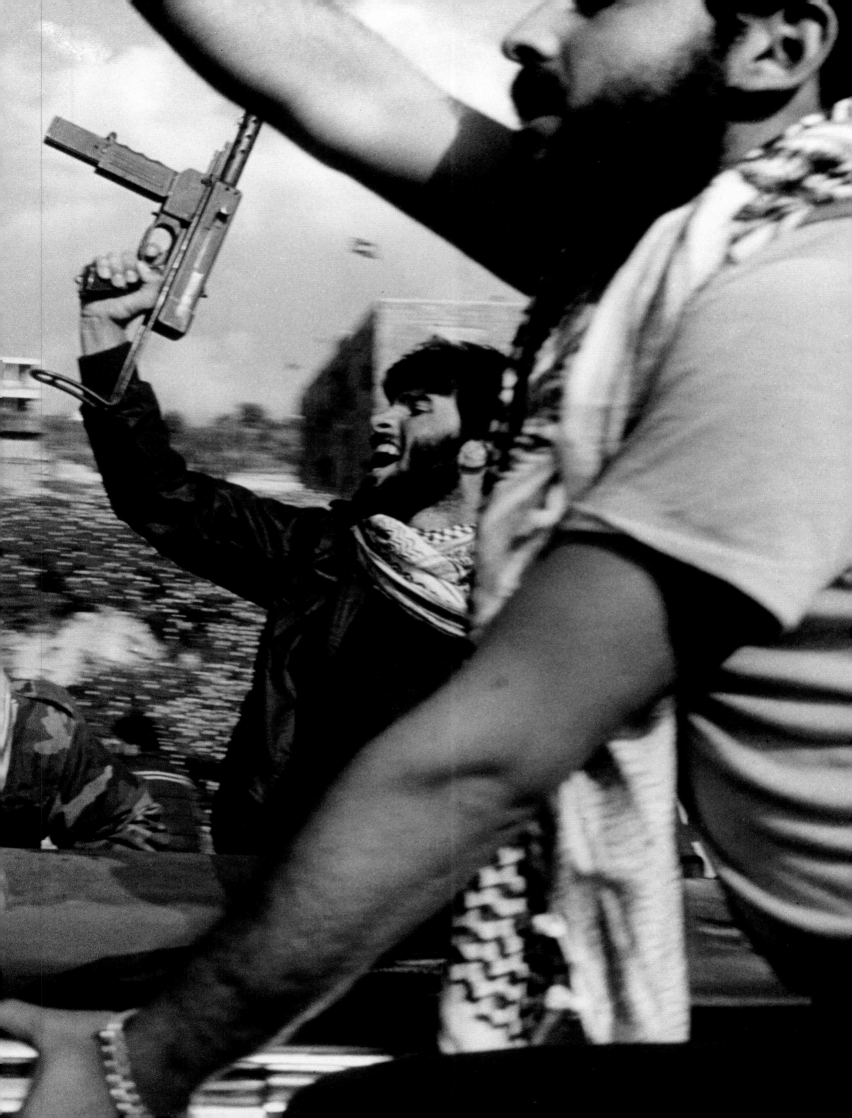

142 Rabbi Meir Kahane,
an ultranationalist
leader, at a rally in
Jerusalem announcing
his intention to enter
Umri El Fahia, the
most populous Arab
village in Israel
Micha Bar-Am 1984

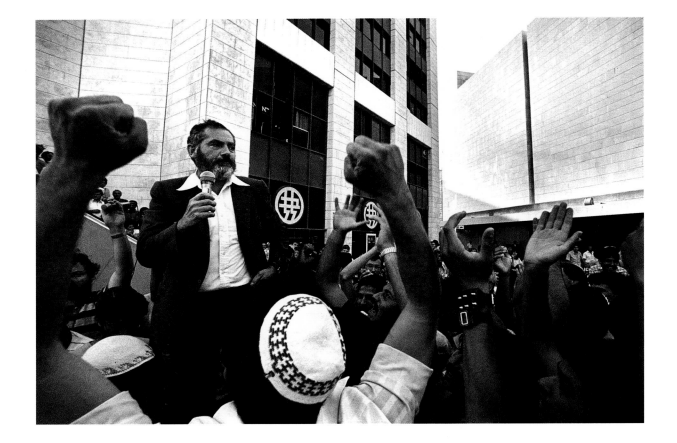

▶
143 As part of Peace
Now movements,
Israeli sculptor
Yitzhak Shmueli set
up cut-out figures
to commemorate
Israeli soldiers who
died in the
Lebanese conflict
Micha Bar-Am 1982

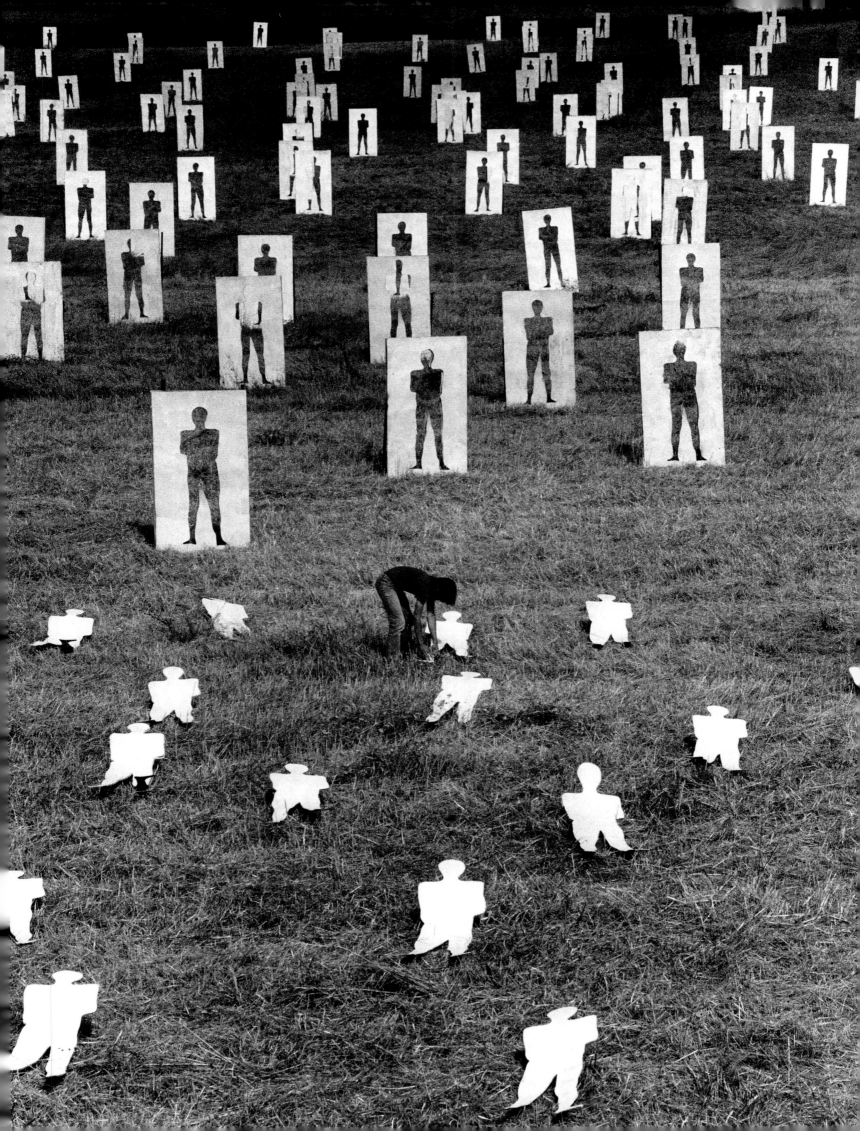

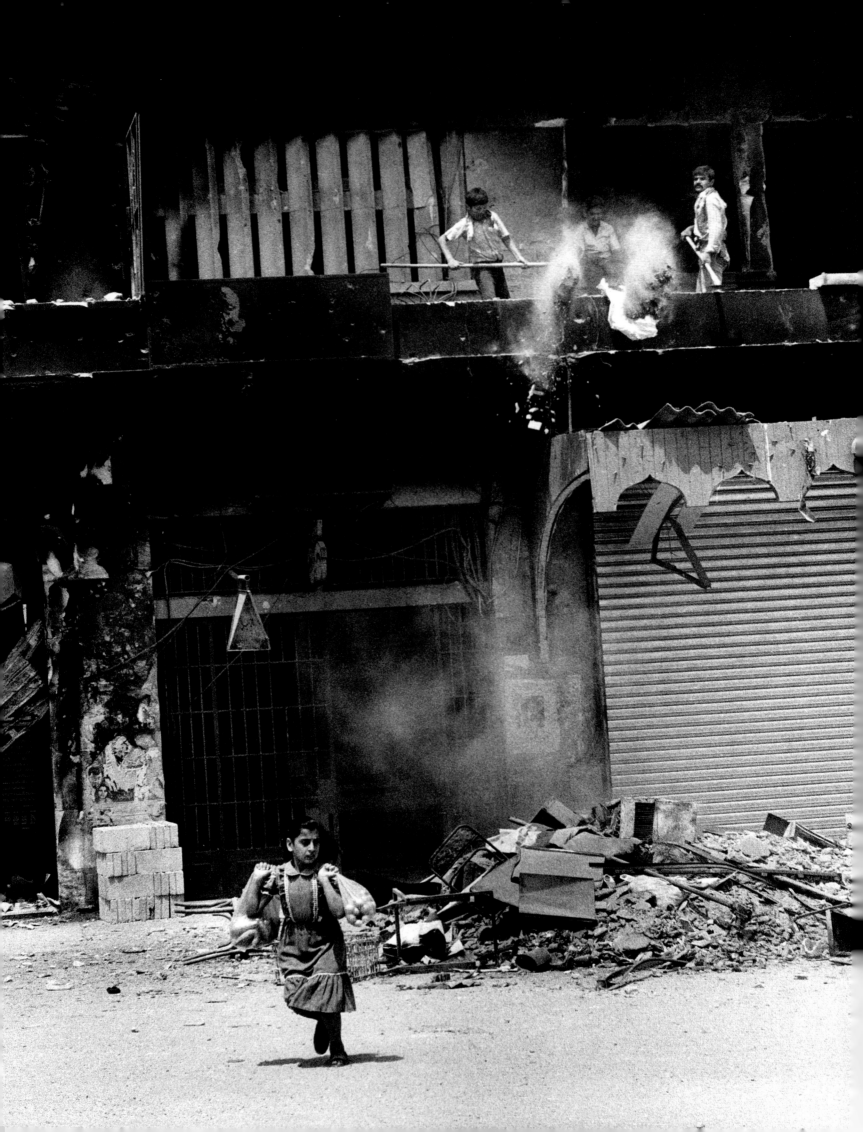

◄
144 **War damage being
cleared in Sidon,
Lebanon**
Micha Bar-Am 1982

►
146 **Scene from the
Intifadah**
Micha Bar-Am 1987

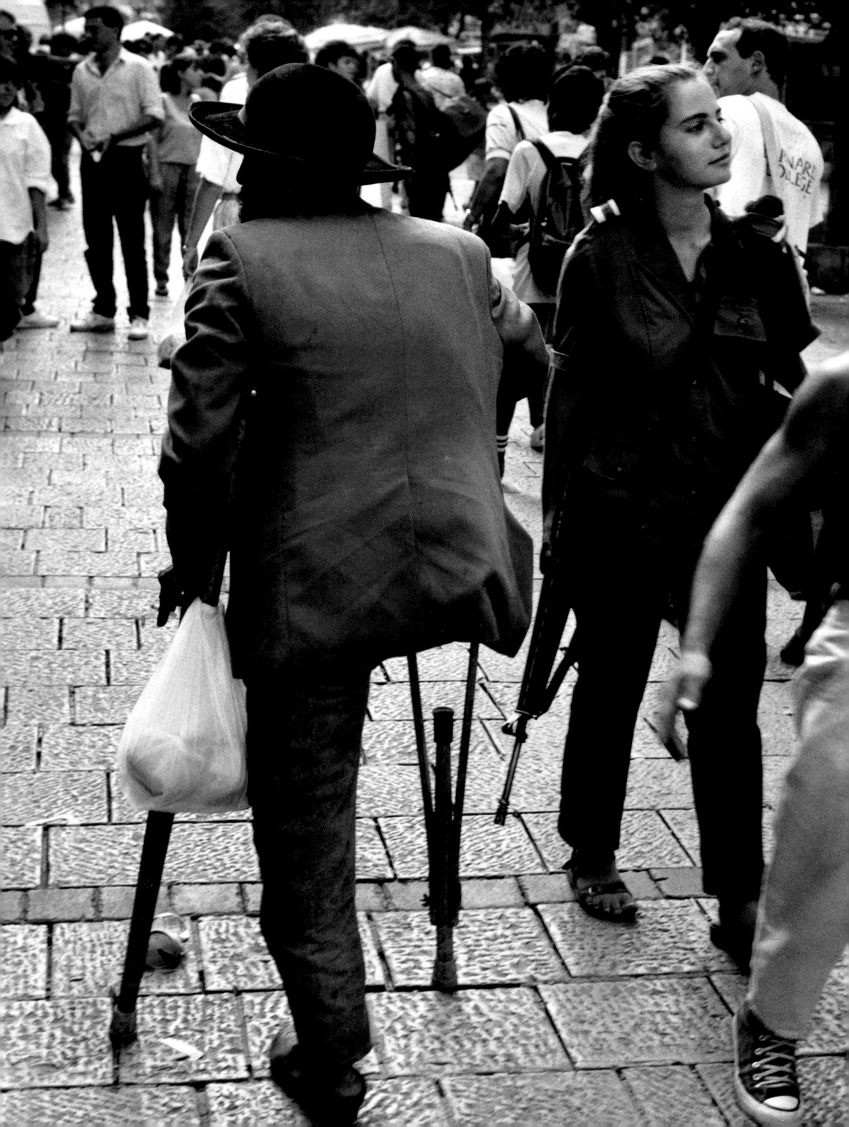

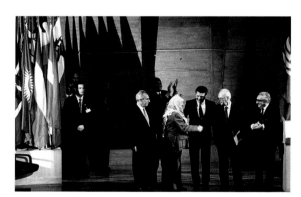

Yasser Arafat greets Yitzhak Rabin, UNESCO - Abbas 1994

YASSER Arafat, the newly elected President of the Palestinian Authority receives credentials of the Danish *chargé d'affaires*. His police present arms to them, before a bleak and hazy landscape full of débris.

The Islamic Jihad, which the nascent Palestinian Authority is fighting against, claims responsibility for two suicide attacks in the very heart of Israel. The mother of one of the two 'chouhadas', the 'martyrs', talks to the international press, constantly referring to 'our village'. However, she lives in Gaza-town. It is only after half an hour that I realise that she is referring to the village that was abandoned at the time of the 1948 exodus, and that she still considers this to be her true home; that of Gaza being, no doubt, only a temporary shelter.

How can one ask this mother to be reasonable and recognise the reality of history when so many Jewish settlers – encouraged today by the Likud, and yesterday by the Socialists – speak of the biblical David and Joshua in terms of being their contemporary cousins on whose behalf they have come to take possession or re-possession of the land?
Abbas 1994

FEBRUARY, 1993. I disembark, pass Erez military checkpoint and flag an Arab taxi into a war-damaged tin and cement block town. We are stopped by a flock of sheep at a congestion of bullock carts. A Bedouin woman with a tattooed face nudges the ewes along with a stick. Where do nomads go on a strip of land crammed with people? The street is full of potholes. It looks like an exploded

minefield. A cigarette in the driver's lips has long gone out.

Soheil brings me to his home in Shati refugee camp for a meal of lime-scented fish. His little sister carries them into the room like hearts on a platter. Her arms tremble in the fragrant darkness. In the month of fasting this is his meal of the day. Before he eats, he faces the Dome of the Rock in East Jerusalem, Islam's third most holy spot an hour and a half away. In his thirty years he has not been allowed to visit Jerusalem or to leave the Gaza Strip. Soheil prostrates on the carpet like a question mark. Mohammed's migraine. Indigestible sorrow. On the beach, a military spotlight spins like a twisting yellow eye in its socket.

Next day relatives are being processed to visit political prisoners in Ansar II. One soldier approaches me and asks what I'm doing. 'Not breaking the law,' I say.

He whispers, 'You know, if I were these people I'd be doing more than throwing stones.' His comrade is separating families with the butt of his rifle.

September, 1993. Two bitter enemies shook hands on the White House lawn after months of secret negotiations in Oslo, hosted by Norwegian Foreign Minister Johan Jørgen Holst, and others.

I arrive at night in Gaza City amid a sea of flags. Flags are silkscreened onto shirts, suspended above children's bicycle seats or wrapped like bedsheets around adults. A thirty foot flag hangs from the army watch post across from the mosque in Palestine Square, replacing the Star of David. Days ago, ownership of this flag, even as a handkerchief, was punishable by up to ten years in prison. Three helmetted Israeli soldiers stand under a streetlight cradling their guns, senseless and stunned. Then, a bearded butterfly of a man wraps his arm around one and kisses him on the cheek. The soldier's rifle hangs limp, his eyes, glazed like a brilliant insect's.

June, 1994. In the Old City in Jerusalem, at the Western Wall,

Gaza - Larry Towell 1993

swallows somersault in the sky. They nest in cracks between the giant stones cut centuries ago by Hebrews. Below them, minuscule prayers have been written onto scraps of paper, rolled up, and pushed into the cracks at human level. Prayers of repentance or prayers of request? The beauty and the mystery of speech linger on human breath. Then a Muezzin begins to chant through the loudspeaker on the nearby Dome of the Rock mosque. Israel controls the streets, but Palestine controls the air.

An Israeli I recognise as a soldier from Gaza is holding his skullcap to his head running down the Via Dolorosa toward the Wall. He had stopped me from entering a refugee camp during a military operation. He slows now in mutual recognition and briefly pauses ... 'It's beautiful here. Calm,' I say. He agrees. Then he breaks off in a trot. What was he about to say had he not been late for prayer? Who was that man now running through the crowded street of Arab children? A Christian tour group wanders by singing hymns to the Virgin, caught between the postcard rack and the needles of rain.
Larry Towell 1993

THE SOCCER field is a dust-covered, hard dirt area in Jericho, beaten by the sun. The crowd has gathered, fans crowd around the edge of the marked field, and set up a deafening roar, constantly enriched by the ear-splitting rhetoric that pours from the public address system. The cause of all the excitement was the first international soccer game

1988-1997

in the occupied territories. The team from France – I had no idea how or who – had arrived, and were ready to play, but the overexcited crowd held up the game for two hours amidst a jostle of PLO flags and colors: the once forbidden flag now being waved in support of a soccer team.

Bunches of happy boy scouts were marching to drums and bagpipes, stirring up even more dust. There were women and young girls, too, among the gathering crowd, though soccer still remained clearly a man's sport. The crowd gradually took their places on the two long bleachers that stretched the length of the ground, some way behind rickety cyclone fencing topped with barbed wire. But there were people everywhere, standing on plastic chairs, dangling from the tired fences like wind-blown litter.

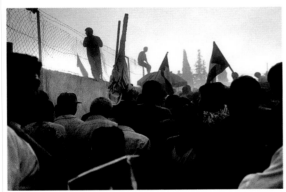
Spectators at a football match, Jericho - Paul Fusco 1993

The game began, and as it progressed the dust rose ever higher. The players appeared as eerie ghost-like figures, casting haloes whenever they were back-lit by the scorching sun. There was only one goal, and it was scored by the Palestinians. The score created even greater pandemonium, but not everyone was overtaken by the excitement: towards the end of the game I noticed an old man on his knees among the crowd, praying towards Mecca.

When the game ended, with the score confirmed, the jubilation was universal: the scorer was hoisted on shoulders, flags were waved in a fury, small boys gathered around the heroes of the game. The crowd dispersed,

still noisily, into the dusky dust to join a three-hour traffic jam. Palestinians had joined one more element of the modern world.
Paul Fusco 1993

IT WILL soon be 50 years since, on 14 May 1948, I crouched on the rooftop of the Haifa Port Authority building, among the scores of British top brass to watch the dramatic lowering of the Union Jack and the farewell salute on the departure of the commander of the British forces. That moment brought to an end almost 40 years of the British mandate over Palestine, the Palestine where I had grown up after my parents had left Germany in the 1930s.

I noticed particularly a photographer who was dressed in battle fatigues, moving through the flags and the bands to shoot from every angle as the boat departed; our eyes met as he shot into the crowd. Many years later, I saw the photograph he had taken at that moment: I was preparing an exhibition of Robert Capa's work for the Tel Aviv Museum of Art, and Cornell and Edie Capa were going through his take from that time, when we came upon an image of myself at seventeen, among the crowd on a momentous day.

It was clear from his demeanor, and from his work, that Capa was moved by those events, and felt strongly about the struggle to create Israel; he spent much time there, photographing the moving scenes of Jewish immigration. While he photographed the emerging state, his colleague and co-founder of Magnum, George Rodger, was depicting the exotic Arab Legion, and the conditions of the Palestinians, whose own diaspora had just begun.

While my work has taken me on assignments all around the world, I always return to what I have come to see as my life's assignment – sharing and recording the conflicts and contradictions of modern Israel, coming to terms with the professional dilemma of being an insider and yet a critical observer – constantly hoping

Israeli family during the Gulf War - Micha Bar-Am 1991

that perhaps some of the images I capture will move people to do better, to recognise their common humanity.

Sometime during the 1970s I came across one of Robert Capa's photographs in a brochure. Obviously some researcher had misunderstood the captioning, because the brochure was about the plight of the Palestinian refugees, but the picture was one that appears earlier in this book of a barefoot little girl, crying in a transit camp for newly arrived Jewish immigrants. It is a great photograph of a universal human condition; there is a sweet irony in its misuse, it creates a gentle pressure upon us all to recognise that we should think and act together, the sons of Abraham and Ishmael, the daughters of Sara and Hagar.
Micha Bar-Am 1993

149 **An Arab child and
Israeli soldier after
a demonstration
by Israeli settlers
in East Jerusalem**
Larry Towell 1993

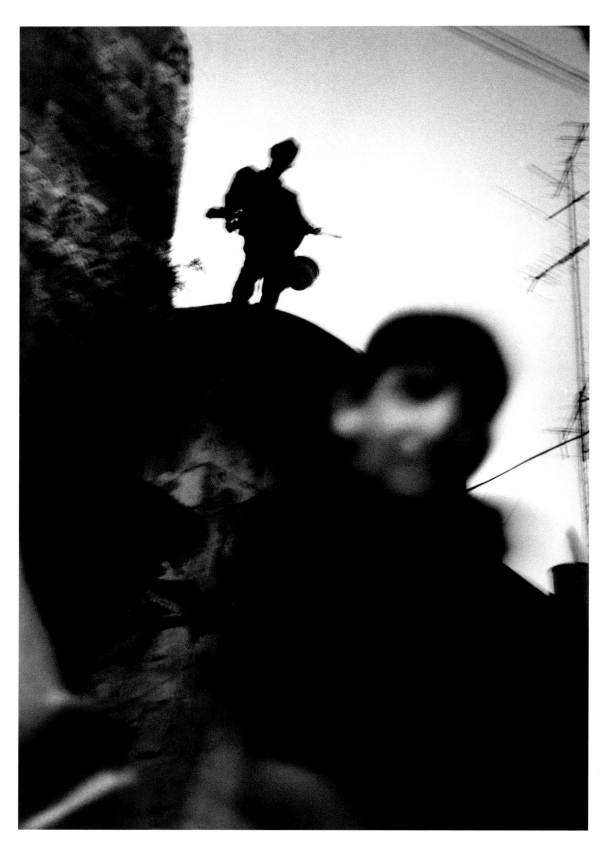

150 **Palestinian graffiti,
 Jerusalem**
 Paul Fusco 1993

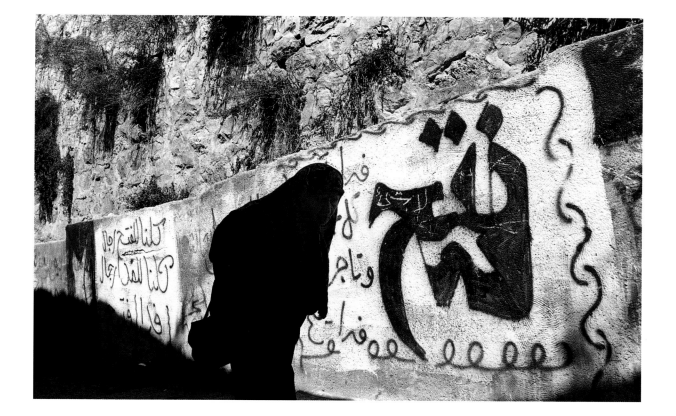

▶
151 **Palestinian youths
 throwing stones
 at Israeli soldiers
 in Gaza City**
 James Nachtwey 1993

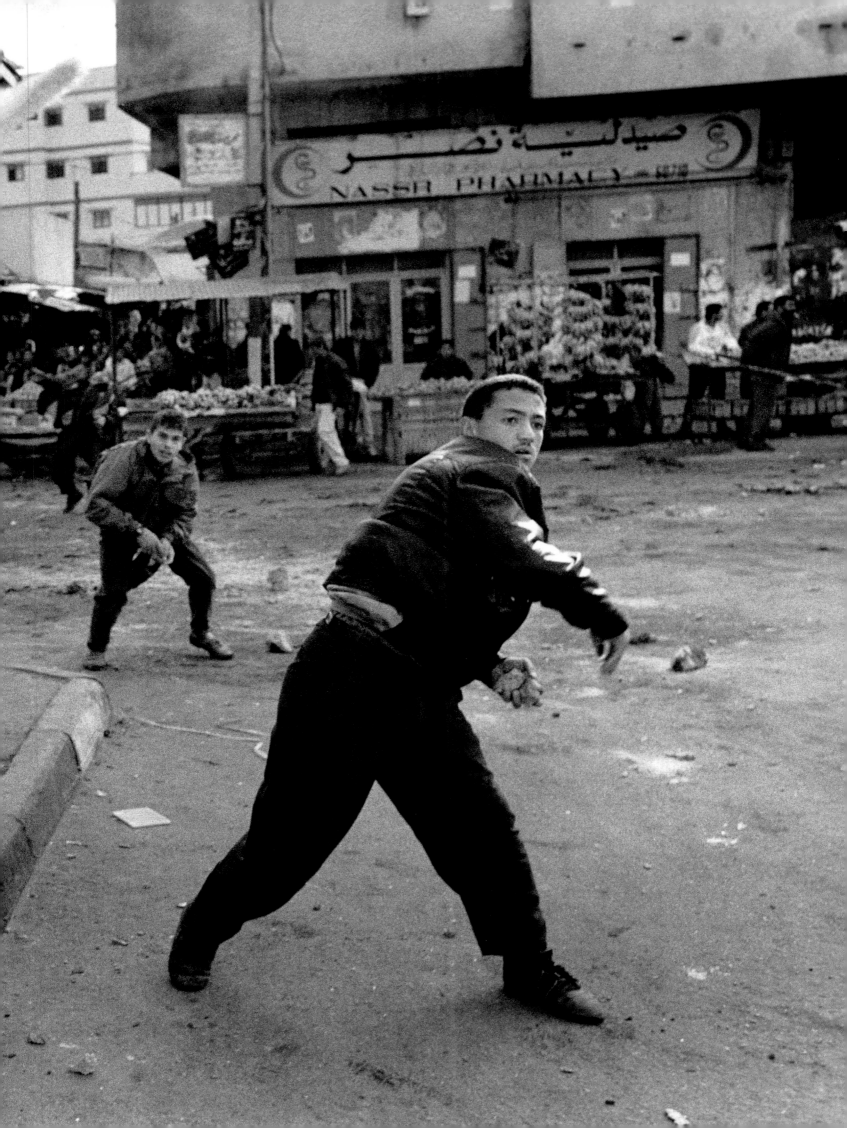

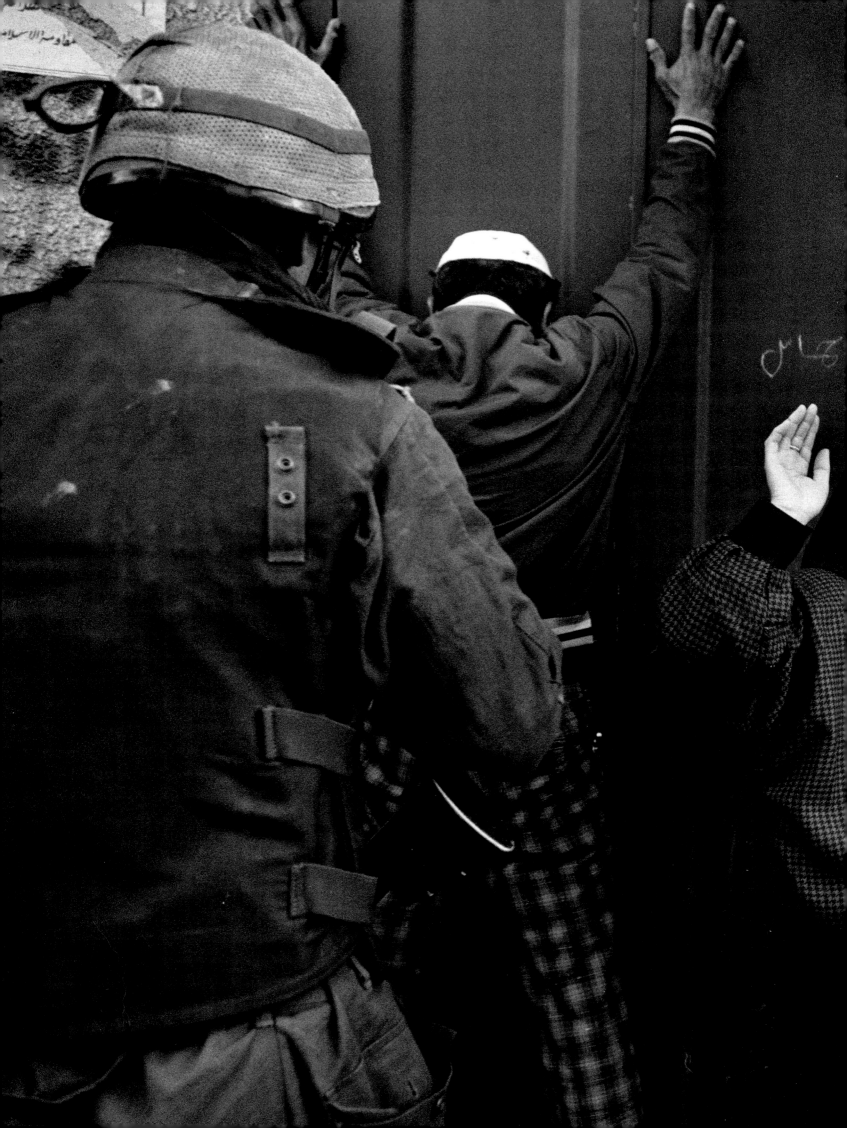

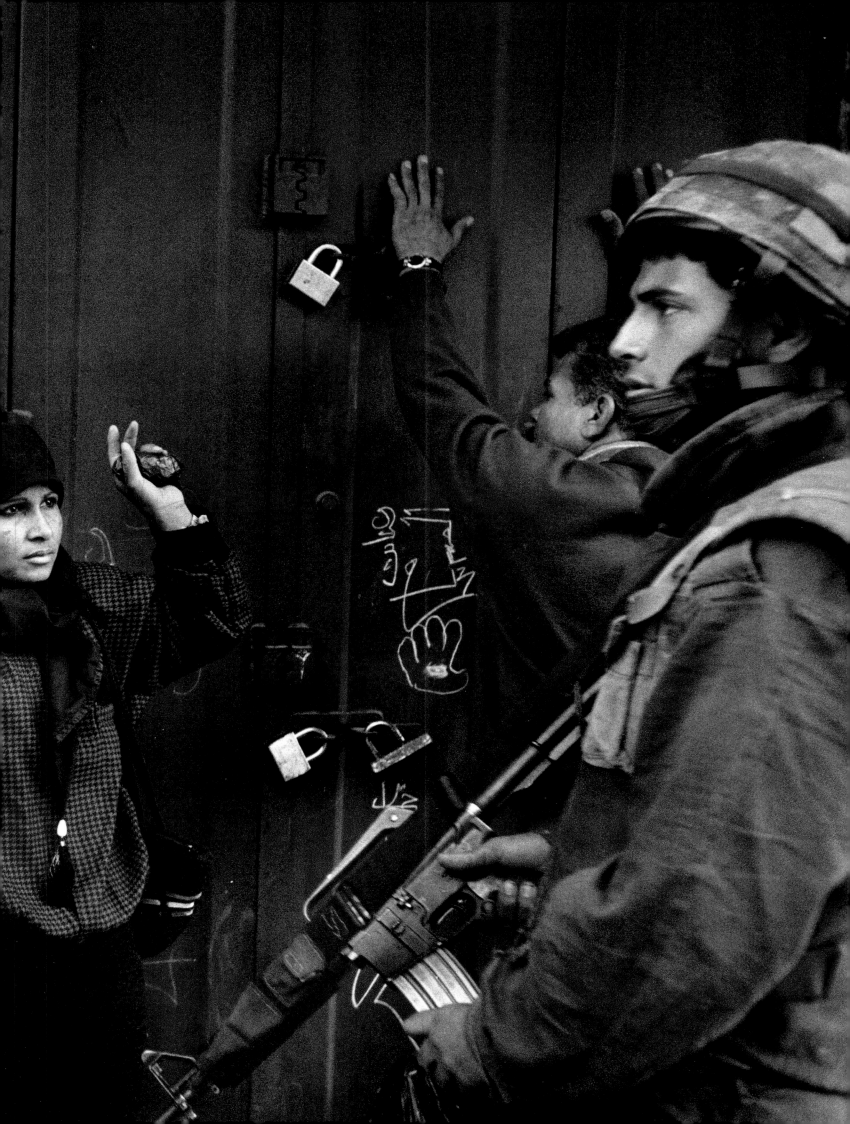

153 **After the signing of peace accords, people flee as Israelis fire on stone throwers in Gaza**
Larry Towell 1993

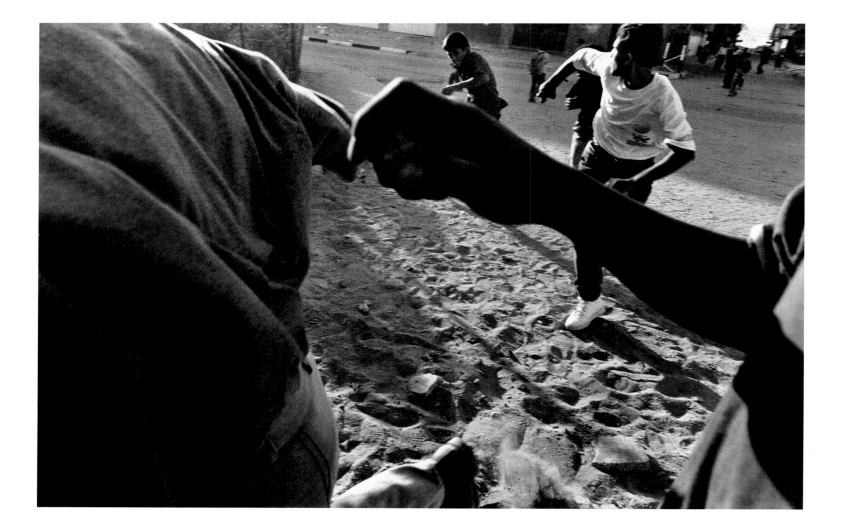

◂

152 **Israeli soldiers searching Palestinian citizens in Gaza City**
James Nachtwey 1993

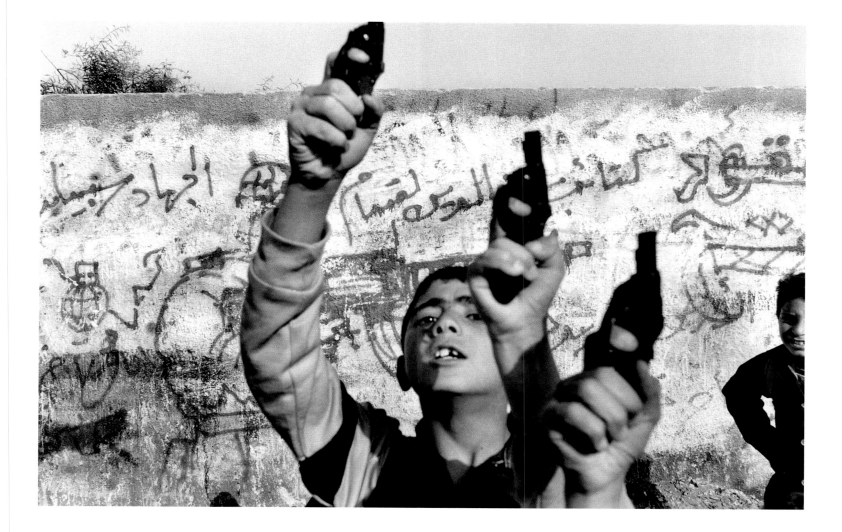

155 **A would-be suicide bomber, aged twenty, is held in custody by the Palestinian authorities in Gaza**
Larry Towell 1996

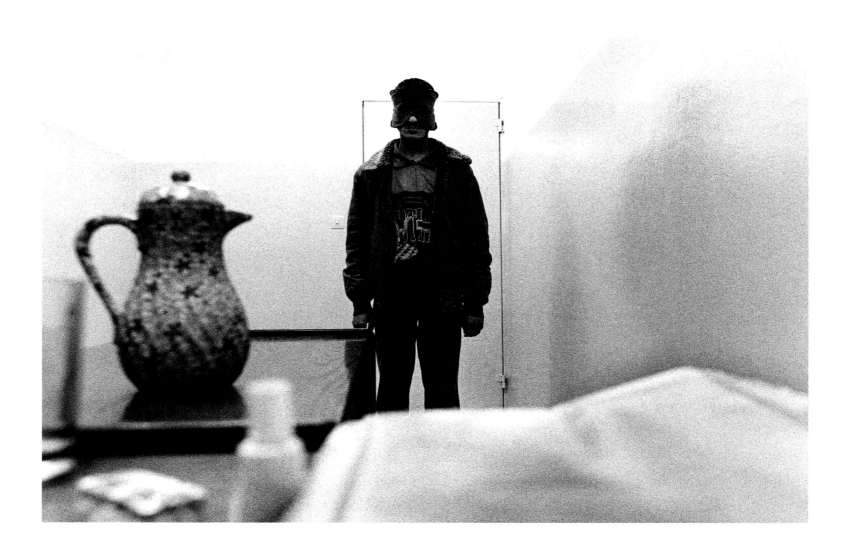

156 Setting up the
staging of a peace
rally in the Jabalya
Refugee Camp
in Gaza
Larry Towell 1993

▶

157 Palestianian brothers
in the ruins of their
house in a refugee
camp in Gaza,
destroyed by the
Israeli army because
of suspects next door
Paul Fusco 1993

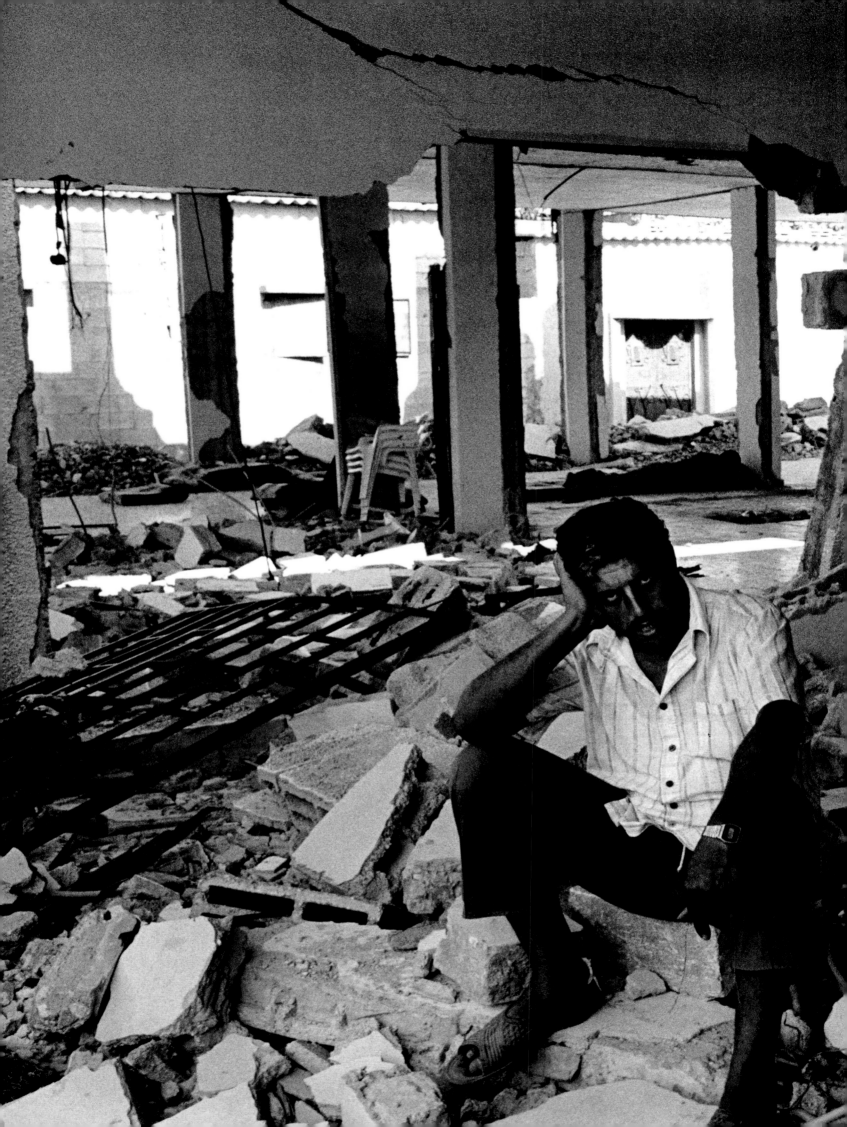

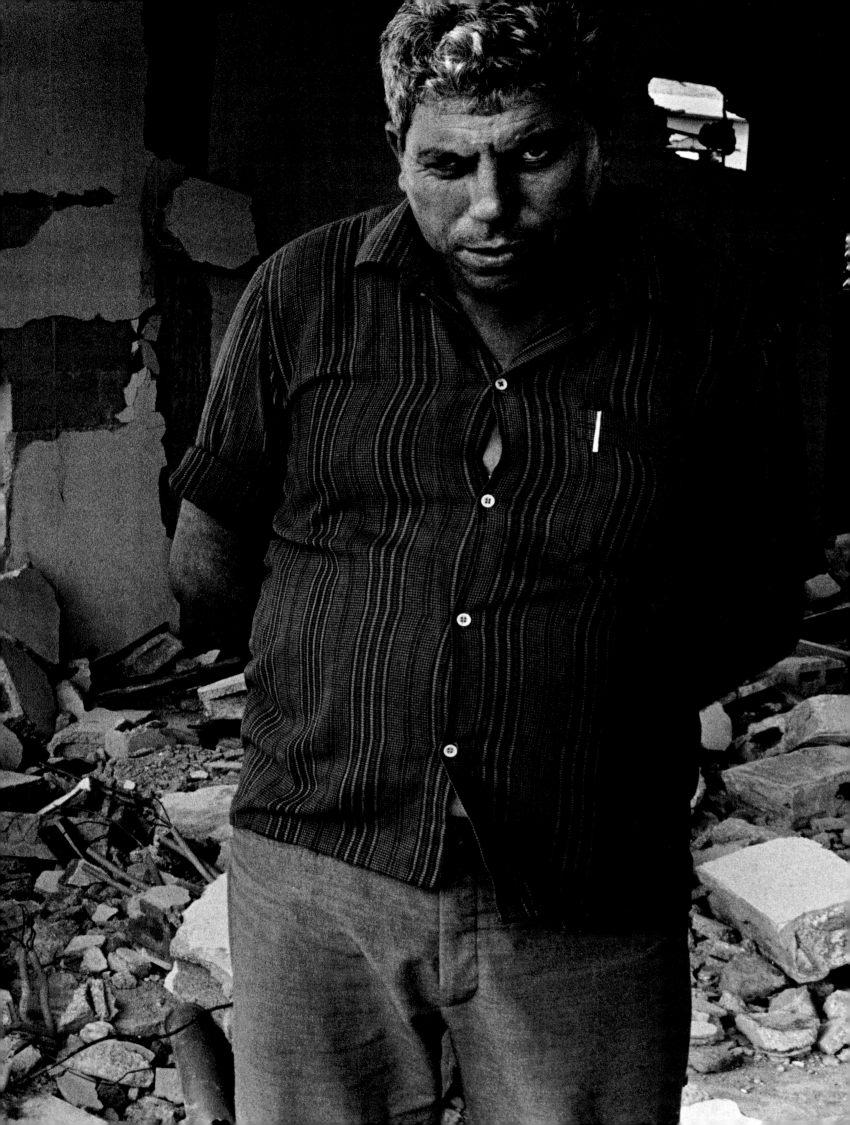

158 **Crowds waiting to pay their last respects to the assassinated Yitzhak Rabin, Jerusalem**
Abbas 1995

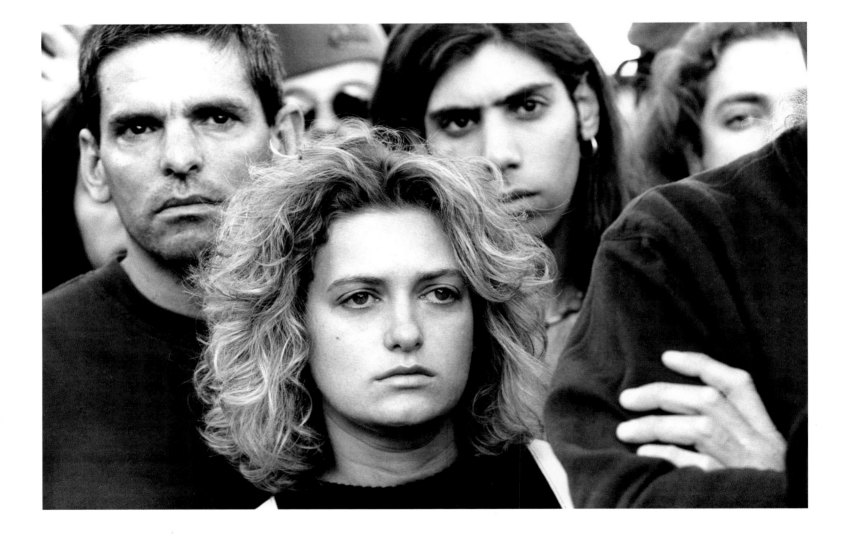

159 The body of a
young Palestinian
killed by an Israeli
private guard,
paraded around
the Dome of the
Rock before burial
Abbas 1995

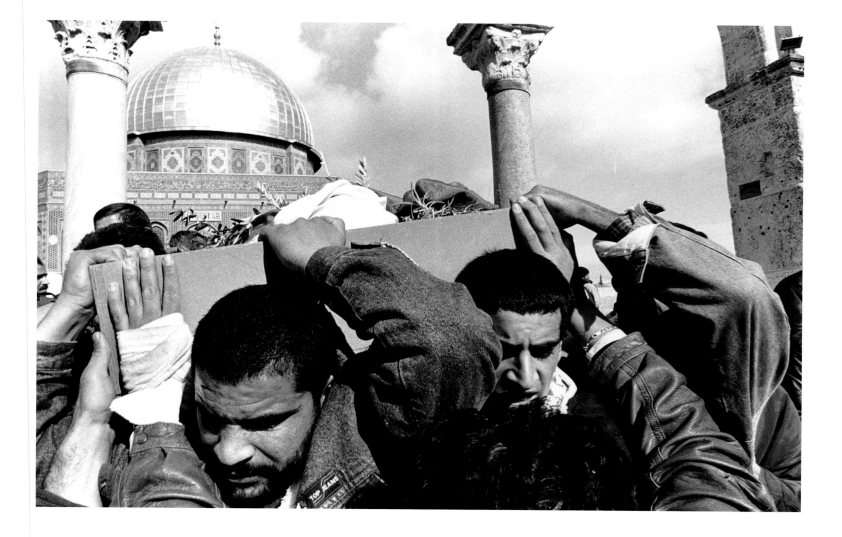

160 **Israeli patrol in the
Old City, Jerusalem**
Susan Meiselas 1994

Security guards, in and out of uniform, await a visit by Ariel Sharon to his apartment in the Old City, Jerusalem
Patrick Zachmann
1990

162 **An Israeli
demonstration
against the creation
of new settlements
in occupied territory**
Leonard Freed 1989

163 **Arab children watch
a demonstration
by religious Jews
as it passes through
the Old City**
Leonard Freed 1989

▸

164 **Orthodox Jews
search for disinterred
human bones as a
religious duty at an
archaeological site
excavated for a new
hotel in Jerusalem**
Larry Towell 1997

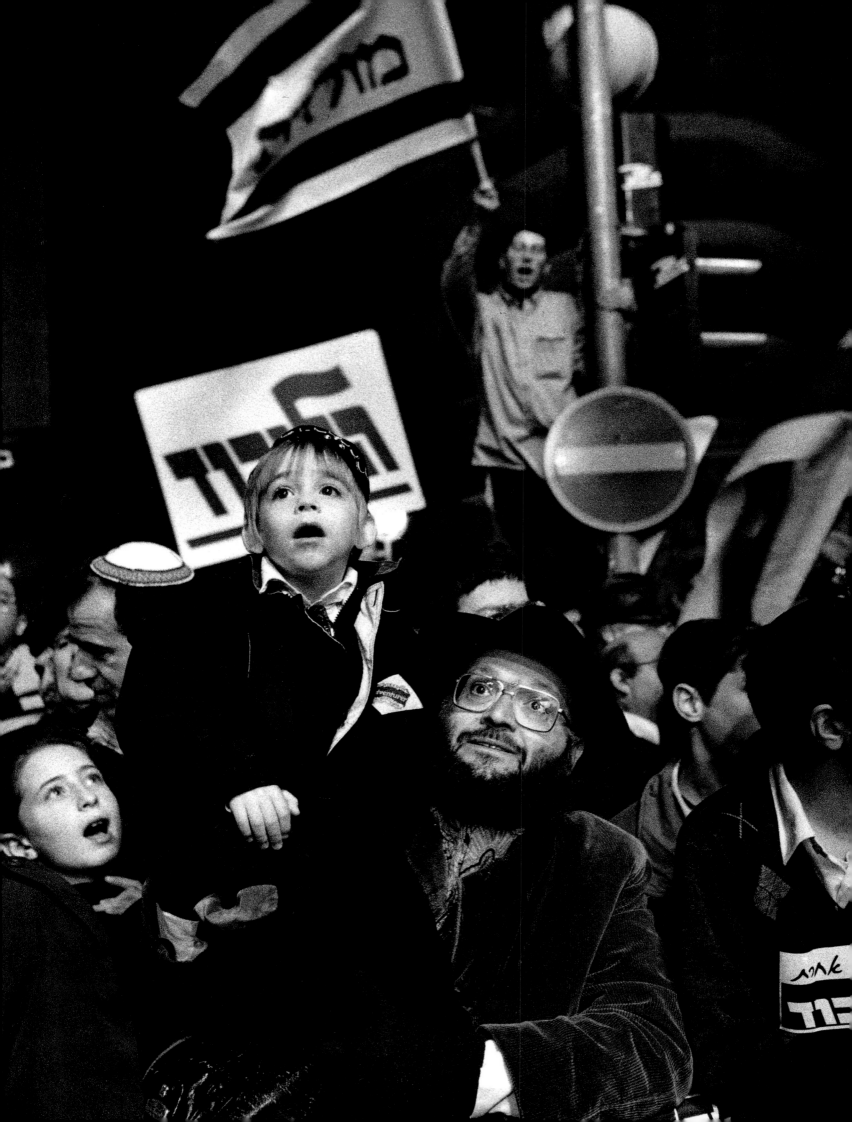

167 **Mudbath treatment
at Ein Gedi on the
Dead Sea**
Carl de Keyzer 1997

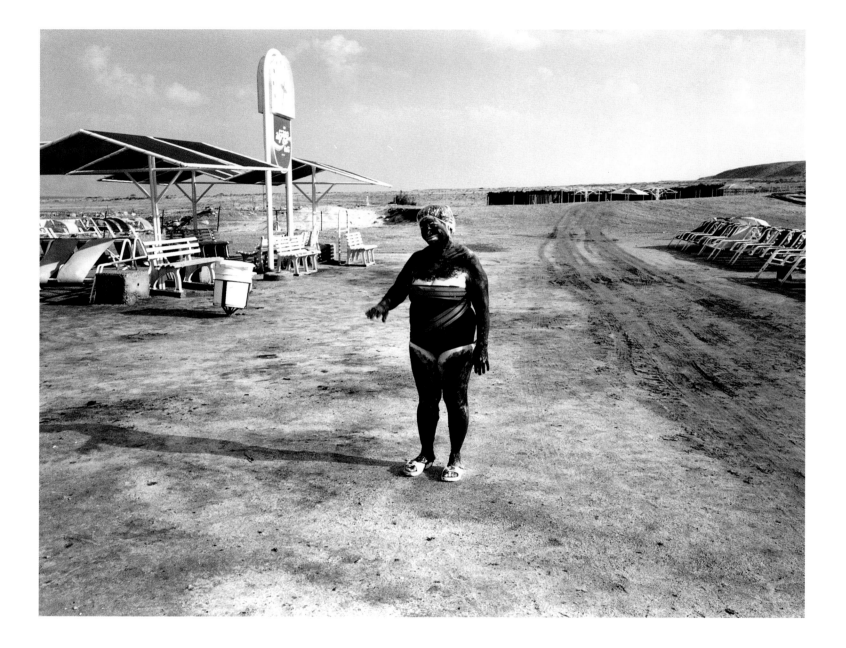

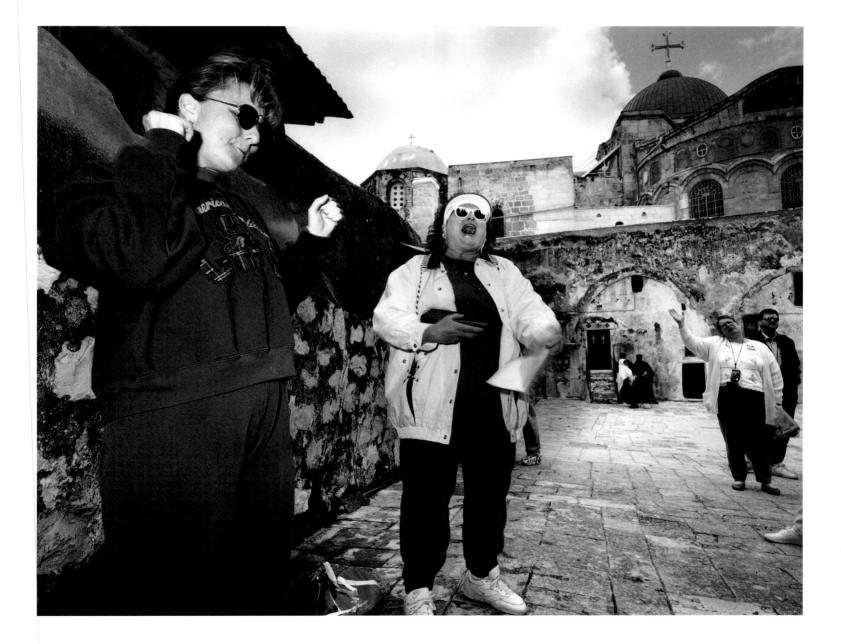

▶
169 **Palestinian boys
in the only
poolroom in Beit
Hanoun, Gaza**
Larry Towell 1993

170 **Russian Jews**
boarding a plane
to Israel in Budapest
airport
Micha Bar-Am 1990

171 A Jewish scholar is
silhouetted against
the window of the
Yeshiva in Hebron.
Through the window
is the Tomb of the
Patriarchs soon to
be the scene of
a tragic massacre
James Nachtwey 1993

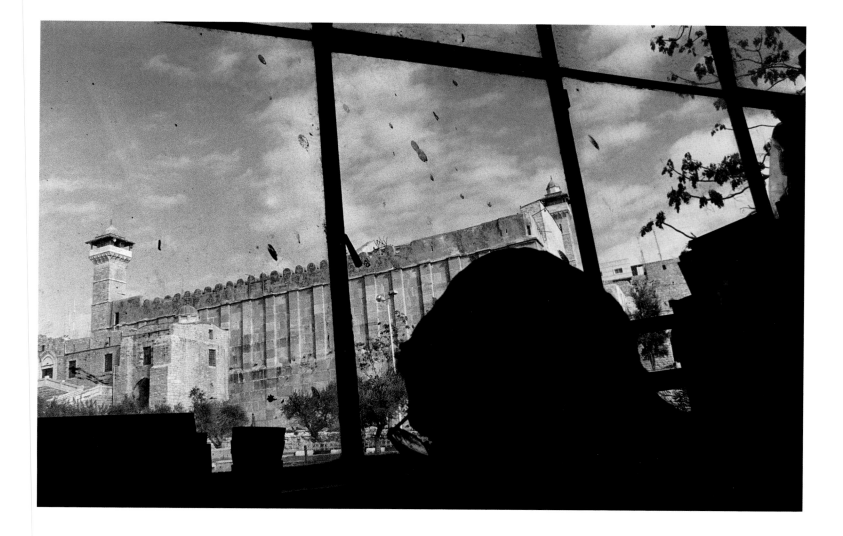

▸

172 Jabaliya Refugee
Camp, Gaza
James Nachtwey 1989

173 **A Russian Jewish
 visitor contemplates
 joining her family in
 Israel while walking
 in the Judean desert**
 James Nachtwey 1991

A Russian family who entered Israel on tourist visas failed to qualify for the absorption allowance normally granted new immigrants
James Nachtwey 1991

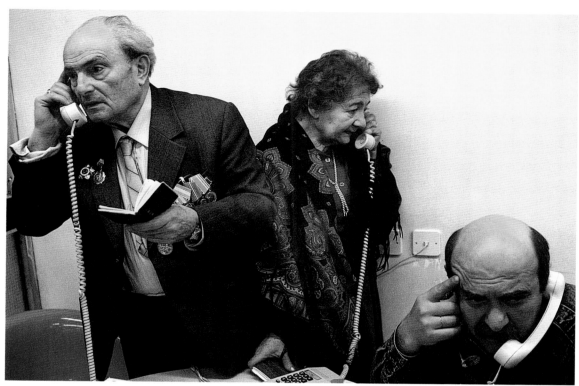

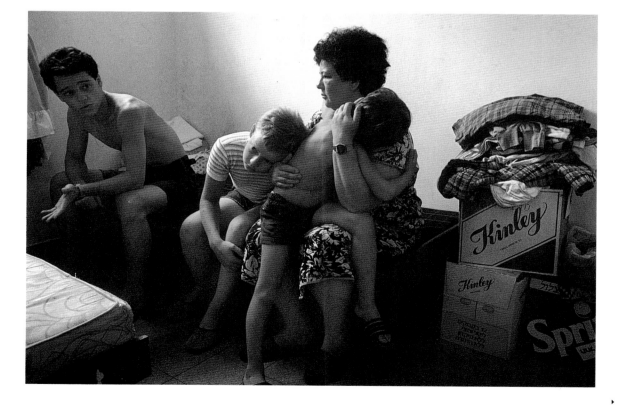

▶

176 **A beach scene, Tel Aviv**
Patrick Zachmann
1997

177 **Planet Hollywood,**
Tel Aviv
Patrick Zachmann 1997

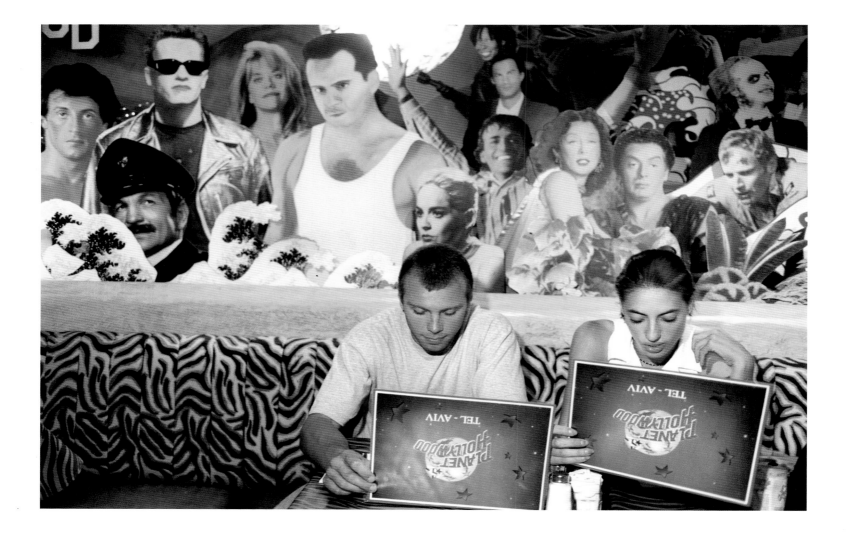

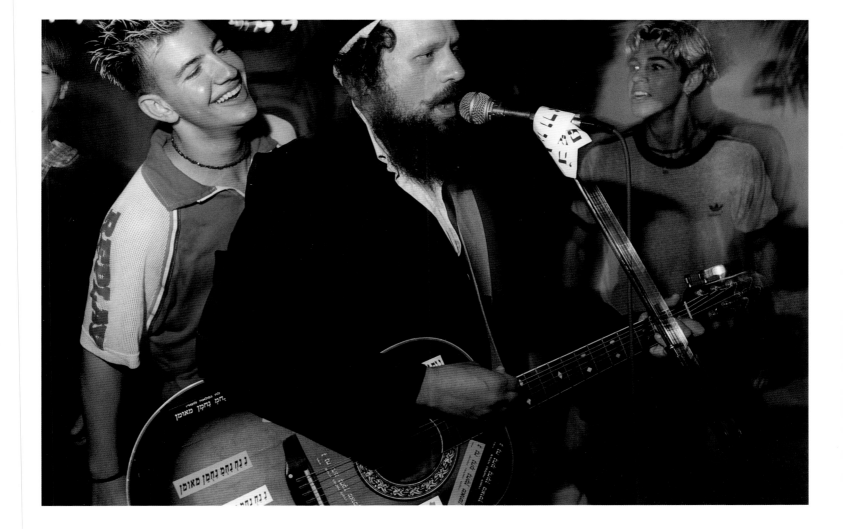

178 **An Orthodox Jew
attempting to
perform despite
harassment from
Israeli youths at the
Arad music festival**
Patrick Zachmann 1997

**Party-goers at a film
festival in Jerusalem**
Patrick Zachmann 1997

**Druze and Bedouin
boys dancing with
Israeli girls in a
techno night club
during the Arad
music festival, near
Beersheba**
Patrick Zachmann 1997

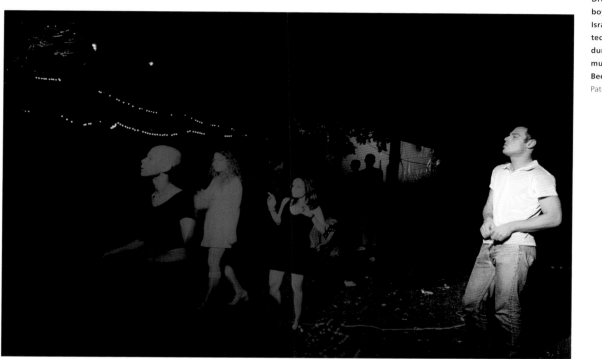

**Trance Music night
at a club in Allenby**
Patrick Zachmann 1997

182 Ata Hula, a Jewish
violinist plays in a
Jerusalem Park as
the sun goes down.
His hookah-smoking
audience are Israeli
Arabs from the
village of Abu Gosh
Patrick Zachmann 1997

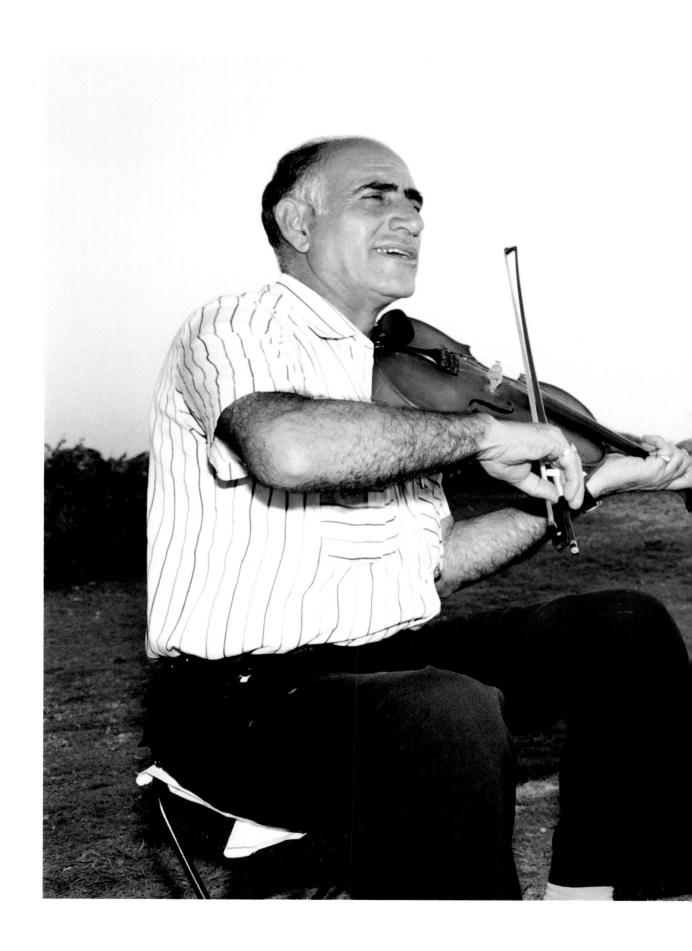

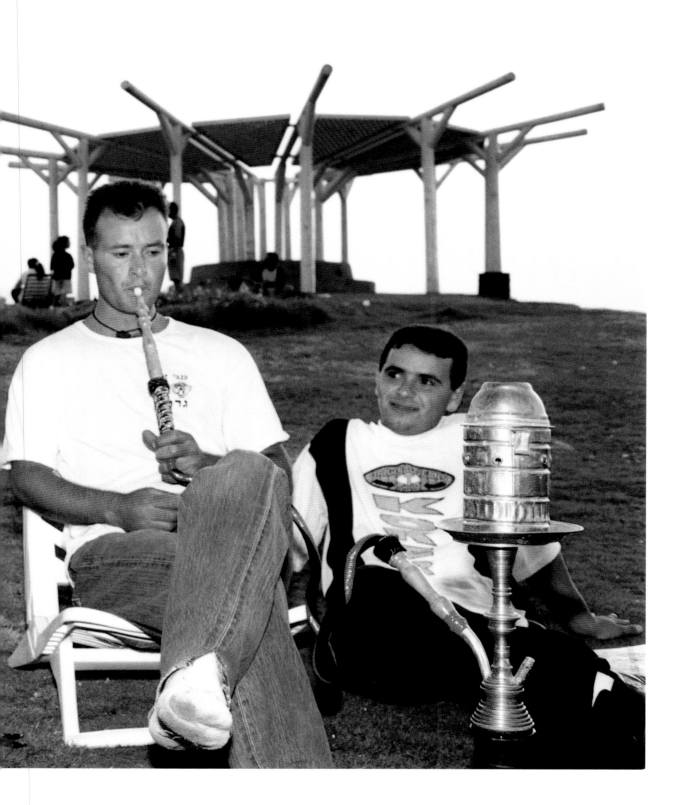

183 **Backstage at a**
fashion show held
in Tel Aviv
Patrick Zachmann 1997

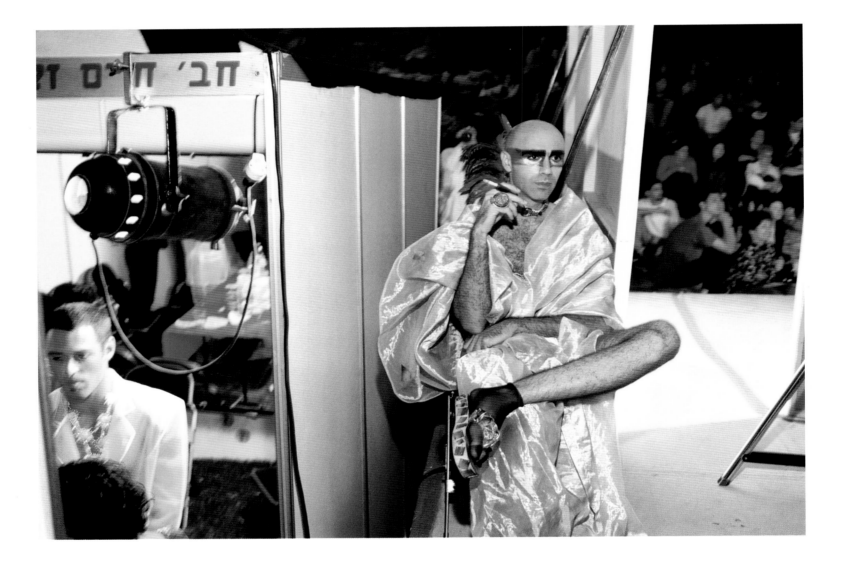

187 Fields of the Kibbutz
Saad, irrigated by
water drawn from
the National Carrier
in a computer
controlled process
Dennis Stock 1987

189 **Church of the
 Holy Sepulchre,
 Jerusalem**
 Carl de Keyzer 1996

190 **Auschwitz, Poland:
twins experimented
on by Mengele visit
the site of the camp**
Micha Bar-Am 1989

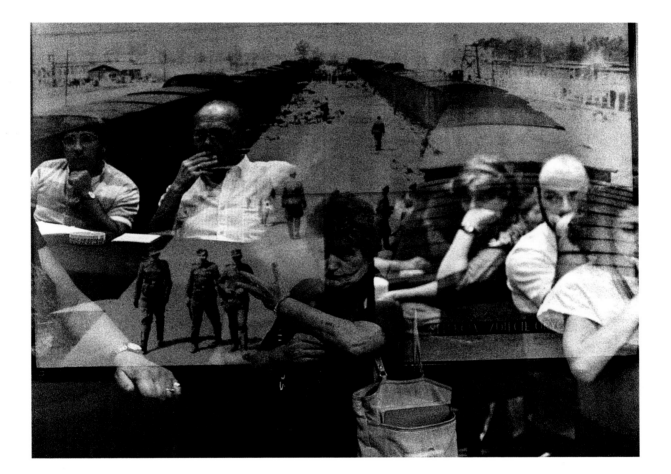

▸
191 **Palestinians at work
in the fields in Gaza**
Larry Towell 1993

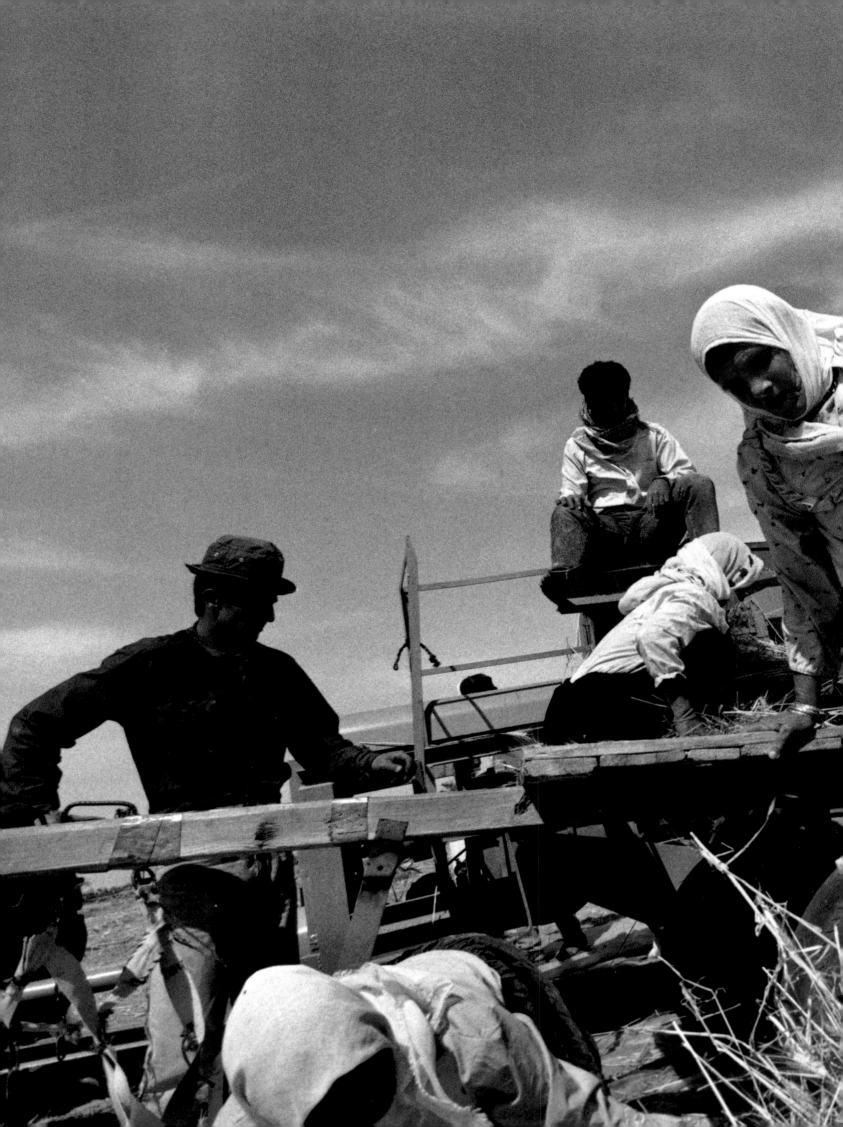

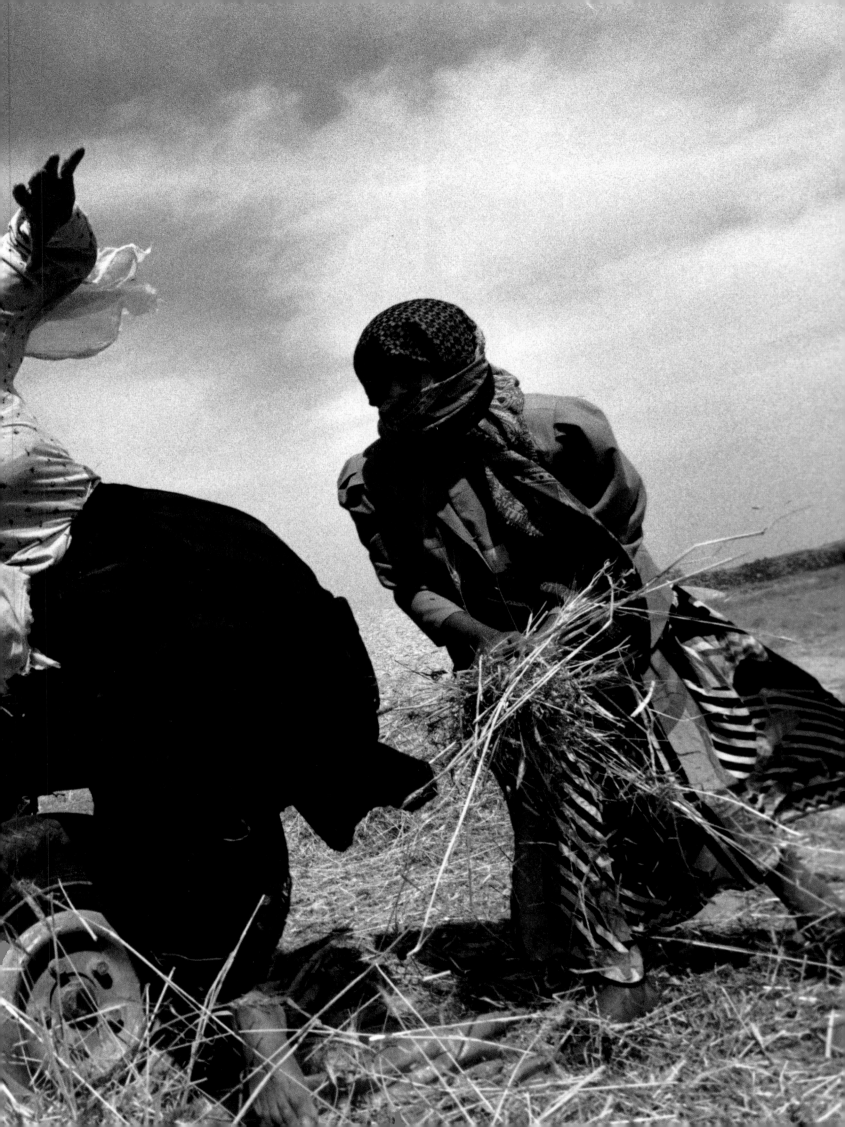

193 **Dome of the Rock**
Carl de Keyzer 1997

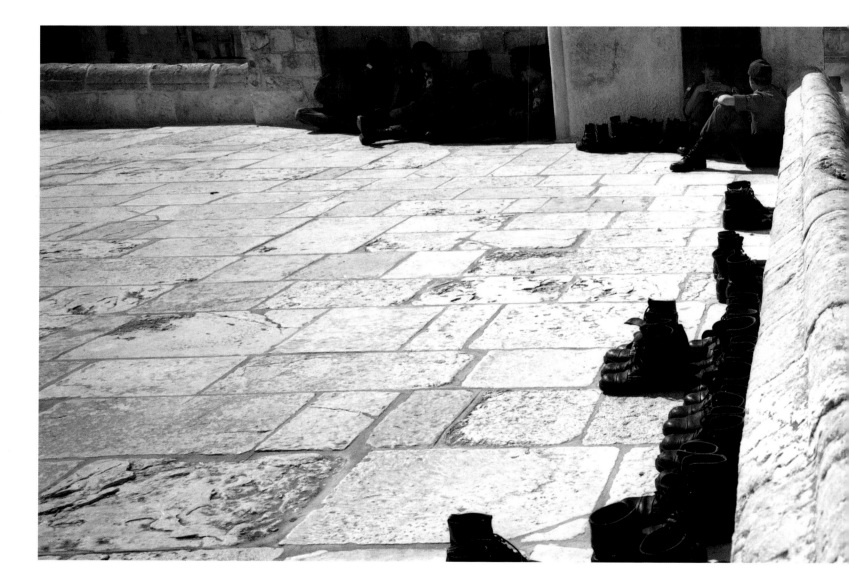

◄

192 **Hassidic Jews in
Jerusalem**
Abbas 1991

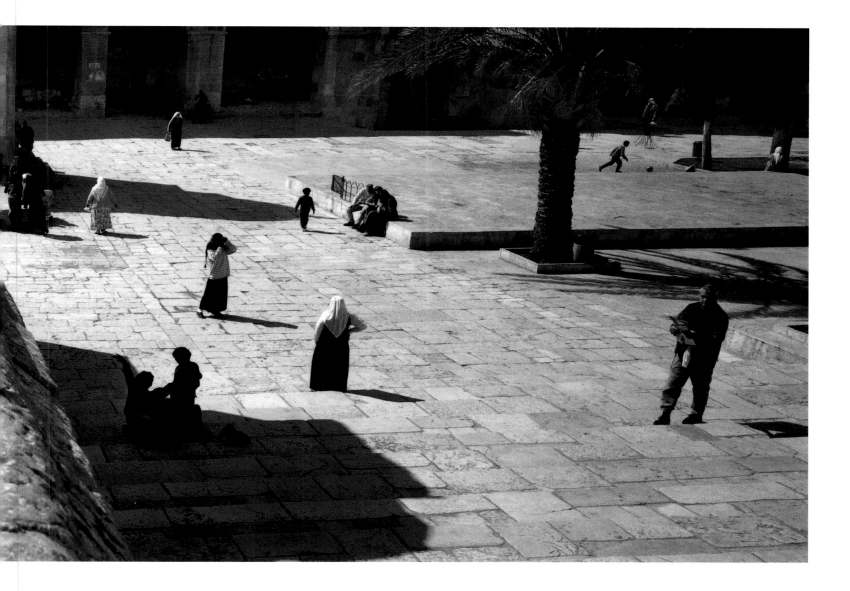

PREHISTORY

1896 January Extracts from Theodor Herzl's *Der Judenstaat* are published in the London *Jewish Chronicle*. 'We are a people, one people. We have everywhere tried honestly to integrate with national communities surrounding us and to retain only our faith. We are not permitted to do so... We are denounced as strangers... If only they would leave us in peace... But I do not think they will.'

1897 August The First Zionist Congress is held under Herzl's chairmanship in the great hall of the Basel Municipal Casino.

1905 The Seventh Zionist Congress rejects the offer from the British government of a Jewish colony of settlement in Uganda.

1910 Turkish troops quell an Arab uprising in Palestine. The first kibbutz, Degania, is founded.

1915 As the Ottoman Empire's control over Arab lands is fatally weakened during the First World War, the British government encourages Arab nationalism.

1917 November The Balfour Declaration is issued from the British Foreign Office:
Dear Lord Rothschild,
I have much pleasure in conveying to you, on behalf of His Majesty's Government, the following declaration of sympathy with Jewish Zionist aspirations which has been submitted to and approved by the Cabinet.
His Majesty's Government view with favour the establishment in Palestine of a national home for the Jewish people, and will use their best endeavours to facilitate the achievement of this object, it being clearly understood that nothing shall be done which may prejudice the civil and religious rights of existing non-Jewish communities in Palestine, or the rights and political status enjoyed by Jews in any other country. I should be grateful if you would bring this declaration to the knowledge of the Zionist Federation.
Yours sincerely,
Arthur James Balfour

1917 December The British Army takes Jerusalem from the Turks, and the British become the occupying power in Palestine.

1918 November A joint Anglo-French declaration, made four days before the Armistice with Germany, states: 'The object aimed at by France and Great Britain in prosecuting in the East the war let loose by the ambition of Germany is the complete and definite emancipation of the (Arab) peoples and the establishment of national governments and administrations deriving their authority from the initiative and the free choice of the indigenous populations.'

1920-1929 Over 100,000 Jewish immigrants enter Palestine so that Jews become 17 per cent of the population.

1921 May The Jaffa riots spread from a clash between Jewish factions, but develop into Arab-Jewish fighting in which 95 die and 220 are injured.

1922 July The British Mandate for Palestine, incorporating the Balfour Declaration in its preamble, is approved by the League of Nations and comes into effect in September, 1923.

1929 August A dispute over the Wailing Wall in Jerusalem leads to intercommunal violence in which 220 die and 520 are injured.

1930-1939 232,000 Jewish immigrants arrive in Palestine, making Jews 30 per cent of the population.

1933 Much-increased Jewish immigration due to the Nazi take-over of power in Germany leads to Arab-Jewish violence, and the establishment of an Arab Executive Committee from the various Palestinian political factions.

1936 April Minor Arab-Jewish clashes become a widespread Arab revolt against the British administration, born of the frustrations over nationalist aspirations. The Arab Higher Committee headed by the Mufti of Jerusalem calls for and achieves a general strike. The rebellion lasts for over three years, with increasing violence on all sides, including Arab attacks on British troops and police, and on Jewish settlements. In response, Jews are enrolled in the British police force, and the role of the Haganah, a covert Jewish paramilitary force, is greatly increased.

1937 The British stage a massive increase in their military presence, and military control is re-established. By now, in addition to the Haganah, the Irgun – a more extreme Jewish nationalist force – has formed, and Jewish soldiers are being trained in counter-insurgency as 'Special night squads' by Major Orde Wingate, later to distinguish himself in guerrilla fighting against Japanese forces in the Second World War. A British Royal Commission, investigating the causes of the violence, recommends the partition of Palestine.

1939 February London conferences are held with Jews, Palestinians and most of the independent Arab states, but British proposals for partition are rejected by all sides.

1939 May The British government issues a White Paper disclaiming any intention to create a Jewish state in Palestine, and also rejecting Arab demands that Palestine become independent as an Arab state. The Paper envisages the end

of the Mandate in 1949 with independence for Palestine as neither a Jewish nor an Arab state. It also creates a limit on immigration over the next five years, and an end to all immigration thereafter.

1939-1945 Both the Arabs and the Jews in Palestine officially support the Allied cause in the Second World War, so inter-communal and anti-British violence lessens, but does not cease. When the Irgun declares an 'armistice', a breakaway group known as the Stern Gang continues violent attacks on the British administration. Illegal immigration of Jews becomes widespread, to break the quotas imposed by the British. In Europe, genocide is practised by the Nazis on the Jewish populations under their control; six million die in the Holocaust.

1946 May An Anglo-American report recommends the partition of Palestine and the immediate entry of 100,000 Jewish refugees from Europe.

1946 July The King David Hotel, containing British government military and civilian offices, is blown up by Irgun, killing 86 people. Jewish terrorism continues to mount through the year.

1947 February The British Foreign Secretary announces in the House of Commons the intention to relinquish the Mandate for Palestine, and to place the problem with the United Nations. The United Nations establishes a committee (UNSCOP) which visits both Palestine and, more controversially, Europe to investigate the European refugee problem. In July, the ship *Exodus* with almost 5,000 Jewish refugees is prevented from disembarking in Haifa by the British authorities. UNSCOP places two proposals before the General Assembly: a majority proposal for the partition of Palestine, and a minority proposal for a federal state of Palestine. In November the partition plan is approved. The British declare an end to their mandate in May 1948, ahead of the timetable envisaged by UNSCOP.

1948-1957

1948 Palestinian Arab leaders and the Arab states reject the UN resolution on partition, while the Zionist leaders accept it. Jewish settlements come under attack, and in April the Haganah is ordered by David Ben Gurion to take action to link up isolated Jewish-held territory. In the process, the area under Jewish control is greatly increased. Many Arabs flee, especially after the notorious retaliatory raid on the Arab village of Deir Yassin near Jerusalem. It is carried out by

the Irgun and the Stern Gang, and there are mass executions, which become a general massacre. Ben Gurion declares the State of Israel on 14 May, and a provisional government is formed. The following day the British High Commissioner leaves. General fighting breaks out, involving all of the surrounding Arab states. Under a secret arrangement sponsored by Golda Meir, the Old City of Jerusalem is officially surrendered to the Arab Legion and to Transjordan. A month's truce in June-July is followed by renewed fighting during which the Israeli Defence Force, as the Haganah has become, makes further considerable territorial gains.

1948-1951 Over 684,000 Jewish immigrants are brought into Israel – a greater number than the Jewish population at the beginning of the period. Many come from Arab lands.

1949 David Ben Gurion's Mapai party wins the January elections and becomes the first Israeli government. Armistice talks are held in Rhodes, and lead to agreements with Egypt, Lebanon, Transjordan and Syria. By this time, over 650,000 Palestinian Arabs have left Israeli-held territory, the majority going to the West Bank of the Jordan and to the Gaza Strip, and many others into the Arab States. Their position as refugees is to be deliberately maintained by themselves and by the Arab States as part of the policy of the rejection of the State of Israel. Israel is accepted into the United Nations in May. In December the capital of Israel is moved from Tel Aviv to West Jerusalem.

1950 May The West Bank is taken over by Transjordan, and the new state is renamed the Kingdom of Jordan. Other Arab States protest, as their policy is to view the area as a Palestinian homeland. The King of Jordan is assassinated a year later.

1952 Chaim Weizmann, first President of Israel, dies. In Egypt, during July, a military coup deposes King Farouk, and a Revolutionary Council takes over.

1955 February In response to Palestinian raids into Israeli territory, the Israeli army makes an attack on the Egyptian-held Gaza Strip – the first major breach of the 1949 armistice between the two countries.

1956 Egypt seizes control of the Suez Canal in July, provoking an international crisis. In October, Israeli forces invade the Gaza Strip and Sinai in a sweeping advance. The following month, Anglo-French forces take control of the Suez Canal in a full-scale invasion. American pressure forces the withdrawal of forces, and their replacement by a UN presence. Initially, Israel refuses to

CHRONOLOGY

withdraw from Gaza, but does so under an agreement with Egypt that its forces will act to prevent Palestinian incursions.

1958-1967

1959 Yasser Arafat, working as an engineer in Kuwait, helps to form Fatah, with a collective leadership including Abu Jihad. A magazine is published in the Lebanon which draws a strong response among Palestinian refugee communities, and a military organisation is formed under Arafat, based on a secretive cell structure as to maintain security.

1960 Adolf Eichmann is captured by the Israeli Secret Services. In his trial he admits to his role in the Holocaust, and is hanged in 1962.

1963 David Ben Gurion resigns as Prime Minster; he retires to his kibbutz at Sede Boger to study and write. Levi Eshkol takes over as leader of the Labour Party and Prime Minster.

1964 Gamal Abdel Nasser, President of Egypt, wanting a Palestinian organisation more under the control of Arab governments, calls a conference of 13 Arab leaders at which it is agreed to form the Palestine Liberation Organisation, the PLO. The first congress of the PLO is held in East Jerusalem, and adopts the Palestine National Charter which calls for the destruction of the Jewish state. Nasser's hope of control rapidly fades as Fatah becomes the largest force within the PLO over the next few years.

1967 June Following an earlier clash with Syria, and the agreement to Nasser's demands for withdrawal by the United Nations, Israeli forces carry out pre-emptive strikes against the Egyptian air force, destroying 347 planes, mostly on the ground. Within six days, in an astonishing string of victories on four fronts, Israel takes control of Gaza, the Sinai, the West Bank, the Golan Heights, and, most importantly of all, the Old City of East Jerusalem. Moshe Dayan, the Israeli Minister of Defence, announces the annexation of Gaza. The United Nations passes Resolution 242, calling for Israeli withdrawal from territories occupied in the Six Day War, and for the right of all states in the region to live within secure and recognised boundaries.

1968-1977

1968 March In what comes to be known as the Karameh incident, the Israelis mount an attack on a Fatah base in Jordan called Karameh, in response to an attack on a school bus. Fatah is aware of the impending attack and counters it with Jordanian help, inflicting heavy losses by the standards of the Israeli Army at the time, and enabling Fatah to claim a victory.

1969 February At the Palestinian National Congress in Cairo, Yasser Arafat is proclaimed Chairman of the PLO, encompassing most of the Palestinian nationalist movement. In November, General Boustani, commander of the Lebanese Army, signs a pact with the PLO, intended to control them within the refugee camps but in effect giving the Palestinians far greater freedom of action. Golda Meir, the Foreign Minister of Israel, becomes Prime Minister.

1970 Following hijackings, several airliners are blown up at an airfield in Jordan. In September the PLO is expelled from Jordan in heavy fighting; the episode comes to be known as 'Black September'. Anwar Sadat becomes President of Egypt.

1972 A suicidal raid by Japanese terrorists at Tel Aviv airport kills 25 people, and provokes Israeli reprisal raids into the Lebanon where the Japanese had been trained. At the Olympic Village in Munich, Black September guerrillas storm the Israeli compound. Eventually they and their hostages are killed in a botched rescue attempt.

1973 October Egyptian and Syrian forces initiate the Yom Kippur War, at first taking the Israelis completely by surprise, and gaining territory. The war in the Sinai is intense, featuring one of the largest tank battles in history, and Israeli losses are far greater than in the Six Day War. Eventually, however, the Israeli forces retake all the ground lost to Egypt and Syria, and threaten to cut off the Egyptian army, forcing the Egyptians to sue for peace.

1974 Golda Meir resigns as Prime Minister of Israel amid concerns over preparedness for the Yom Kippur War. She is succeeded by Yitzhak Rabin.

1976 July In an extraordinary operation, Israeli commandos free 100 hostages held by Palestinian hijackers at Entebbe airport in Uganda, flying out the hostages despite the hostility of the Ugandan government under Idi Amin. Civil war rages in the Lebanon, and Syrian military intervention leads to enmity between the PLO and Syria.

1977 Amid scandals, Rabin loses the elections to a new Knesset coalition grouping known as the Likud, under Menachem Begin, who had commanded the Irgun. The Likud take a hard line over any territorial concessions. It is the first time in Israeli history that the government coalition has not been led by the Labour party, and reflects changes in Israel's population. In November the President of Egypt, Anwar Sadat, causes worldwide astonishment by flying to Jerusalem and addressing the Knesset, calling on Begin to attend peace discussions.

1978-1987

1978 Following Sadat's call for peace, talks are brokered by United States President Jimmy Carter at Camp David. Sadat and Begin share the Nobel peace prize, and the following year a peace treaty is signed – the first treaty between Israel and any of its Arab neighbors. A group of reserve army officers establish the Peace Now movement in Israel.

1981 July In an attempt at reprisals, Israeli jets bomb Beirut, resulting in over 150 deaths. In October, Anwar Sadat is assassinated.

1982 As part of the agreement with Egypt, Israel undertakes a total withdrawal from the Sinai. At Yamit, an Israeli settlement in the Sinai, settlers and their supporters have to be expelled by force by the army. Israel annexes the Golan Heights, and in June launches a full-scale invasion of Lebanon, rapidly advancing on Beirut, and overwhelming Syrian forces in southern Lebanon. The Israeli forces bombard Beirut, and eventually 14,000 Palestinians are evacuated under an American agreement, mostly into Damascus. Arafat, however, continues resistance to Syrian control, and leaves for Athens. For the next four years the PLO is disunited.

1983 An Israeli government inquiry criticises the role of Israeli forces in failing to prevent the massacres of Palestinian refugees in the Lebanese camps of Sabra and Chatila the previous year. In August, Menachem Begin resigns as Prime Minister, and is succeeded by Yitzhak Shamir.

1984 Israeli elections are inconclusive and lead to a government of national unity with Shimon Peres as Prime Minister, subject to an agreement to give way to Shamir after two years.

1987 December Following Palestinian suspicions regarding the deaths of four men in a road accident in Jebalya in the Gaza Strip, riots break out. The Israeli response is tough, but the riots are unquelled and begin to spread throughout the occupied territories. The Intifadah has begun, and is to continue for many years.

1988-1997

1988 November The Palestinian National Council meets in Algiers, and declares the State of Palestine. A month later Yasser Arafat issues a political statement in which all forms of terrorism are renounced, and there is an acceptance of the State of Israel as a state within the region. The United States agrees to enter into talks with the PLO for the first time.

1991 Israel comes under direct missile attack as Iraq fires Scud missiles during the Gulf War, injuring more than 200 people and damaging almost 9,000 homes in the Tel Aviv area. Israeli forces remain out of the conflict.

1992 Elections lead to a Labour-led coalition with Yitzhak Rabin as the new Prime Minister.

1993 Secret negotiations between the Israeli government and the PLO, held at the same time as the international conference established in Madrid in 1991, lead to the signing of a joint declaration on interim self-government arrangements for the Palestinians in occupied territories, and the famous Arafat-Rabin handshake at the White House in September.

1994 May The Israeli forces withdraw from Gaza and from Jericho, and in July Yasser Arafat visits and swears in members of the Palestinian Authority. Israel signs a peace agreement with Jordan.

1995 November Prime Minister Rabin is assassinated by an Israeli opposed to the peace process. Shimon Peres becomes Prime Minister and continues negotiations over the West Bank, which are slowed by Israeli concerns over settlers. Resistance to withdrawal from the West Bank, and particularly Hebron, grows, but withdrawal begins.

1996 In the first direct elections to choose a Prime Minister, the Likud party wins and Benjamin Netanyahu takes over with a coalition of parties who take a far stronger line on the rights of Israeli settlers in the West Bank. In September, trouble erupts again in Gaza over Israeli insistence on opening a tunnel that is very close to a Muslim holy site.

1997 Agreement is finally reached over Hebron's status but as the year progresses, tensions continue to mount between the Palestinian Authority and the Israeli Government. The fragile peace process remains under constant threat.

First published in 1998 in the United States of America, Great Britain, Israel, Canada, and
the Philippine Republic by Aperture Foundation, Inc. Copyright © 1998 by Magnum Photos, Inc.
Photographs copyright © 1998 by Magnum Photos, Inc. All rights reserved under
International and Pan-American Copyright Conventions. No part of this book may be
reproduced in any form whatsoever without written permission from the publisher.

Library of Congress Catalog Card Number: 97-75184
Hardcover ISBN: 0-89381-774-0

Cover photograph: *The arrival of refugees by boat in Haifa*, 1948, by Robert Capa

Printed and bound by Arti Grafiche Motta, Milan, Italy.

ISRAEL: 50 Years produced for Magnum Photos Inc. by:
 Chris Boot and Roger Sears, Editorial Direction
 David Pocknell, Art Direction
 James Fox, Photo Research
 Jonathan Allan (Pocknell Studio), Layout

The staff at Aperture for *ISRAEL: 50 Years* is:
 Michael E. Hoffman, Executive Director
 Lois Brown, Editor
 Stevan A. Baron, Production Director
 Elizabeth Franzen, Managing Editor
 Michelle M. Dunn, Design Associate

Aperture Foundation publishes a periodical, books, and portfolios of fine photography to communicate
with serious photographers and creative people everywhere. A complete catalog is available upon request.
Address: 20 East 23rd Street, New York, NY 10010. Phone: (212) 598-4205. Fax: (212) 598-4015.

Aperture Foundation books are distributed internationally through:
Canada: General Publishing, 30 Lesmill Road, Don Mills, Ontario, M3B 2T6. Fax: (416) 445-5991.
United Kingdom and Continental Europe: Robert Hale, Ltd., Clerkenwell House,
45-47 Clerkenwell Green, London EC1R OHT. Fax: 171-490-4958.
Netherlands: Nilsson & Lamm, BV, Pampuslaan 212-214, P.O. Box 195, 1382 JS Weesp,
Netherlands. Fax: 31-294-415054
Israel: Steimatzky Ltd., Steimatzky House, 11 Hakishon St., P.O. B. 1444, Bnei Brak 5114, Israel.
Fax: 972-3-579-4-567.

For international magazine subscription orders for the periodical *Aperture*, contact Aperture International.
Subscription Service, P.O. Box 14, Harold Hill, Romford, RM3 8EQ, England. Fax: 1-708-372-046.
One year: £30.00. Price subject to change.

To subscribe to the periodical *Aperture* in the U.S. write:
Aperture, P.O. Box 3000, Denville, NJ 07834. Phone: 1-800-783-4903.
One year: $40.00

First edition 10 9 8 7 6 5 4 3 2 1

Magnum would like to thank: Abbas, Eve Arnold, Micha Bar-am, Clarisse Bourgeois, Glen Brent, Cornell Capa,
Carrie Chalmers, Stephen Gill, Burt Glinn, Elizabeth Grogan, Hayette Hannouf, François Hébel, Nigel Horne, Pablo Inrio,
Margot Klingsporn, Roberto Koch, Brigitte Lardinois, Peter Marlow, Enrico Mochi, Jan Mun, Weltraud and Siegfried
Scheld, Agnès Sire, Howard Squadron, Chris Steele-Perkins, Raj Valley, Lorena Vazzola, and Patrick Zachmann.